AFRICAN ART

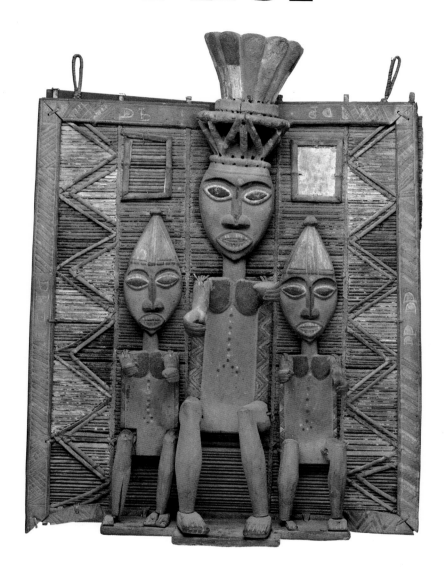

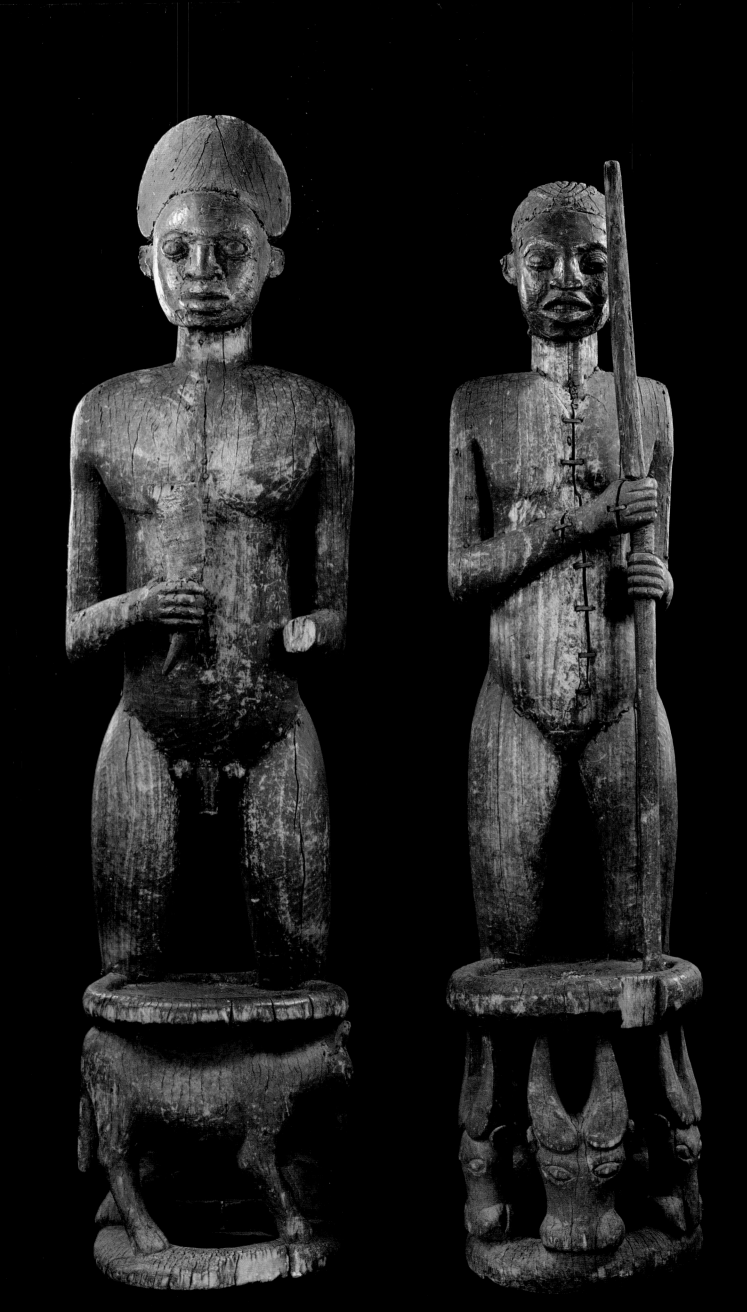

AFRICAN ART

Crescent Books

New York/Avenel, New Jersey

This 1995 edition published by Crescent Books, distributed by Random House Value Publishing, Inc., 40 Engelhard Avenue, Avenel, New Jersey 07001

Random House
New York · Toronto · London · Sydney · Auckland

Produced by Brompton Books Corporation, 15 Sherwood Place, Greenwich, Connecticut 06830

ISBN 0-517-12080-1

8 7 6 5 4 3 2 1

Printed and bound in China

PAGE 1
Duen Fobara
(Memorial Screen)
Kalabari region, Niger delta, nineteenth century
Wood, raffia and traces of paint, 37½ × 28 inches (96 × 72 cm)
Minneapolis Institute of Arts, John R. van Derlip Fund

PAGE 2
Royal Ancestors as Throne Figures
Bamun kingdom, Cameroon, nineteenth century
Wood, 19¼ inches (49 cm) high
Museum für Völkerkunde, Berlin

PAGE 4/5
Welcome in our Peace World
Johannes Segogela (b. 1936), South Africa
Painted wood
Goodman Gallery, Sandton, South Africa

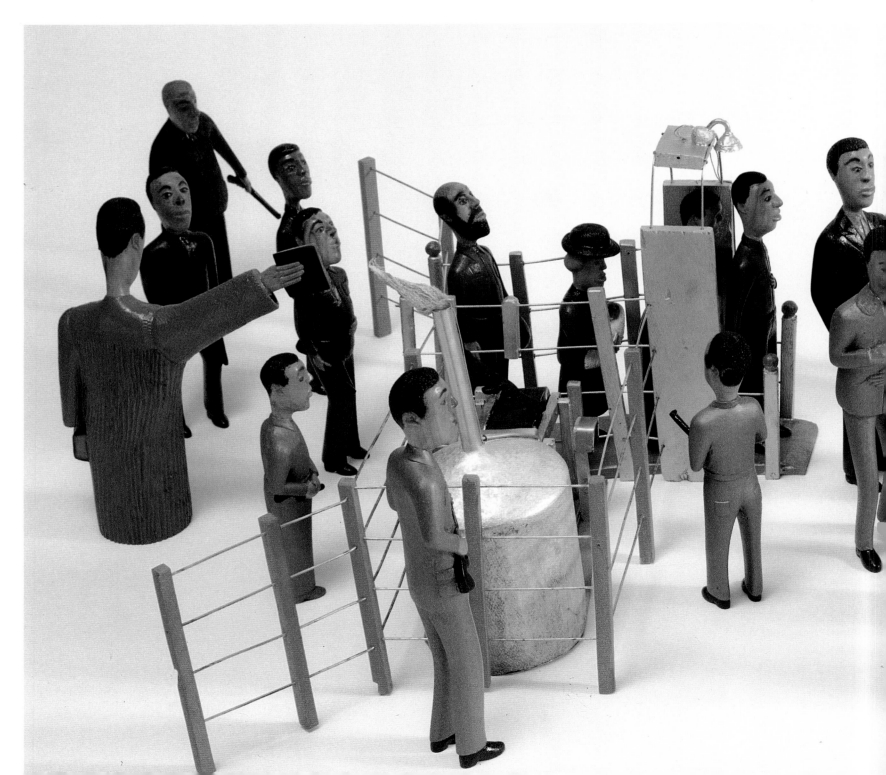

CONTENTS

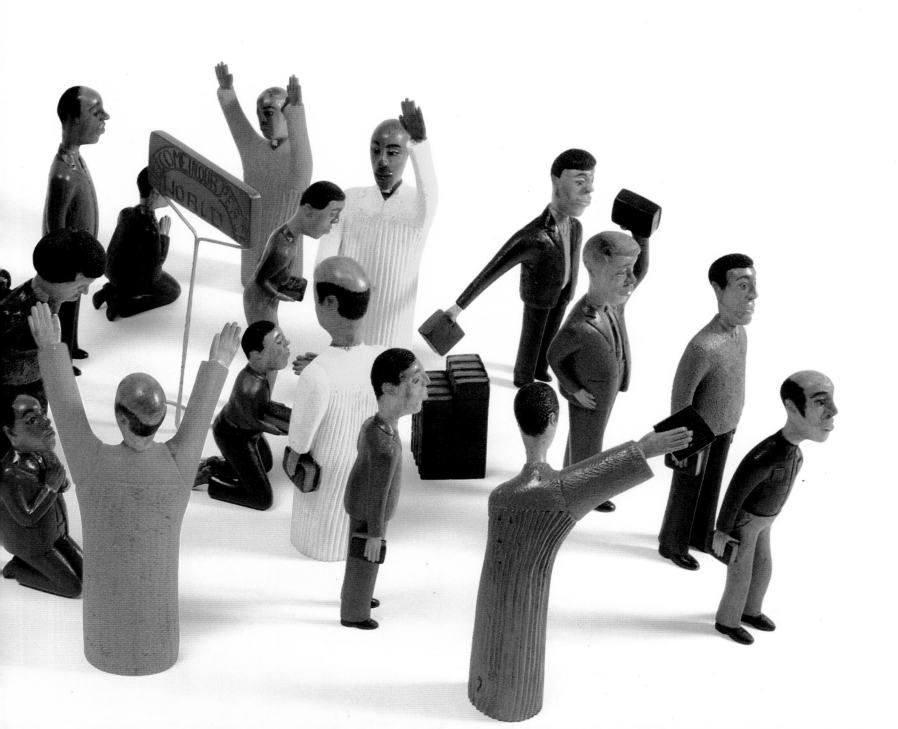

INTRODUCTION

Africa is a vast continent covering some 12 million square miles, with a population well in excess of 350 million people. Art from Africa has been the subject of both local and external appreciation for thousands of years, with the culture of ancient Egypt a vital source of inspiration for both Greece and Rome. It is perhaps not surprising, therefore, that the first impression created by the arts of the peoples of Africa is often one of immense variety and bewildering diversity. One response to this, in the West at least, has been to impose a degree of selectivity, to try to find order, to fit African arts within systems of classification constructed from outside.

While some form of selection may be inevitable, it is important to be aware of the ways in which the organizing gaze of outsiders has operated at various periods, and has favored certain types of art and artistry that suit the intellectual and artistic preoccupations of the observers, rather than the local priorities of their African makers and users. The photograph *Two Faces of Yoruba Artistry* was taken in 1964 by an art historian cataloging Yoruba sculpture for the Nigerian National Museum. It shows a fine veranda post, with a typical horse and rider motif, by the Yoruba sculptor Olowe, of Ise-Ekiti (died 1938). It was only when the photograph was reviewed a quarter of a century later that the background came into new focus; a woman weaving cloth on the upright loom then widespread in the eastern part of the Yoruba region. Inevitably the woman artist ignored for so long remains anonymous.

This image encapsulates the problems created by the assumption of European observers that sculpture is the pre-eminent African art. Of course sculpture in wood, metal, terracotta, or more rarely stone, is clearly a major art form in many areas of Africa, as the photograph and many others in this book will illustrate. It is, however, only one aspect of the visual arts in Africa, taking its place alongside rock painting, pottery, mud sculpture, architecture, textiles, jewelry, various forms of body decoration and, increasingly, painting and sculpture in the modernist tradition. To ignore this is not only to risk distorting local perceptions of artistry but, since sculptors in Africa are almost all male, to silence the contribution of women to African arts.

Art objects from Africa, along with those of other non-European cultures, have long been collected in Europe. The Mediterranean civilizations of Greece and Rome drew on the artistic heritage of Egypt, while from the time of the fifteenth-century Portuguese explorations of the West African coast, a range of artifacts was brought back for the curio cabinets of kings and nobles. Ivory carvings of great delicacy were commissioned in Sierra Leone and Benin for sale in Europe, creating a hybrid fusion of local carving styles with Portuguese motifs. Soldiers and merchants from Por-

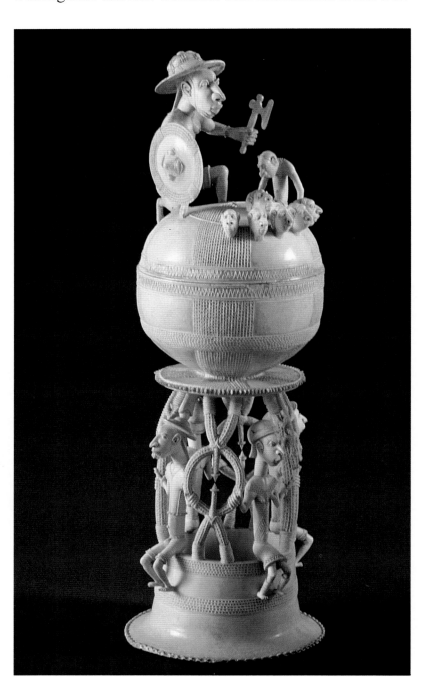

BELOW LEFT: Ivory salt cellar, *c.*1490-1530, 16¾ inches (43 cm) high, carved in the Sherbro style on the coast of Sierra Leone, for sale to Portuguese traders.

RIGHT: *Two faces of Yoruba Artistry.* In the foreground a magnificent veranda post by the sculptor Olowe of Ise-Ekiti demonstrates his creativity within the canon of north-eastern Yoruba sculpture. Behind an unidentified woman prepares her loom; in the nineteenth century women's weaving was the economic mainstay of this region.

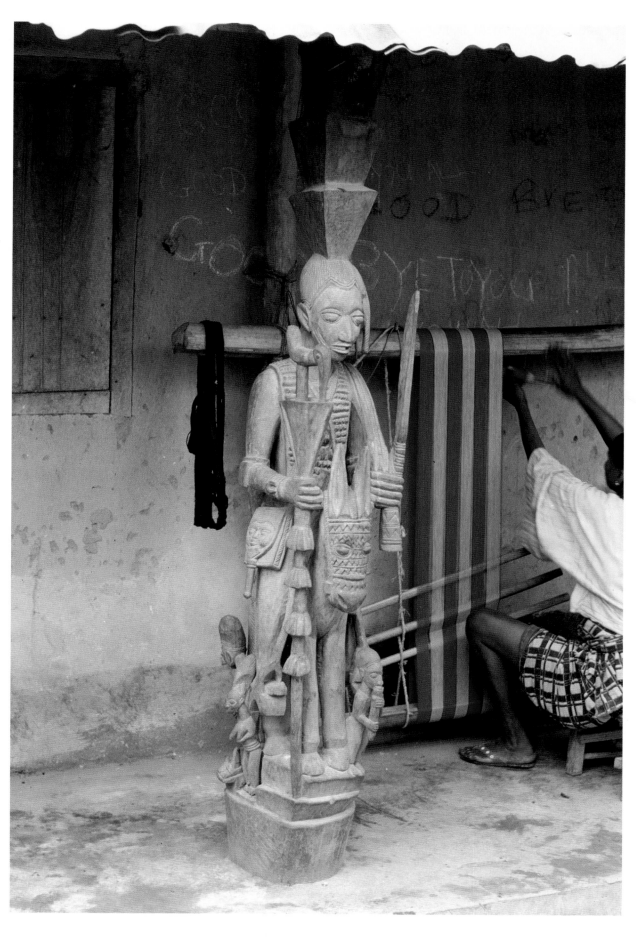

tugal were also represented in artworks for local use, such as the bronze plaques and ivory hip masks that adorned the palace and costume of the Oba of Benin.

Although the Atlantic slave trade began almost immediately after the first Portuguese exploratory voyages, it was only with the development of evolutionary theories and so-called 'scientific' racialism in the late nineteenth century that the status of African objects began to be reclassified as specimens rather than curiosities. Coinciding with the early phases of colonialism, expeditions were mounted during which collections of literally thousands of artifacts were amassed. In addition to the immediate damage caused by this looting of local cultures, it has recently been demonstrated that, far from giving objective support to racial hierarchies, as imagined and intended by the Natural History Museums and Colonial Ministries that supported them, the collections made by these ventures

in fact reflected the participants' preference for figurative sculpture, and often imposed these priorities on African artists, who were eager to supply this sudden new custom.

The further transition in the role of African art, from specimens for scientific analysis to objects regarded as suitable for aesthetic appraisal, is customarily attributed to the interest taken in certain types of African sculpture by avant-garde artists in Paris and Germany in the early decades of the twentieth century. A few earlier artists had appreciated and been inspired by non-European art. The arrangement and forms of figures in some of Gauguin's paintings, for example, appear to have been influenced by the stonework on Javanese Hindu temples and the sculpture of the Marquesas Islands in the Pacific. Picasso, Braque and others, however, saw the particular formal solutions to the representation of the human face and figure in certain African masks and sculptures as corresponding to their own desire to break away from the constraints of European classicism.

This interest in form did not, in most cases, extend to any corresponding interest in the local meanings of the art, let alone in the artists who had created it. Nevertheless, the fashion for collecting and displaying African art alongside contemporary Western art was set in this period. The tastes of the early collectors, and of the few powerful dealers who supplied them, established a canon of 'major' African art that has only recently been challenged. The values and associations formed then still exert a powerful influence on collectors, museums and scholarship today. A sculpture owned by the artist and photographer Man Ray was sold in 1990 for nearly $3.5 million, a record for any piece of African art. It was its documented association with Man Ray and its past links to well-known early collectors, however, rather than its use or significance in its African context, that boosted its price to such an unprecedented level. Although known as the *Bangwa Queen*, the statue, collected in 1898 in the Bamileke region of the Cameroon grassfields, is probably a commemorative figure of a priestess of the Earth cult and mother of twins.

LEFT: Erich Heckel's *Still Life with African Mask*, 1912, reflects the Western taste for African art in the early years of the twentieth century.

RIGHT: Anthropomorphic pot, Mangbetu or neighboring peoples, north-eastern Zaire, 10¼ inches (26.25 cm) high. Recent research suggests that these pots, which depict the shaped heads and elaborate hairstyles of Mangbetu noblewomen, were mainly produced in response to European interest in the early colonial period.

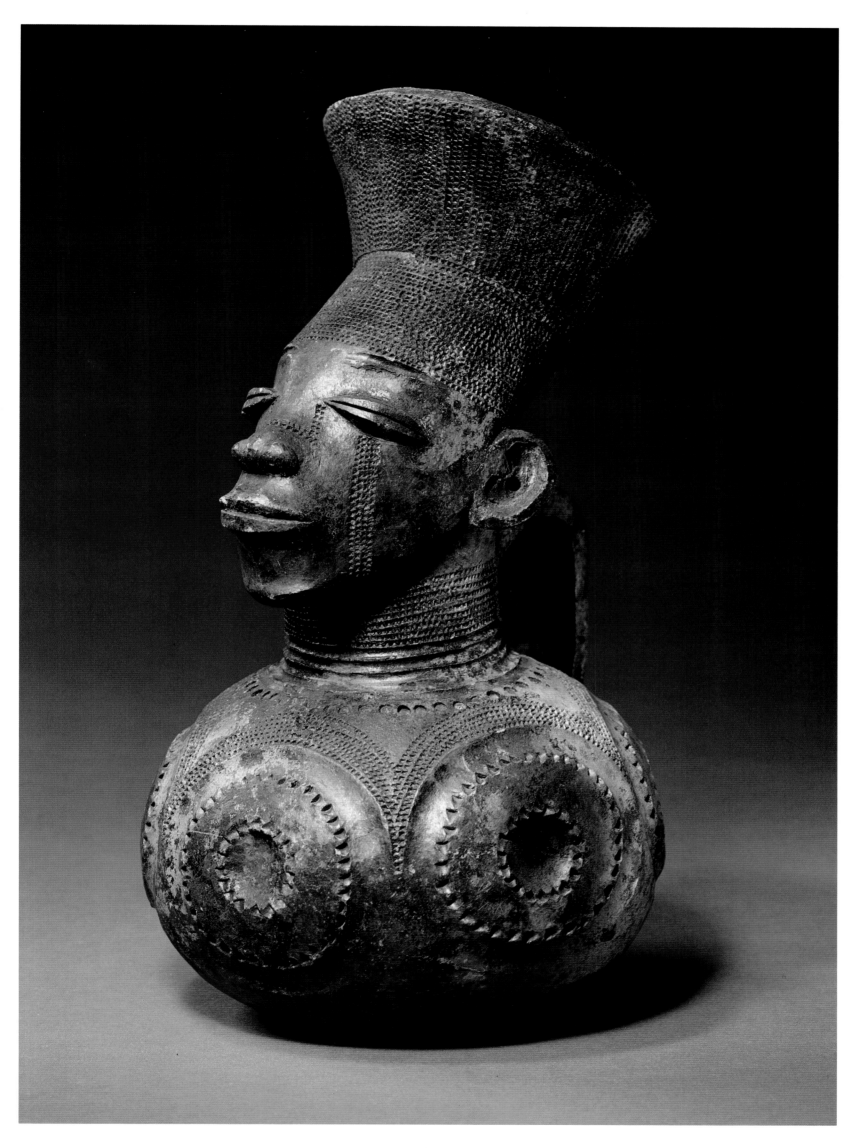

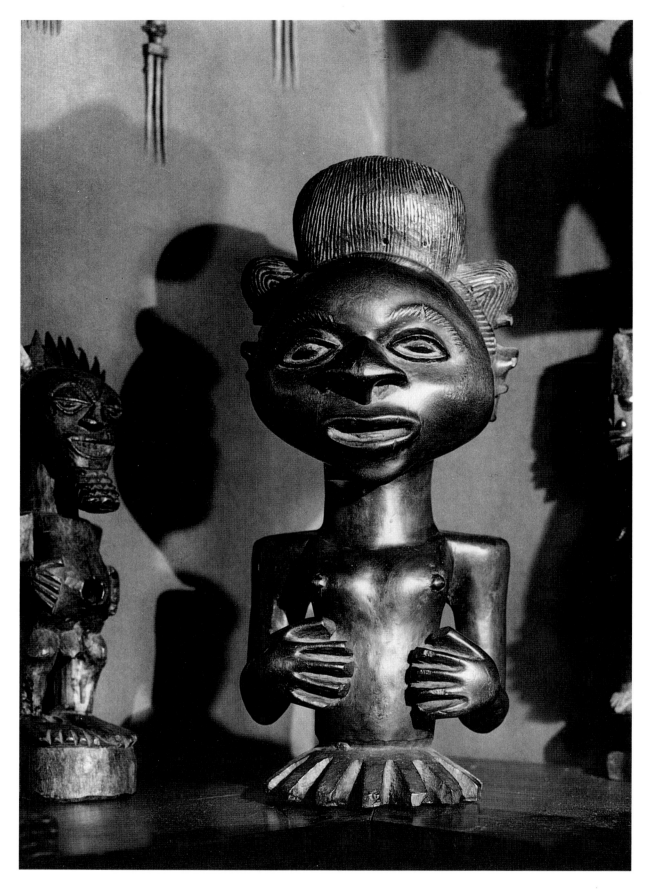

LEFT: Part of Man Ray's collection of African sculpture. Ideas of exotic otherness and mystique imposed on African art by European primitivists in the early decades of the twentieth century continue to distort perceptions today. (Association Internationale des Amis et Défenseurs de l'Oeuvre de Man Ray)

When a few art historians in the United States and Great Britain began to take a more serious interest in African art during the 1950s, the inadequacy of concentrating on the formal features of the objects alone became rapidly apparent. An effort to remedy this led many to draw on anthropological research and methods in a search for knowledge of local contexts and meanings. There were a number of advantages to this approach. Time was spent in Africa studying how art was made, the ways in which it was used, the sources of patronage. A great deal of such information

had been contained in the earlier works of travelers, colonial officials and missionaries, but systematic study led to many more sophisticated, nuanced accounts. A changing attitude toward African culture reflected in part the influence of African and African-American intellectuals in the lead up to, and immediate aftermath of, the independence struggles. Negritude and the pan-Africanist movement had their impact on the work of painters in some African countries, as well as the African diaspora. Nevertheless the scholarship of this period also left a legacy of problems for the appre-

RIGHT: Wrapper (*adweneasa*), Ashanti people, Ghana, silk, 78⁹⁄₁₆ × 54¾ inches (199.5 × 139 cm). National Museum of African Art and National Museum of Natural History, Washington, D.C., purchased with funds provided by the Smithsonian Collection Acquisition Program, 1983-85, Lamb 230 GA.

Perhaps the finest achievement of African narrow-strip weavers, cloths of this type were woven from imported silk in the village of Bonwire, near Kumasi, for the court of the Asanthene, king of the Ashanti confederacy.

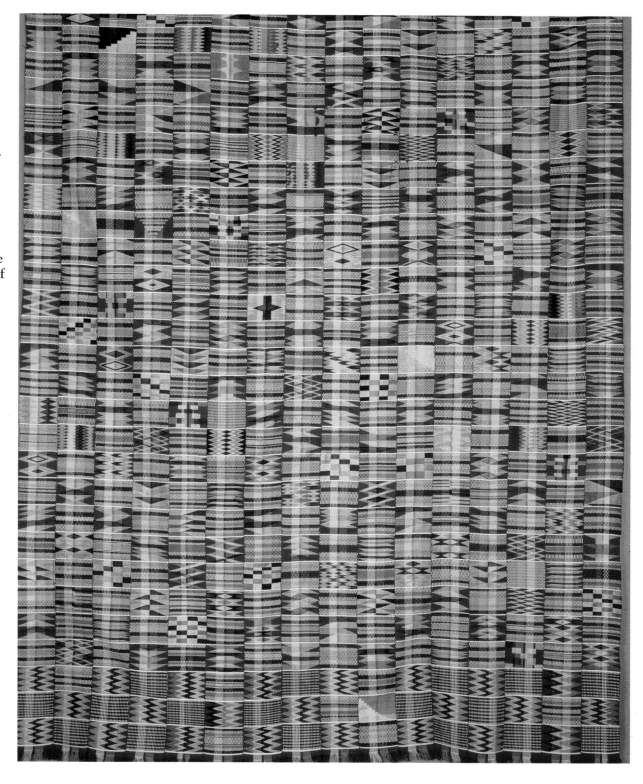

ciation and understanding of African art. An uncritical borrowing of ideas from anthropology led many to see African art solely in terms of an oversimplistic contrast between the authentic art of the unchanging past, produced by generally anonymous artists working in the style particular to their 'tribe,' and a dislocated postcolonial present in which less and less genuine art was to be found.

While it was rare in Africa until recently for works to be considered primarily in terms of the artist who created them, many instances have been documented of particular artists, renowned for their skill and originality, drawing patronage from a wide area. The supposed anonymity of African artists was often due as much to the circumstances in which their work was collected by outsiders (both foreign and African dealers) as to the state of knowledge available locally. The issue of 'tribal styles' is a complex one. Names for ethnic groupings such as Yoruba, Kongo, Baule, etc., are virtually unavoidable as a convenient shorthand for designating both the inhabitants of a particular area and the art associated with them. These names often also conform with current local usage. However it is essential to bear in mind that many of them only came into use in the colonial period; both wider and narrower identities may be used depending on the context. Although it is possible to demonstrate historical continuities in specific cases over long periods, it cannot be assumed that either the groups of people, or the styles of art we associate with them, are somehow 'traditional' and therefore existed unchanged for centuries preceding the colonial conquests.

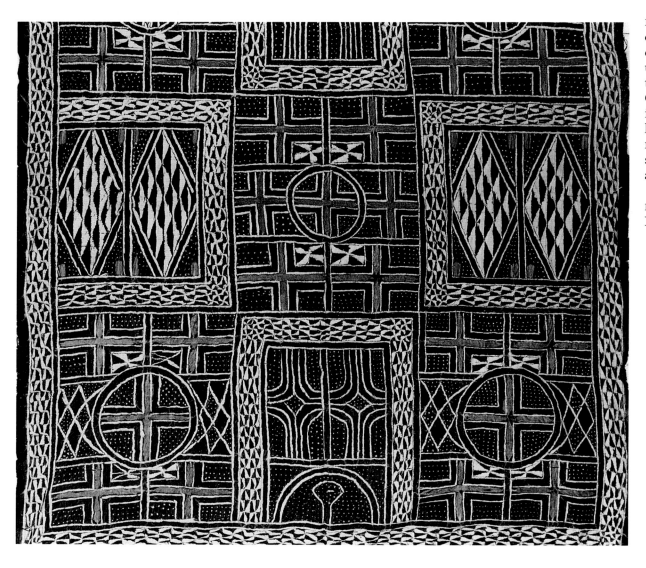

LEFT: Indigo resist-dyed cotton cloth, Bamun, Cameroon, detail. Cloths such as this were used in royal courts throughout western Cameroon. Their production involved a complex system of long-distance trade between narrow-strip weavers, specialized pattern sewers, and indigo dyers.

RIGHT: Mask/headdress, Bambara association, Mali.

In any event, the vast majority of African artworks with which we are familiar today date from after 1850. As many of the photographs in this book illustrate, art in Africa has thrived in the face of great disruptions in the last one and a half centuries, as it did over equally turbulent periods in earlier times. The implications of historical events must be investigated in terms of their impact, whether positive or negative, for particular art

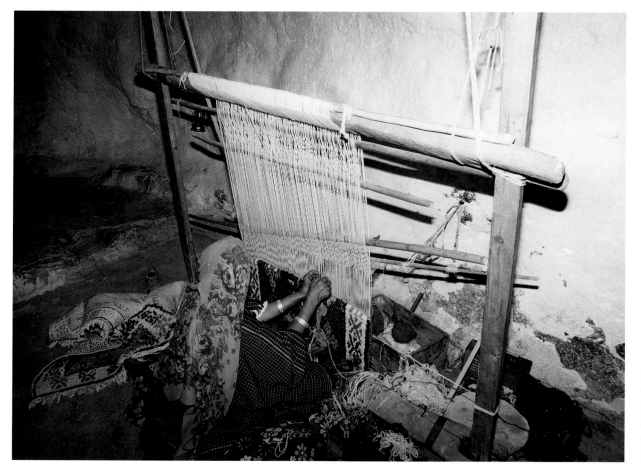

LEFT: Berber woman weaving, Tunisia. Among the Berber people, the loom is the center of a complex web of symbolic concepts. (Photo Alastair Lamb)

traditions at specific periods, rather than in terms of sweeping contrasts. The fact that access to imported silk thread, through the European presence on the Gold Coast, was a vital factor in the development of the complex and sophisticated textiles of the Ashanti and Ewe in present day Ghana, in no way diminishes the astonishing creativity with which the weavers developed ever more elaborate designs.

In almost all African cultures there is a clear division of tasks, duties, power and responsibilities, between men and women. While the allocation varies between different groups, and occasional exceptions may be found to even the strictest of divisions, forms of artistic practice are generally divided by gender. Blacksmiths, goldsmiths, woodcarvers, weavers on certain types of loom, are virtually always men. Other loom types are used by women in some regions and men in others, while in most, but not all, areas pottery is made by women. Mural decoration of houses is generally the work of women, but sometimes shrines are painted by men. Even the presence of women, or at least of pre-menopausal women, was often regarded as dangerous, either to the success of operations such as iron-smelting, or to the fertility of the woman. Attempts have been made to explain these concepts in terms of an analogy between certain transforming activities and childbirth, with a consequent belief that bringing the two types of transformation too close together may damage one or both. More research is needed, but it is probable that we will never know the processes that have led to, for example, Yoruba women weaving broad pieces of cloth on upright looms, while in the same compounds their men weave narrow strips on entirely different, horizontal looms. Some but not all of these gender divisions are being modified today; Yoruba women have largely abandoned the upright loom and are taking up horizontal loom weaving in growing numbers, while art schools have produced a few female sculptors.

A similar and fully developed analogy between the creative transformation of artistry, and that of female fertility and childrearing, was apparently drawn by Berber women weavers in the Atlas mountains of North Africa. Here the wool used for the warp (the set of threads held in tension by the loom) was taken from the slightly longer and rougher fibers of rams, while the weft (the threads inserted back and forth across the warp in weaving) came from ewes. The warp thread itself was regarded as male, and spun tightly on a small spindle regarded as female, while the female weft was spun more loosely on a larger 'male' spindle. Before the arranged set of warps was positioned upright on the loom, the woman raised her skirts and walked slowly over it, while the moment when the mounted set of warps was drawn apart to commence weaving was re-

ferred to as a birth, from which men were excluded. The interweaving of male warps and female wefts was analogous to intercourse, and only married women could weave. In some cases young girls had to avoid crossing over the loom beams or the warp threads, while in others a ritual passage through the warps was believed to protect a girl's virginity until marriage. The implications of rituals of this nature, and their relationship to the dominant male ideology, are still the subject of ongoing research too complex to be explored here, but clearly there can be much more to artistic processes than is at first apparent.

The social status, working organization, and significance of artists varies both between different African cultures, and according to the cultural and practical values associated with their products. In some cases artists have a complex, anomalous status, although this should not be directly compared to the image of artists as rebellious loners developed in post-Renaissance Europe. Manding speakers dispersed from the time of the medieval Mali Empire (*c*.1300-*c*.1700) across large parts of Mali, Guinea, Senegal, Burkina Faso, Ivory Coast, Sierra Leone, Gambia, and Guinea-Bissau, taking with them a social structure in which artists form distinct groups, often referred to as 'castes,' separate both from free noblemen and former slaves. Each group, such as blacksmiths, praise-singers

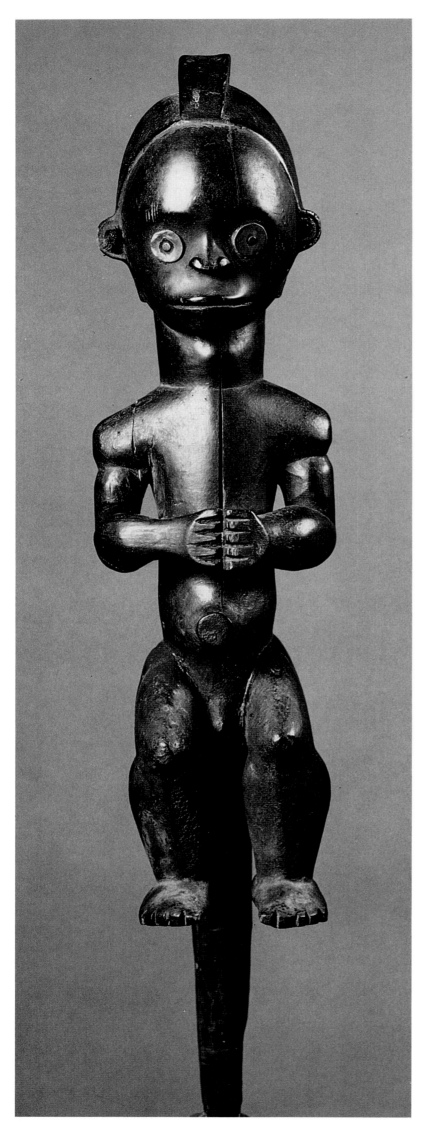

('griots'), and leather-workers, has its own body of mythical lore and secret wisdom, enabling them to safely manipulate the powers inherent in their craft. They are respected and valued for the essential roles they perform and the products they provide; feared for the powers they control; and often despised because of their potentially polluting contact with those powers.

Generally, skills are passed on from fathers, uncles or older brothers through informal systems of apprenticeship, with very few unrelated youths taking up a craft. Marriages are normally contracted either within the same craft group or with women from the clans of other craft specialists. Griots are of particular importance, because they control the performance of the great historical epics by which the major clans recall their links to the heroic days of the founding of the empire. Blacksmiths, who are also woodcarvers, make and dance the powerful masks of the *kómó* association, and monopolize the knowledge necessary to make a whole range of other mystically-charged objects. Yet within the same cultures other crafts lack the same associations. The fine embroidery of robes, for example, is often carried out by itinerant Islamic scholars and taught to the pupils in their Koranic schools.

Superficially similar forms of hereditary craft specialization often existed without being maintained by similar systems of belief. Research in the Nupe emirate of central Nigeria in the 1930s found a complex system of craft guilds in operation in the Nupe capital Bida. Blacksmiths, brass- and silversmiths, glass-makers, weavers, bead-workers, builders, and woodworkers were all organized in guilds, but tailoring, embroidery, leatherwork, indigo-dyeing, pot-making, mat- and basket-making were not. Here the explanation for the differences was sought not in patterns of belief, but in the need for efficient organization to meet the demands of both a highly prestige-conscious court and a flourishing export trade. The guild structure is believed to date back only to the second half of the nineteenth century, when captured slaves were brought in to work for the Fulani emirs.

In other areas, particularly those where there was no centralized government, there was insufficient demand for full-time specialized artists. Among the Tiv of the Benue valley in Nigeria, and the Fang people of Gabon, all men were expected to be able to carve; woodworking was one pastime among many carried out as men sat talking in the village meeting-house. A few men did develop a particular talent for carving, and consequently received occasional orders from others but, at least until European colonial officials and art dealers arrived, never enough to sustain anyone full-time. According to the anthropologist James Fernandez, Fang carvers were marginal figures, who never

contributed to the more important village decisions. Yet the Fang have produced carvings regarded by collectors as among the finest examples of African sculpture. The purpose of these figures was not primarily aesthetic appreciation; they were positioned on top of bark boxes containing the bones of ancestors, both to protect and honor the relics, and as a focus of communication with the ancestors. Because of this link to the forefathers, it was often considered more important that the carver should be a family member than an artist of great talent. Despite their ritual role, however, these carvings were not always treated with respect.

Occasionally they were detached from their boxes to be scolded and danced almost mockingly as puppets.

The making of artifacts was not always governed by complex and elaborate rituals. In some regions, while crafts were handed on in particular families, carving or smithing were merely options among various ways of achieving the wealth and followers that produced social status. A successful carver would have been regarded little differently to a rich trader or a warrior.

A contrast is often drawn between functional art in Africa and the 'art for art's sake' ethos of post-Renaissance Europe. Like many such generalizations,

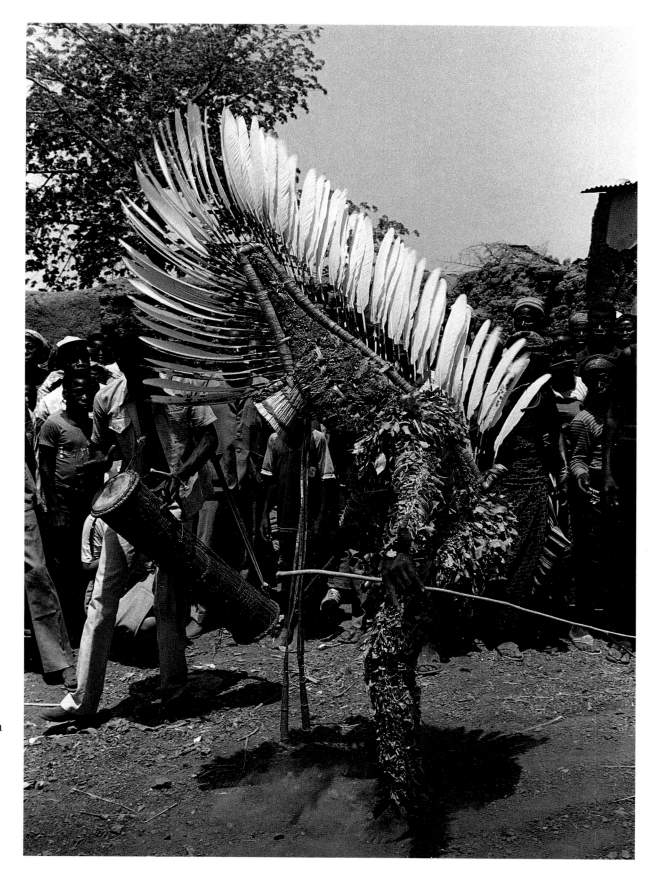

FAR LEFT: *Reliquary Figure*, Ntumu Fang region, southern Cameroon, early twentieth century. Wood and brass, 17½ inches (45 cm) high.

RIGHT: Dancing masquerade in a costume of leaves, fiber and feathers, Bwa region, Burkina Faso.

this claim is both partially true and seriously misleading. Until the development of art schools on the Western model in the twentieth century, very little sub-Saharan art was intended solely to be the object of abstract contemplation. It was not made to be displayed in a glass case, hung on the wall of an art gallery, or photographed for a book such as this. Many art objects were commissioned and displayed by kings, chiefs and the wealthy, however, and the fact that they could enhance their prestige by the possession of fine things is surely little different from the motivation underlying much art collection worldwide. Moreover, although the issue of cross-cultural aesthetics is problematic, a growing number of studies have demonstrated the sophisticated and discriminating vocabulary of aesthetic discourse in many African languages. Nevertheless it is important to remember that for much African art the aesthetic element was not the isolated spotlit focus it becomes in an art gallery, but one factor among many in a masquerade performance, a ritual ceremony or a shrine altar.

BELOW: Masqueraders of the Mende Sande society, which organizes female initiation and circumcision, together with new initiates, Sierra Leone, 1960s.

FAR RIGHT: *Gèlèdé* mask, possibly by the carver Duga of Meko, south-western Nigeria, twentieth century. Wood, 14⅝ inches (37.5 cm) high.

If we look at masquerade in more detail, some of the functions of masks and the complexities of the contexts in which they are performed can be appreciated. The first point to remember is that the carved wooden artifact we see on display is only a part of the costume, let alone of the total performance. It is usually part of a cloth or fiber assemblage covering the wearer's head, often containing medicines to enhance the mask's power or to protect the performer from jealous rivals. The body of the performer may be wholly concealed in a thatch of raffia fibers, draped in local or imported cloth, or dressed up as a woman, as a white colonial official, or even an anthropologist. The final appearance is the work not just of the carver, but of an array of different people. The mask may be painted by the performer, the dress contributed by his mother or wife, the final look assessed and altered by a senior male, or sometimes female, official of the masquerade society. Many masks lack the carved face we expect, being made entirely of cloth or leaves or woven raffia. In others, for example with some Niger Delta Kalabari performances, the carved face is almost totally concealed from the spectators, turned upward to face the gods.

Masquerades are rarely static. They arrive after a long build-up of tension, surrounded by drummers and singers, and sometimes by youths threatening spectators with sticks. The performers dance, sing, try to attack people, speak mockingly of the wealthy or

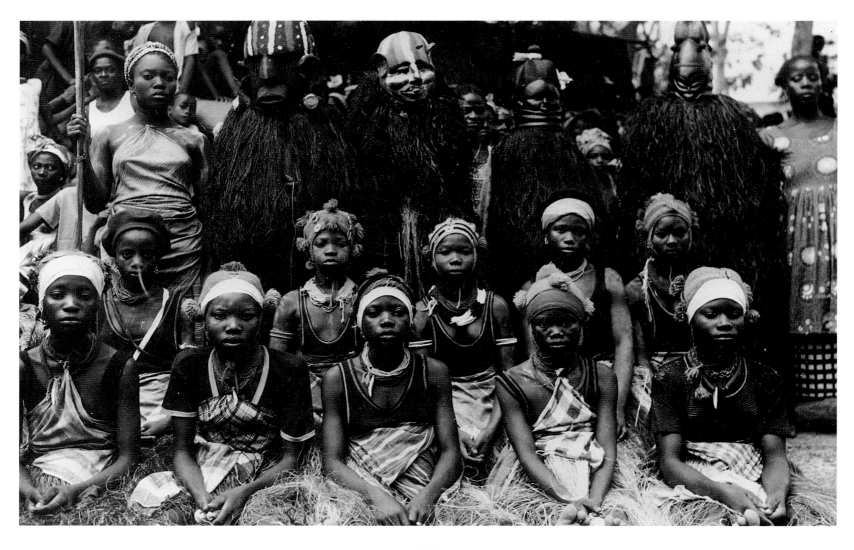

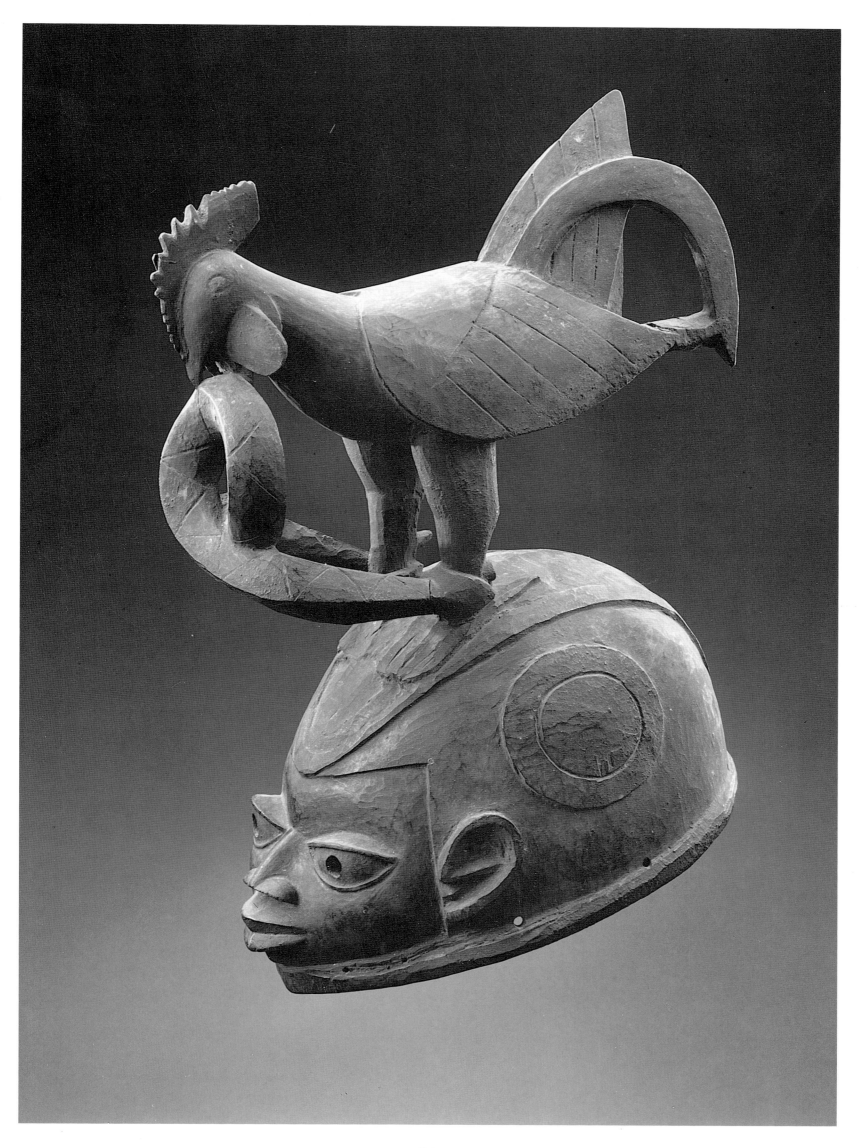

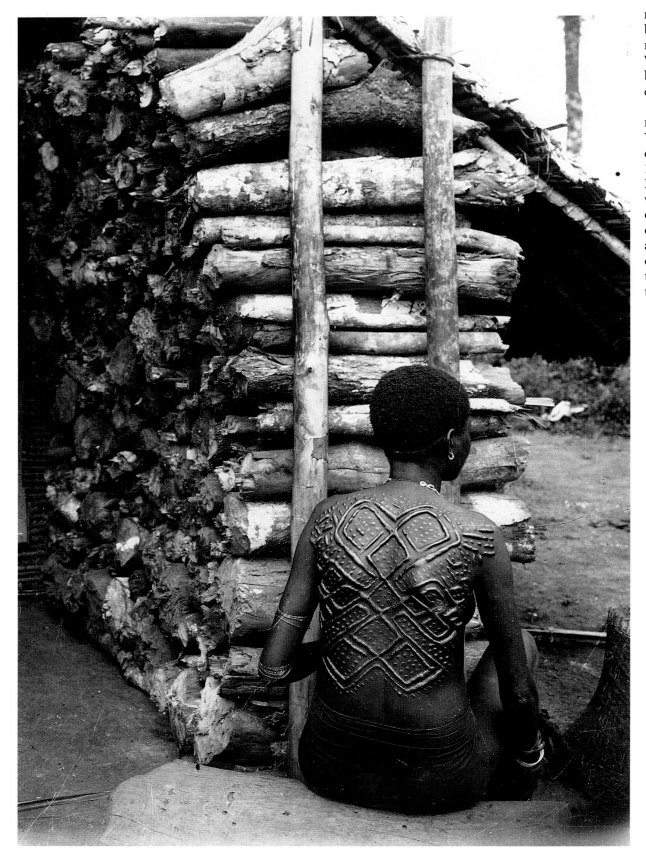

LEFT: Woman with elaborate body decoration, Yombe region, lower Zaire, 1908. Wearing such designs was both a sign of bravery and an enhancement of beauty.

FAR RIGHT: Maternity figure, Yombe region, lower Zaire, early twentieth century. Wood, 11⅛ inches (28.5 cm) high. Patterns of body decoration were accurately reproduced on wood sculpture. Similar designs on woven raffia cloths and hats reached European collections from contacts with the Kongo empire as early as the sixteenth century.

immoral, or growl in the unknown language of the dead or the bush spirits. Sometimes there is a single performer, sometimes the masqueraders are part of elaborately choreographed ceremonies in which tens of different masks appear. Some dance on stilts, others manipulate their cloths to perform magic transformations. Some masks take no visual form at all, being merely cries heard from the bush at night. Among the Lega of Zaire, the carved ivory masks that are used in the initiation of elders into the Bwami society may be dragged along the ground by their beards but are rarely actually worn. In some areas the used headpieces are

discarded or sold; in others they are repositories of power, sacrificed to for healing. Among the Dan of northern Liberia, the same mask may go through different roles over a long life history, beginning in young men's entertainments but accumulating authority over the years to become a feared and powerful judge.

In an effort to get to grips with the variety of masquerade phenomena in Africa, John Picton has proposed that beneath the surface diversity the majority may be understood in terms of a three-part schema. Many masks appear to be used merely as devices to create dramatic distance, without necessarily keeping secret

the identity of the performer. The elaborate masquerade plays satirizing village elders and immoral women documented in the eastern Igbo village of Afikpo might be taken as an example of this group. Other masks, however, seem both to create dramatic distance and to be a means of denying human agency. The identity of the wearer is 'secret' because officially the mask is, or is animated by, some supernatural force, the power of the ancestors or of a bush spirit. Elaborate rituals may be needed to prepare and protect the dancer who occupies the same sacralized space as, and is sometimes possessed by, a metaphysical force. The ancestral *egúngún* masquerades of the Yoruba provide an example here, although within the same type are found variations from harmless conjurers to the feared powerful masks that executed criminals and witches.

In the third group, dramatic distancing and the denial of human agency remain important, but the material artifact of the mask itself is believed to embody some metaphysical power. This may be a temporary presence during performance, or the power may remain in a properly consecrated mask. Here we often find sacrifices to the mask even when it is not being worn, with accumulations of sacrificial material literally representing the build-up of its power. Masks of this type sometimes become too powerful and dangerous to be worn, as were some of the senior Night Society masks of the kingdoms of the Cameroon grassfields. Finally there remain some masks which elude this categorization: for example, the hip masks worn by the Oba in Benin. Whatever the explanatory value of this type of classification, however, we should remember that it cannot substitute for knowledge of local schemas and perceptions.

Women participate in many of the masquerades referred to above, interacting with the other performers in various ways, as singers and dancers or as an active audience. In a few cases post-menopausal women, and more rarely young girls, may be involved in the rituals or dressing that precedes a masked dance. Many masquerades are enacted by men, but about women, the best-known example being the *Gèlèdé* of the western Yoruba, where the feared spiritual power of older women is praised and invoked to benefit the community and sanction social criticism. There is, however, only one significant example where women themselves control and dance carved wooden masks. Societies which organize the rites of passage accompanying the initiation of boys and girls into adult status were common in sub-Saharan Africa, teaching both practical and arcane knowledge, often supervising circumcision and various other ordeals. In many areas they remain important today, although periods of seclusion have generally been reduced to fit in with

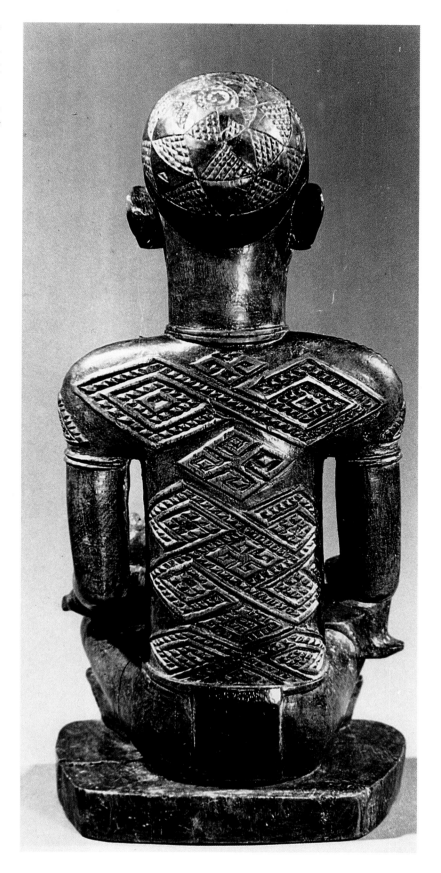

school holidays and work commitments. While many of the societies for boys involve masquerades, the women's initiation society known as Sande among the Mende peoples of Sierra Leone (but also found among Temne, Gola, Vai and other neighboring groups into Liberia) is unique, in that senior women dance the masks. The mask of the Sande *sowei* is interpreted as an idealized image of Mende female beauty, helping the Sande society to pass on to each generation of women the correct behavior and deportment expected of them.

Various suggestions have been advanced in an effort to account for the relative scarcity of female masque-

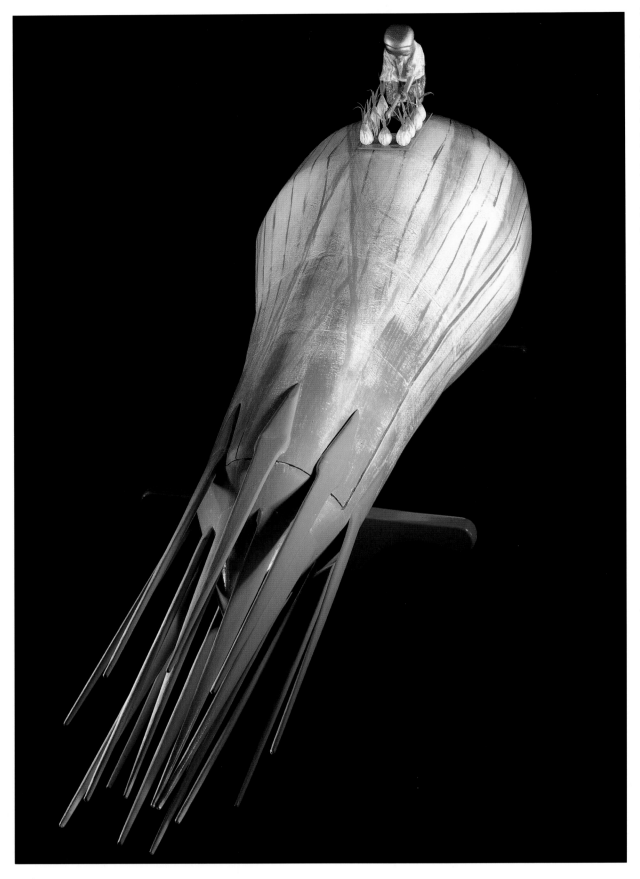

LEFT: Onion-shaped coffin, 1980s, wood and enamel paint, by Kane Kwei (born 1924), Ghana. Kane Kwei's work began as an innovative adaptation of local demands for elaborate coffins in the shape of Mercedes cars and similar trappings of wealth. These are increasingly collected as exotic curiosities by Western museums.

BELOW FAR RIGHT: *A Chacun son Destin*, 1994, acrylic on canvas, by Cheri Samba (born 1956), Ghana. Cheri Samba is the most internationally successful of a group of Zairean artists whose work draws on a tradition of popular painting developed in the 1960s.

rading. As we have seen, masks are often a direct expression and instrument of power. Where women are credited with sources of power, these are generally more covert and of less practical application. Women do seem, however, to be much more fully involved and represented in the many healing and possession cults found in large areas of Africa, and this has been interpreted by some as a counterpart to male control of masquerade. It is also significant that in some areas women's initiation involves extensive use of body decoration, with a similar role to, and sometimes described in the same terminology as, the masks used as markers of transformation in male initiations.

It is easy to regard a move from a discussion of masks to a consideration of modern painting and sculpture as a shift from the traditional to the contemporary. While there is a sense in which this is valid, we have already noted the problems raised by a simplistic application of the term 'traditional' to the variety of African contexts and diverse historical experiences. Within the art that has been broadly referred to as 'contemporary,' there are also a range of both individual and group histories

too varied to be easily summarized here. While the attitudes toward art from Africa discussed above may have had comparatively little relevance to, or impact on, the actual work and living conditions of the people in question, when we turn to modern painting and sculpture we find African artists struggling to find a valid means of expression within an art world dominated by the perceptions, preconceptions, and often prejudices, of the Euro-American art establishment.

Although there have, of course, been conflicting views and dissident voices, the position assigned to African and other non-Western art within the establishment ideology has been that of a silent Other: a Primitive to be tapped as a source for the Modern. That there are African, African-American, Native American, and Asian artists who themselves demand to participate in that modernity, is a challenge which many prefer to ignore or divert. It is significant that there is much greater demand among Western museums and collectors for the work of untutored artists, producing barbershop signs, painted coffins, and genre paintings, than there is for that of the academically trained. While, for example, the work of Kane Kwei is not without visual appeal, and an enquiry into why certain wealthy people in Ghana choose to be buried in elaborately decorated coffins might be interesting, works such as these are all too easily stripped of their local contexts and repositioned in art galleries so as to appear naive, bizarre and exotic. Artists such as Cheri Samba have been able to draw on their roots in popular painting to impart an image of Africa appealing to certain European collectors.

Before looking at the work of some of those artists who have managed to obtain formal training along European lines, we must note the occurrence of a variety of 'workshops,' missionary craft schools, and individual teaching and sponsorship efforts. Many of these have seen their roles not as teaching students about art, but as providing materials and sometimes a knowledge of techniques, by which they could express some supposedly inherent, mystical, creativity that would be tarnished by exposure to Western art history. The most well known in the early 1960s were the Oshogbo (southern Nigeria) workshops and the carving school set up at the National Gallery in Zimbabwe (then Rhodesia). The patronizing and paternalistic premises underlying some of these ventures have been strongly criticized of late, and the output of artists in both areas has become generally repetitive and stale. Nevertheless the participation of the important African-American artist Jacob Lawrence in one of the Oshogbo sessions undermines the view that this was a wholly European expatriate project, and many of the artists have certainly benefited, even if they have been unable to sustain the promise of their early works. The Mozambican Valente Malangatana (b.1936) provides an inspiring example of an artist who was able to continue to develop his career even when the patronage of a Portuguese sponsor was lost. Despite, or perhaps because of, his close involvement in the revolutionary turmoil in his country since the late 1960s, he has produced a body of both committed and artistically effective work.

Access to formal art education in Africa has been and remains all too restricted. The education systems of most colonial regimes were concerned to impart skills regarded as having more direct practical uses. Even the small number of missionary schools where art was taught were generally geared to produce either church ornaments or objects for sale to tourists and expatriates. Those who wanted fine art education were obliged to attend art schools in Europe, an option clearly open only to those few who had the support of wealthy parents, or official scholarships. Some of these artists led the way in campaigning for, and later teaching in, art schools in Africa. Although the earliest art departments were established in Ghana (1936), and at Makerere University College, Kampala, Uganda (1939), it was not until the 1950s that significant advances were made. In Nigeria the College of Arts, Sciences and Technology was founded at Zaria in 1953, and art training at Yaba College, Lagos, began in 1955, while an art school was opened in Addis Ababa in 1957, and Dakar in 1960.

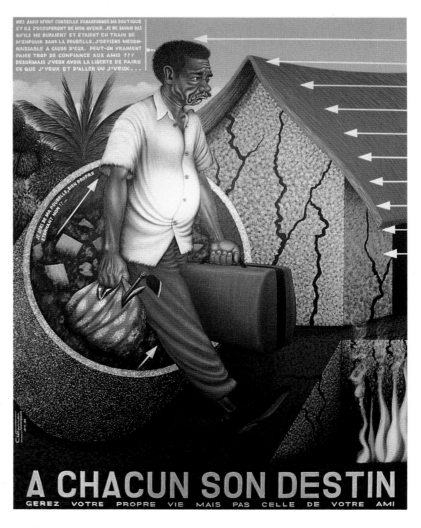

LEFT: *A Criança essa Esperança*, 1973, by Valente Malangatana (b. 1936), Mozambique. Mozambique's best known artist, Malangatana has worked extensively on mural projects and government cultural programs during the long-running war.

If there is a need to seek a common thread or theme running through the diverse and ever-expanding body of works produced by academically-trained African artists, it can perhaps be found in the differing ways they have sought to address issues of identity. The relation between training, techniques and materials of Western origin, and an awareness of the rich heritage of indigenous art forms, has raised questions for many on both a personal and a political level. Should an African artist adopt a specifically 'African' subject matter and what might this be? Artists reliant on official sponsorship and patronage have in some countries

been obliged to adopt the solution promoted by the governments. In Senegal under the presidency of the philosopher and poet of Negritude, Léopold Senghor, and in Zaire under the degraded version known as 'authenticity' imposed by President Mobutu, artists found it advisable to depict African masks, carvings, and idealized scenes of traditional life. More generally, they can find themselves pressured, by the expectations both of local audiences and of Western art dealers, to produce works that look obviously 'African.' While compliance with these demands only makes it easier for their work to be dismissed as exotic and marginal

RIGHT: *Spring Scrolls*, 1983-84, acrylic on paper, by Alexander 'Skunder' Boghossian (b. 1937), Ethiopia. Acrylic, canvas, 50⅜ × 71¾ inches (128 × 182.2 cm). National Museum of African Art, Washington D.C., museum purchase, 91-18-1.

Working at Howard University in the USA, Skunder Boghossian is the central figure in an influential group of exiled Ethiopian artists.

BELOW RIGHT: *Mediations*, 1994, by Youssouf Bath (b. 1949), Ivory Coast. Maquette for a 230-meter-square mural painted at the Musée Urbain Tony Garnier, Lyon.

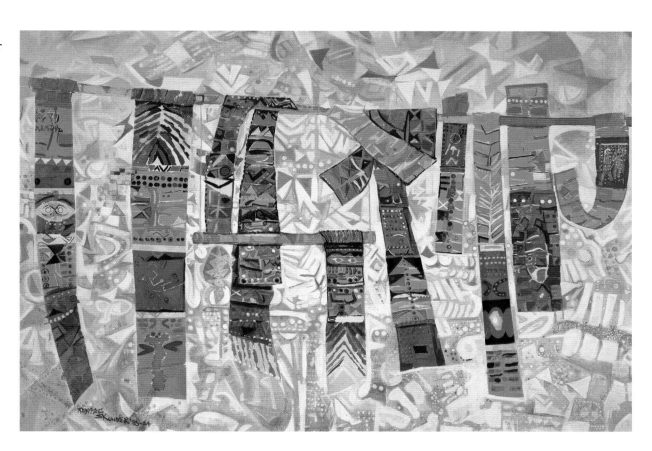

by the mainstream of art criticism, artists that reject them are frequently accused locally of being 'un-African,' and internationally of being derivative. Similar problems face artists from Egypt and the Maghreb, where there is pressure to adopt recognizable Islamic motifs.

In seeking personal or collective solutions to these problems, a number of broad tendencies may be indicated. A few, such as South African David Koloane (page 111), have argued that African artists, like all artists, should be free to adopt and experiment with any style or technique they choose. More common, however, have been various ways of combining innovation with an acknowledgment of tradition. Bruce Onobrakpeya, one of Nigeria's most successful artists, exploits the full potential of printmaking, along with innovatory techniques of his own, while drawing aspects of his subject matter from the history of his Urhobo people and other Nigerian cultures (pages 67, 68). Other Nigerian painters have found inspiration in the *'uli'* designs Igbo women used for wall decorations and body painting. Both Arabic and the various precolonial scripts of Ethiopia and parts of West Africa have been exploited as a rich source, the Ethiopian painters Skunder Boghossian (above) and Wosene Kosrof (pages 72, 73) combining symbols from Amharic scripts with complex personal imagery. Elsewhere groups have been formed that attempt to create new images using indigenous materials and techniques. These include local pigments on bark-cloth or hand-made paper in the Ivory Coast and mud-dyed cloth in Mali. These, and many other attempts to address the still-unresolved issues of participating in and achieving a distinctive

identity within worldwide art movements, remain a major stimulus to the imagination and creativity of African artists.

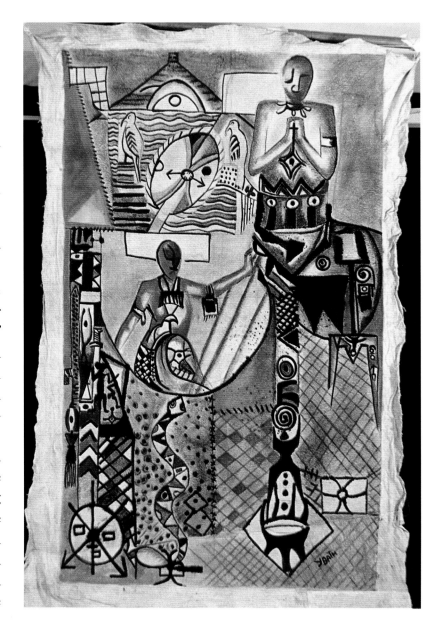

NORTH AFRICA

The arts of the countries of Arab North Africa, Egypt and the Maghreb (Algeria, Tunisia, Libya, Morocco) have developed as distinctive regional variations on wider pan-Islamic forms. Although these are best understood in the context of contributions to and departures from the various historic periods of classical Islamic art, this should not obscure the many links between the arts of northern and sub-Saharan Africa. These links may be traced back thousands of years before the Islamic period, to extensive contacts with the ancient civilizations of Upper Egypt and the Nile valley.

Although the trade contacts and mutual influence between Egypt and other African civilizations are undeniable, the extent and significance of these remains extremely controversial. Martin Bernal, in his book *Black Athena*, has demonstrated that European scholars of the late nineteenth century sought to systematically downplay the Africanity of Egypt, and to co-opt its contributions to Graeco-Roman culture into a notion of a white Mediterranean civilization. The eminent Senegalese scholar Cheikh Anta Diop challenged the continued exclusion of these ties from academic respectability in Europe and America. He used his own historical studies, linguistic analysis and research into Egyptian and African religions as a basis to call for future scholarly enquiry into his theories of black Egyptian culture. Today these theories form the inspiration for a growing body of Afrocentric research, largely by African-American academics.

The Nubian Kushitic civilizations of the Upper Nile valley provide both the earliest known artifacts of sub-Saharan art and the best documented trade and cultural ties with dynastic Egypt. The earliest artifacts excavated in the region are decorated pots dated to about 3000 BC, while Egyptian influence has been noted from the beginning of the 'Old Kingdom,' around 2500 BC. Artistic influence, like trade, is likely to have flowed in both directions, with the extent of Egyptianized customs in Nubian courts waxing and waning with the relative economic and military power of the two centers. Kushitic leaders even established control in Egypt in the mid eighth century BC, before being displaced by an Assyrian invasion a century later. A bronze sculpture (right) of a kneeling king, King Shabaqo, from this period of Nubian dominance, clearly indicates the melding of Egyptian and local forms, while the sculpture of a swimming girl (page 27) has aspects that prefigure later Meroitic art from the same region.

The capital at Meroë on the Upper Nile was founded around 600 BC and remained a regional power center until the Aksumite invasions from neighboring Ethiopia in the seventh century AD. Archeological work at Meroë has uncovered evidence of iron smelting, and clay spindle whorls indicating cotton spinning, suggesting to some that it provided an early site for the diffusion of iron-working and weaving through sub-Saharan Africa. These arguments, however, remain contested.

Further west, large regular trade caravans across the Sahara seem to have been established following the Arab conquest of the Maghreb in the seventh century AD, although there is considerable evidence, including rock paintings depicting chariots found almost as far south as the Niger bend, that the nomadic groups of the region traded across the desert far earlier. An expedition searching for gold traveled to Mauretania in 734 AD, and reference to the early African kingdom of Ghana has been found in Arabic manuscripts of the period. Gold, and many hundreds of thousands of African slaves, were transported across the Sahara to North Africa and the Middle East by these caravans, while in return African traders and kingdoms received copper, textiles, and various other luxury prestige goods.

RIGHT: *King Shabaqo*, ancient Kush
Late 8th century BC
Bronze, 6 inches (15.6 cm)
National Museum of Athens

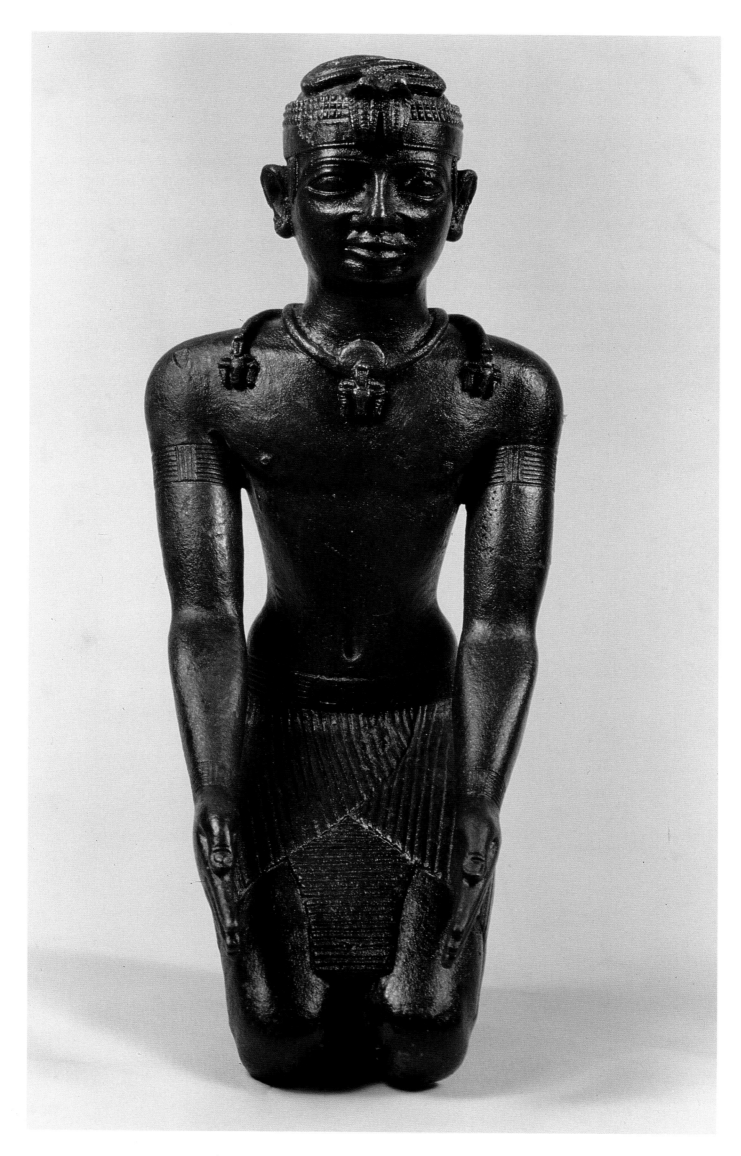

These goods were diffused far to the south along the complex networks of inter-regional trade routes that were only finally displaced by the colonial invasions of the 1890s. The extent of these trade routes at an early date is indicated by the discovery of thousands of European glass beads at the grave site of Igbo Ukwu in south-east Nigeria, dated to the ninth century AD. The direct influences on sub-Saharan art were many, although difficult to date with any precision. The designs on textiles of non-Islamic Berbers have been suggested as a source for many of the motifs on woollen cloths woven around the Niger bend, while further west, nineteenth-century Hausa, Nupe, and Yoruba weavers used magenta waste silk transported from Europe in local prestige robes. Chased brass bowls from North Africa have served as valued treasures in the courts and on shrines in the Ashanti kingdom, possibly stimulating their own ornamental brassworking. Of equal, if not greater, long-term significance for the arts of sub-Saharan Africa was the Islamic faith brought by the traders from the north. Mass conversion to Islam only occurred during the colonial period in most regions, but communities of Muslim traders and itinerant Islamic scholars formed in most major trading towns, advising, and in some cases converting, local rulers. West Africans are thought to have made the pilgrimage to Mecca as early as the eleventh century, while the ruler of the Mali Empire, Mansa Musa, brought with him thousands of followers and vast quantities of gold for his famous journey in 1324–25 AD.

The impact of Islam has been so profound and continuing over such a long span of time and such a vast

region that it is virtually impossible to make simple generalizations about it. Although it has resulted in the abandonment or modification of certain art traditions, it has introduced or stimulated others. The degree of accommodation possible between pre-Islamic religious practices and their associated art forms, such as masquerades, has varied from place to place and over time. The elaborate decorative patterning developed by Islamic artists in response to the proscription on representational images in many contexts has continued to influence artists both north and south of the Sahara. Muslim beliefs in the sanctity of the texts of the Qur'an have reinforced African concepts of the inherent power of words; art forms depicting motifs inspired by Arabic calligraphy are an important theme both in the paintings of North Africa, and in many arts further south.

BELOW: Spoon of glazed faience, *c.* 600-700 BC
4½ inches (11 cm) long
Ashmolean Museum, Oxford

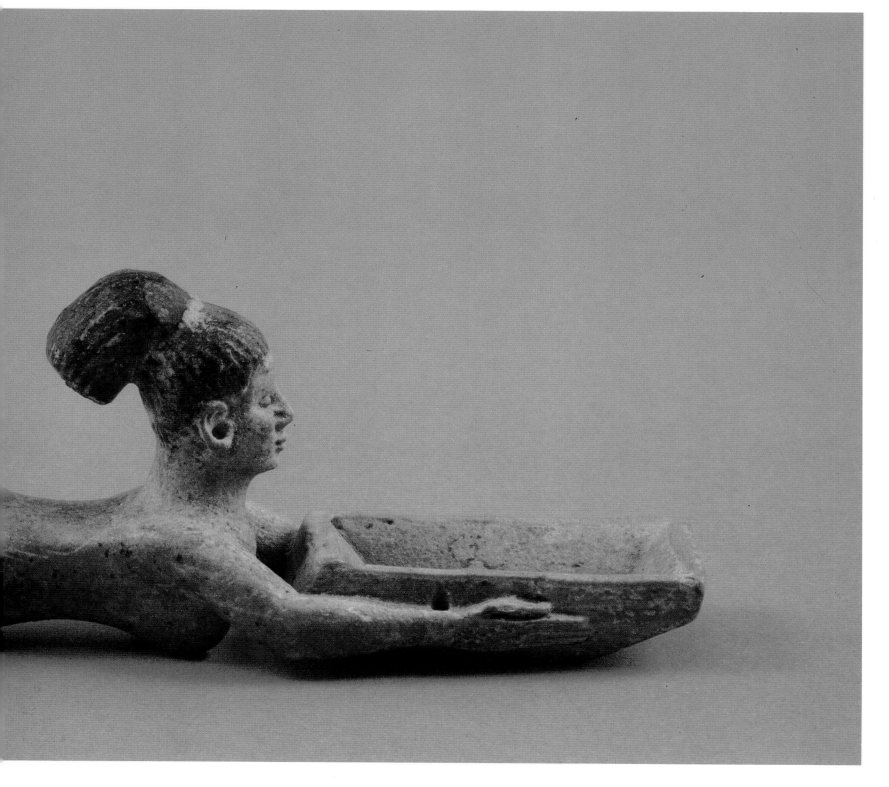

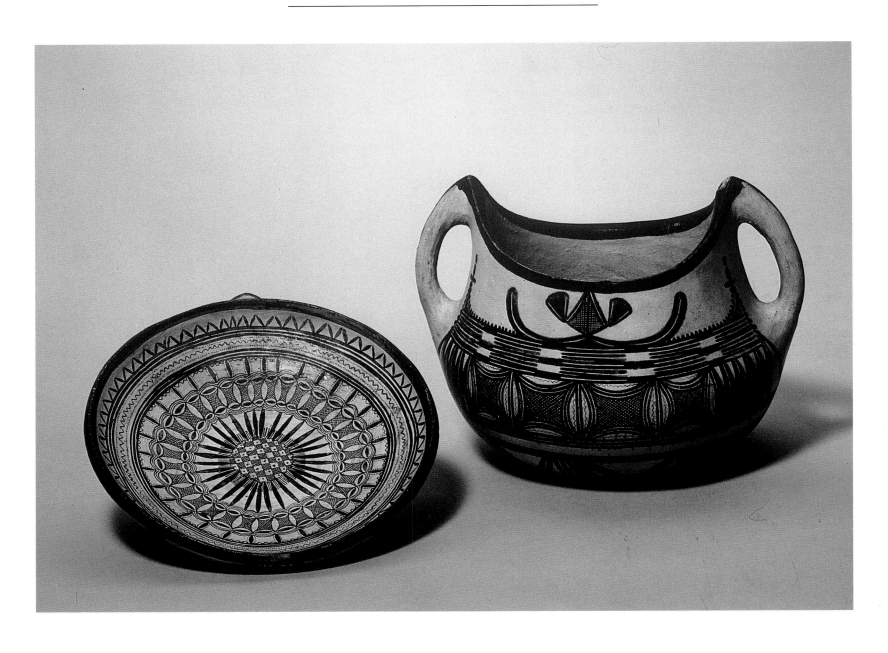

ABOVE: Berber pots
Morocco, late 19th/early 20th century, clay
Museum of Mankind, London

RIGHT: Kabyle textile, Algeria
Wool, 41 inches (104 cm) long
Museum of Mankind, London

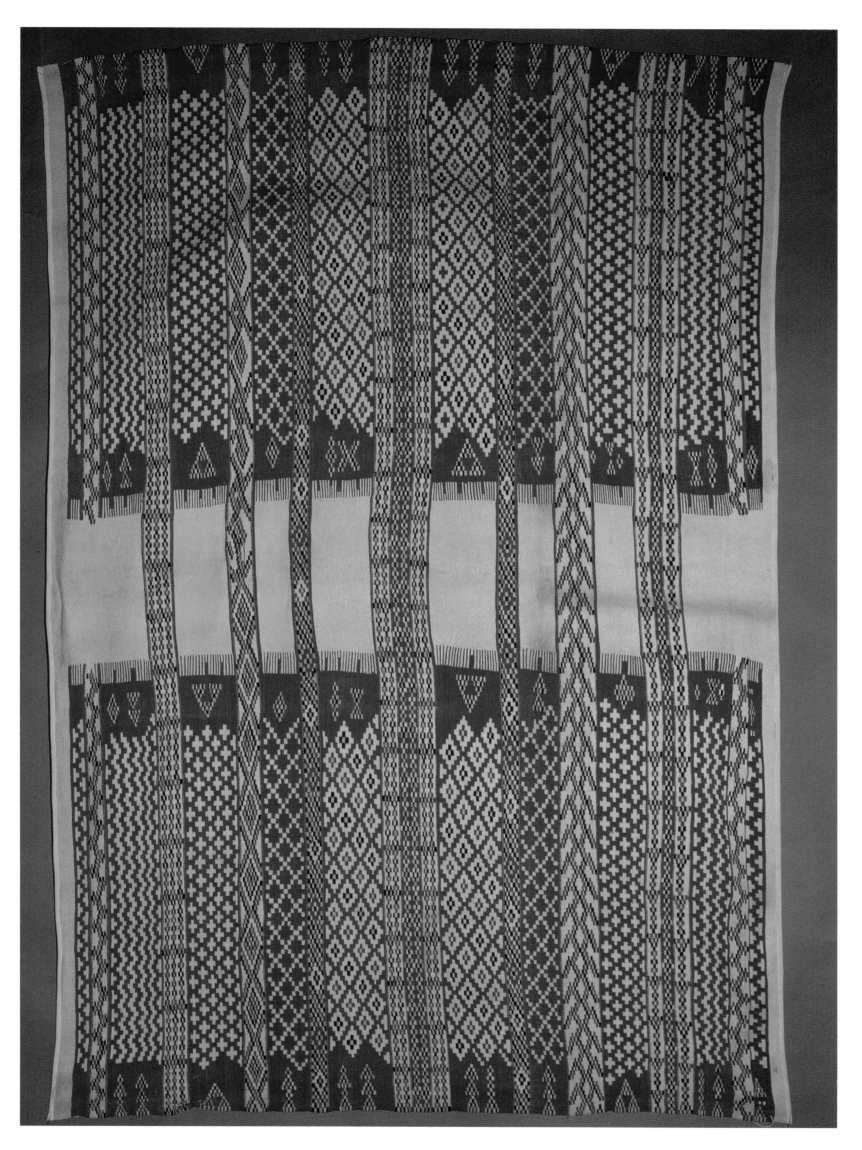

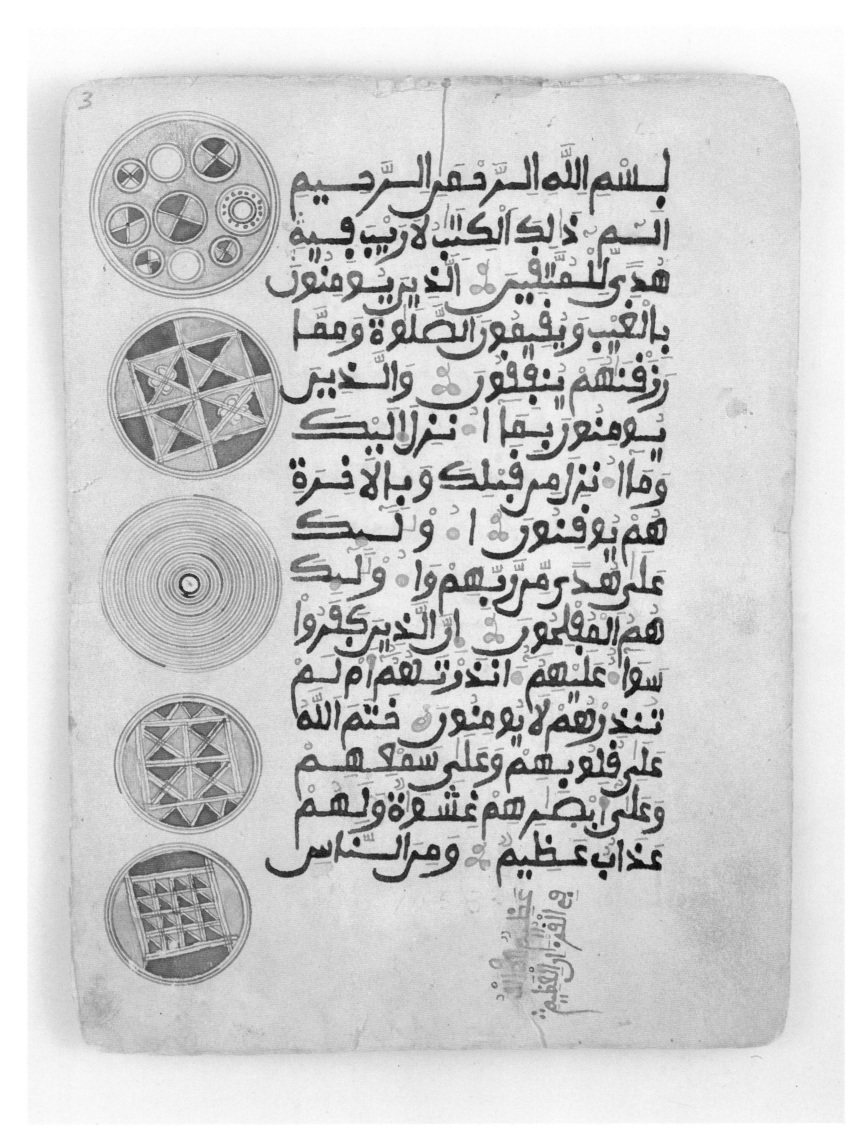

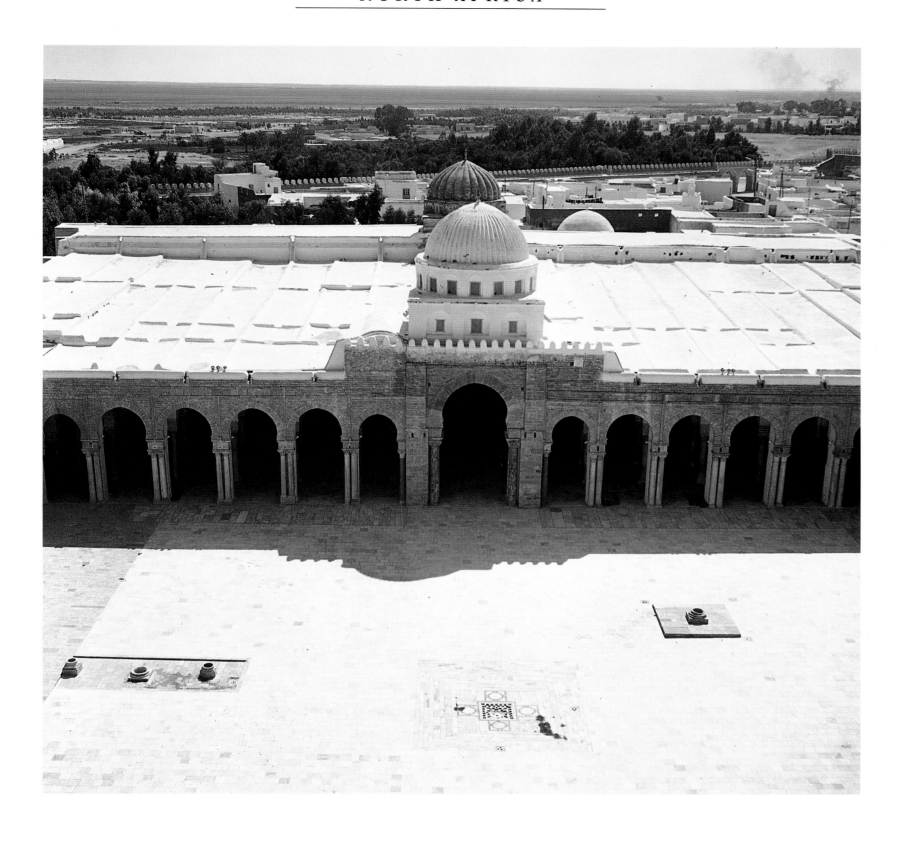

LEFT: Single-volume Qur'an
North Africa, 19th century
Paper and ink, 9 × 6¾ inches (23 × 17 cm)
The Nour Foundation, London

ABOVE: The Great Mosque, Kairouan, Tunisia, *c.* 670 AD
Werner Forman Archive

ABOVE: *Untitled*
Chaibia (b. 1929), Morocco
Gouache on paper
25½ × 19⅝ inches (50 × 65 cm)
Institut du Monde Arabe, Paris

RIGHT: *Untitled*, 1993
Gouider Triki, (b. 1949) Tunisia
Gouache, 26½ × 21 inches (67.5 × 53.5 cm)
Institut du Monde Arabe

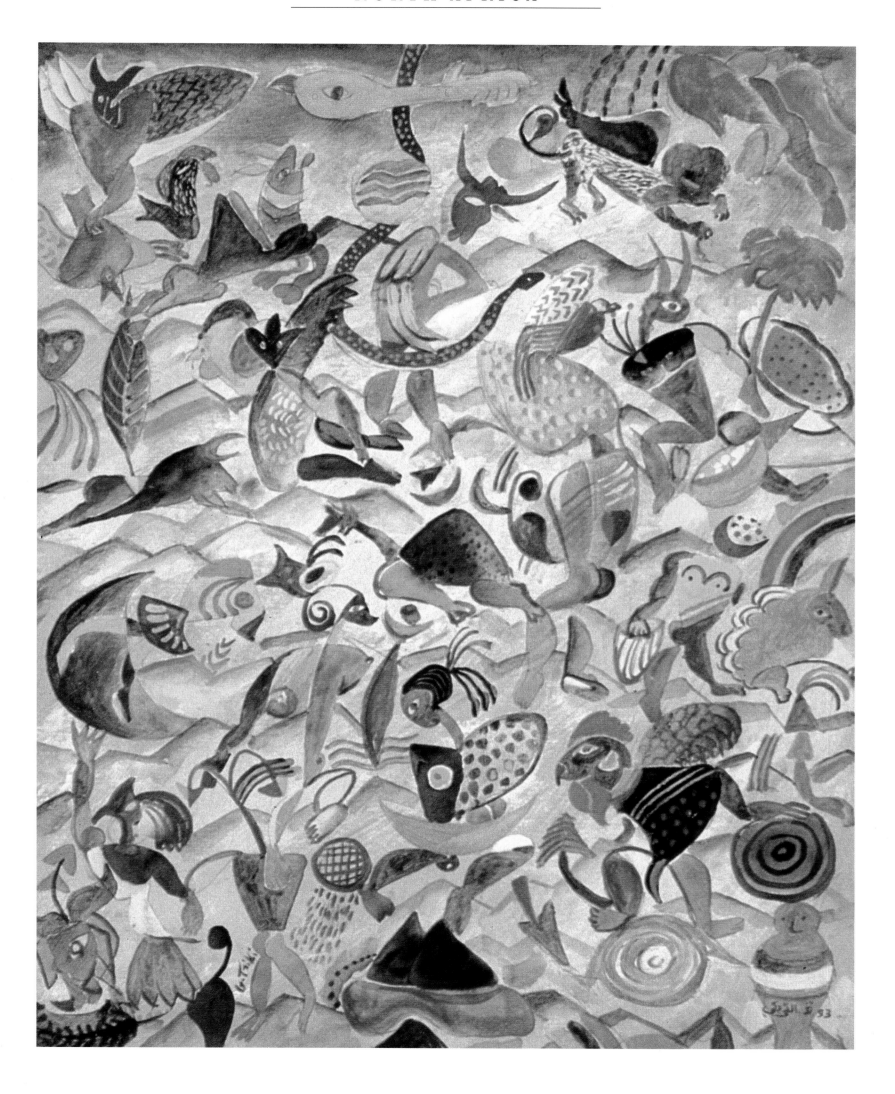

WEST AFRICA

Many of the older artifacts of West African art are the products of cultures about which relatively little is known. Lack of funding has meant that organized archeological investigation has been rare. Most of the ceramics of the Nok cultures of north/central Nigeria (*c*.700 BC-400 AD) were uncovered during open-cast tin-mining. Similarly, despite some research and government attempts at control, large numbers of the ceramic sculptures from the inland Niger Delta region in Mali (*c*.1100-1500 AD) have been found in unauthorized digs financed by art dealers rather than by archeologists. Where proper excavations have been carried out, the results have sometimes been spectacular.

Among the finds at three major sites uncovered at Igbo Ukwu in south-eastern Nigeria was a wood-lined burial chamber containing the dressed body of a man, presumed to be a religious leader or king, buried with ivory tusks, cast bronze treasures, and sacrificed slaves. The artworks recovered from the sites (dated to the ninth century AD), now in the Nigerian National Museum in Lagos, include a bronze vase roped to its stand; small bronzes of the heads of elephants, rams, and leopards as well as humans; and large bronze shells. All have elaborately decorated surfaces and many include tiny casts of flies and other insects. They show a mastery of fine detail, and a degree of control of the process known as lost-wax casting, entirely unexpected for such an early date. The probability that the finds were treasures of the ancestors of the present Nri Igbo rulers of the area is suggested by the burial of nineteenth-century Eze Nri in wood-lined chambers; similarities between the facial scarifications on the bronze heads and the scars of contemporary titled men; and the continued use of certain distinctive decorative motifs in early twentieth-century wood carving.

The courts of kings and chiefs were also the patrons of many of the other artifacts illustrated in this section.

The town of Ife in south-western Nigeria is regarded by Yoruba-speaking peoples as the cradle of civilization from which the sons of the first *Oba* (king) set out to found the other Yoruba kingdoms, and also, according to oral traditions, to form the second dynasty of Benin rulers. The precise relationship between these legendary figures and the naturalistic bronze and terracotta sculptures found at Ife is uncertain, as is the nature of their link to the later brass-castings of the Benin Empire. Nevertheless we can be confident that the standing figure sculpture (page 37) represents an early ruler (*Oni*) of Ife, wearing the insignia of his office and holding symbols of authority. While the splendor of their art suggests that the rulers of Ife once held great political and economic power, this was eclipsed by the growing empires of Oyo and Benin, at least by the sixteenth century. Nonetheless Ife retained sufficient spiritual authority to protect it from invasion until the wars that devastated large tracts of the Yoruba region in the nineteenth century. The present Oni of Ife is still regarded by many as the leader of the Yoruba peoples, although his pre-eminence is disputed by the Alafin of Oyo.

Much more is known about the history and the organization of artists in Benin, where we have the records of European visitors since the first Portuguese contact in the late fifteenth century to supplement local oral accounts. The famous ivory tusks that adorned shrines to royal ancestors were among the many objects in both ivory and wood carved for the Benin court, by members of a hereditary guild of full-time carvers called the *Igbesanmwan*. Other similar specialist craft guilds, each with its own ranks, rituals, protective deities, and alloted area of the capital, were responsible for brass-casting, leatherwork, blacksmithing, and weaving. Strict rules governed who could commission and own certain types of object and

RIGHT: Nok head, Nigeria, 500 BC – 200 AD
Terracotta, 14⅛ inches (36 cm) high
National Museum, Lagos, Nigeria/Werner Forman Archive

34

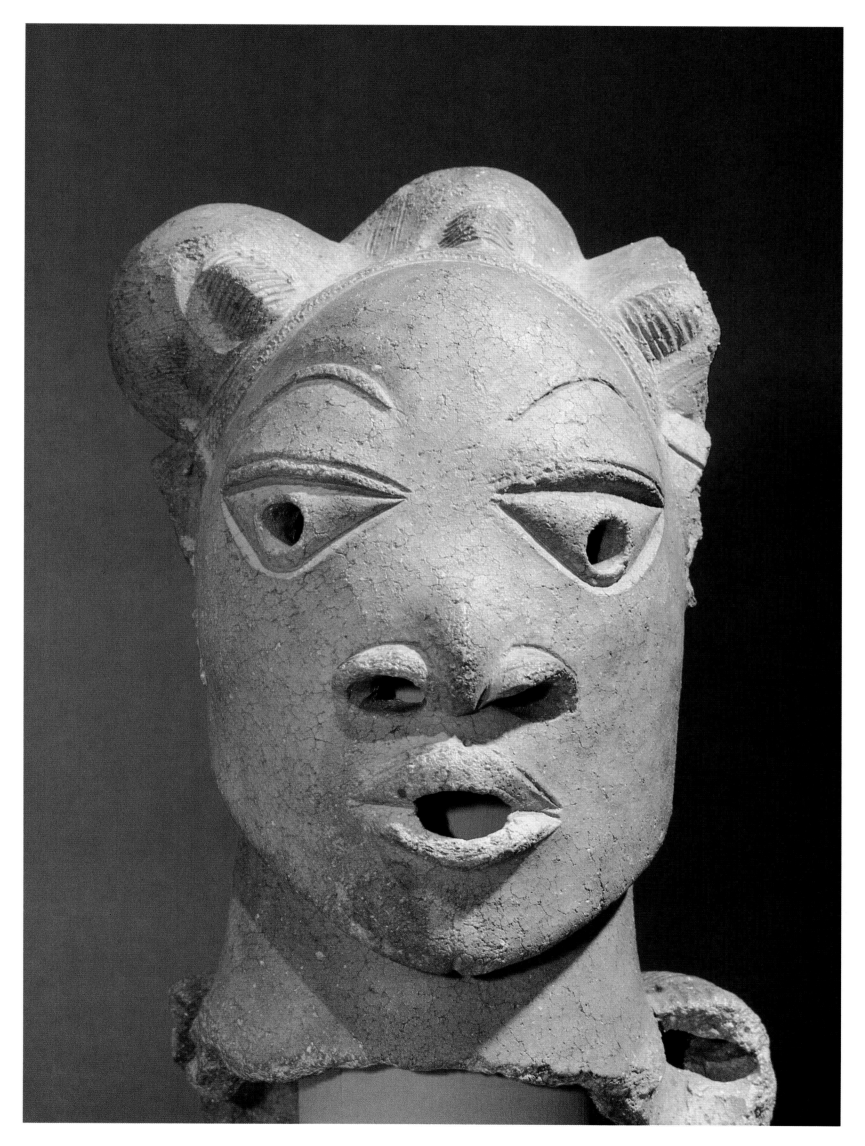

materials. For example, only the *Oba* and the Queen Mother were permitted brass commemorative heads on their ancestral altars; chiefs used wooded heads, while members of the brass-casters' guild used heads made of terracotta. Wood carving was also a part-time occupation among the pages of the royal court, known as the *Omada*. Efforts have been made to link various features, including stylistic differences and a greater variation in iconography, to the more secular, flexible training and organization of this second group of carvers.

The final artifacts associated with a West African court we will consider here are the extraordinary life-sized sculptures (page 47) that served as power objects, both enhancing and representing kings of Danhomè (now in the Republic of Benin). While these may appear bizarre and surreal now, in their original context they had precisely-determined and well-understood references to the identity and power of the kings who commissioned them. On assuming the throne, each king consulted his diviners, who determined the *Fa* divination sign that would govern his reign, and henceforth be closely intertwined with his personality. Aspects of the divination verses associated with that sign then provided both praise names for the king and the iconography of the art created for him. The metal sculpture commissioned by King Glele, probably in the 1860s, in honor of his father Guezo, refers both to the vodou of iron and war, Gu, and to the sword of Gu, in Glele's own praise names. The second figure represents King Behanzin as a shark.

Although kings and chiefs often possessed the greatest power and wealth to sponsor arts, other individuals and groups in chiefly societies, as well as people in less-centralized cultures, also produced or commissioned a rich variety of artworks. Diviners and doctors bought implements and regalia from carvers, smiths, weavers, and beadworkers. Masks were generally danced under the control of organized masquerade or age groups, whether at initiation ceremonies, funerals or annual festivals. Carvings were used on shrines to gods or ancestors as a focus for prayers, or sometimes, as in the case of the female figures of the Dan, simply for the pleasure and prestige of owning beautiful, expensive objects.

Within many of the countries of West Africa there are growing and important schools of Modernist art, each with their own heroes and milestones in the struggle for acceptance and recognition. The Nigerian painter Aina Onabolu (1882-1963) is frequently cited as a pioneer, arguing with sceptical British colonial officials to get art teaching introduced in Nigerian schools and, ironically, turning to European academic painting just as many of his contemporaries in Europe were looking to African sculpture. Bruce Onobrakpeya, perhaps the most successful West African artist of today, was a leading figure at the Zaria art school in the 1960s, when the limitations of drawing only on European modes of art were recognized, and efforts were made to find a creative response to African traditions and artistic heritage. As a talented female sculptor working in welded metal, Sokari Douglas-Camp is achieving growing recognition around the world as one of a new generation of artists from Africa who have achieved such a synthesis.

RIGHT ABOVE: Igbo Ukwu pot on stand
South-eastern Nigeria, 9th century AD
Bronze, 12¾ (32.3 cm) high
National Museum, Lagos, Nigeria (photo John Picton)

RIGHT BELOW: Ife figure
South-western Nigeria, *c.* 12th–15th centuries AD
Bronze, 18½ (47.1 cm) high
National Museum, Lagos, Nigeria (photo John Picton)

FAR RIGHT BELOW: Ife head
South-western Nigeria, *c.* 12th–15th centuries AD
Terracotta, 9⅞ inches (25 cm) high
National Museum, Lagos, Nigeria (photo John Picton)

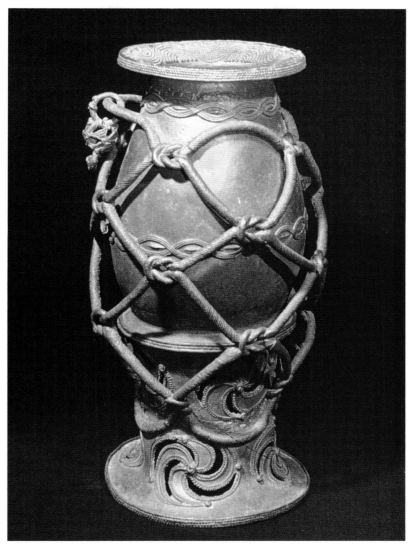

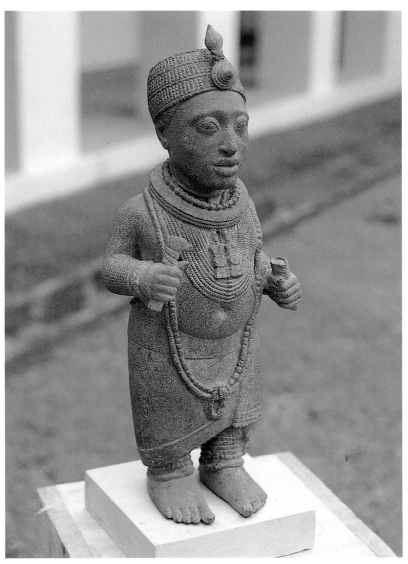

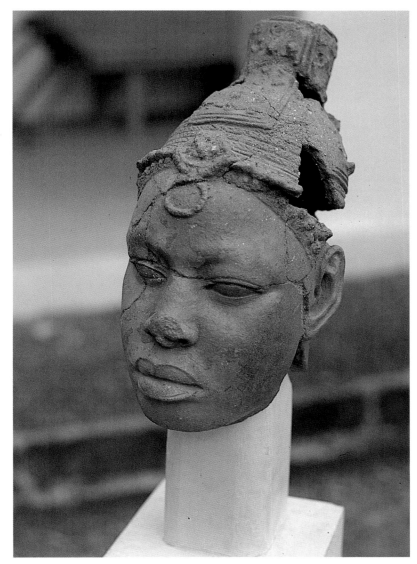

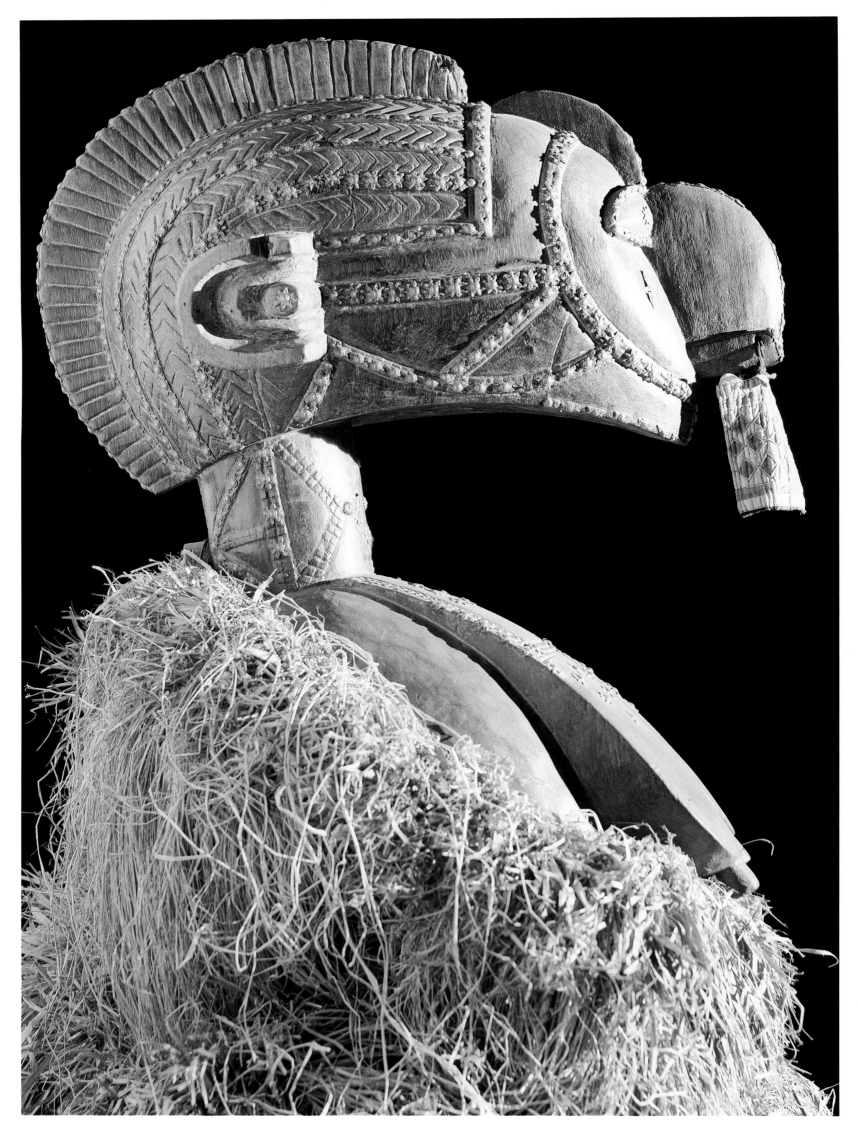

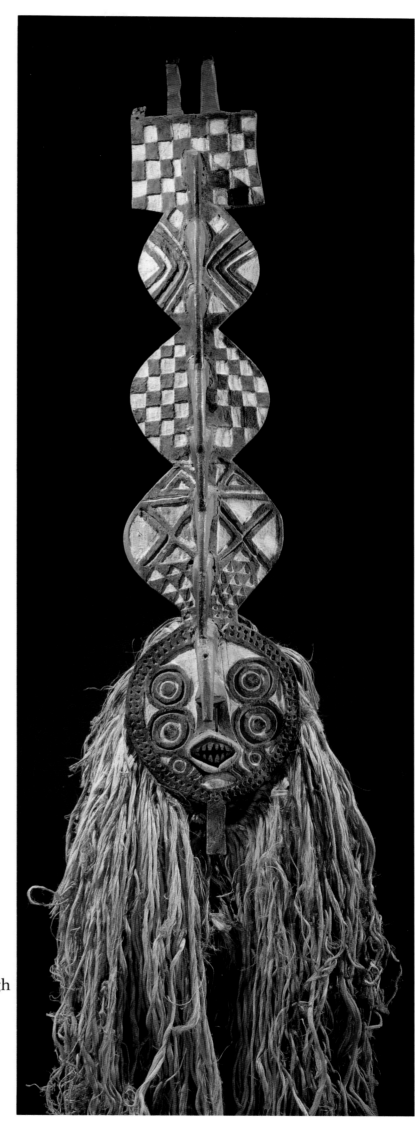

LEFT: Yoke Mask
Baga, Nimba, Guinea
Wood, fiber, leather, fabric, metal, 86½ inches (220 cm) high
Musée de L'Homme, Paris

RIGHT: Mask
Bwa, Bobo Nienege, Upper Volta
Wood, paint, fiber, 46½ inches (118 cm) high
Musée de L'Homme, Paris

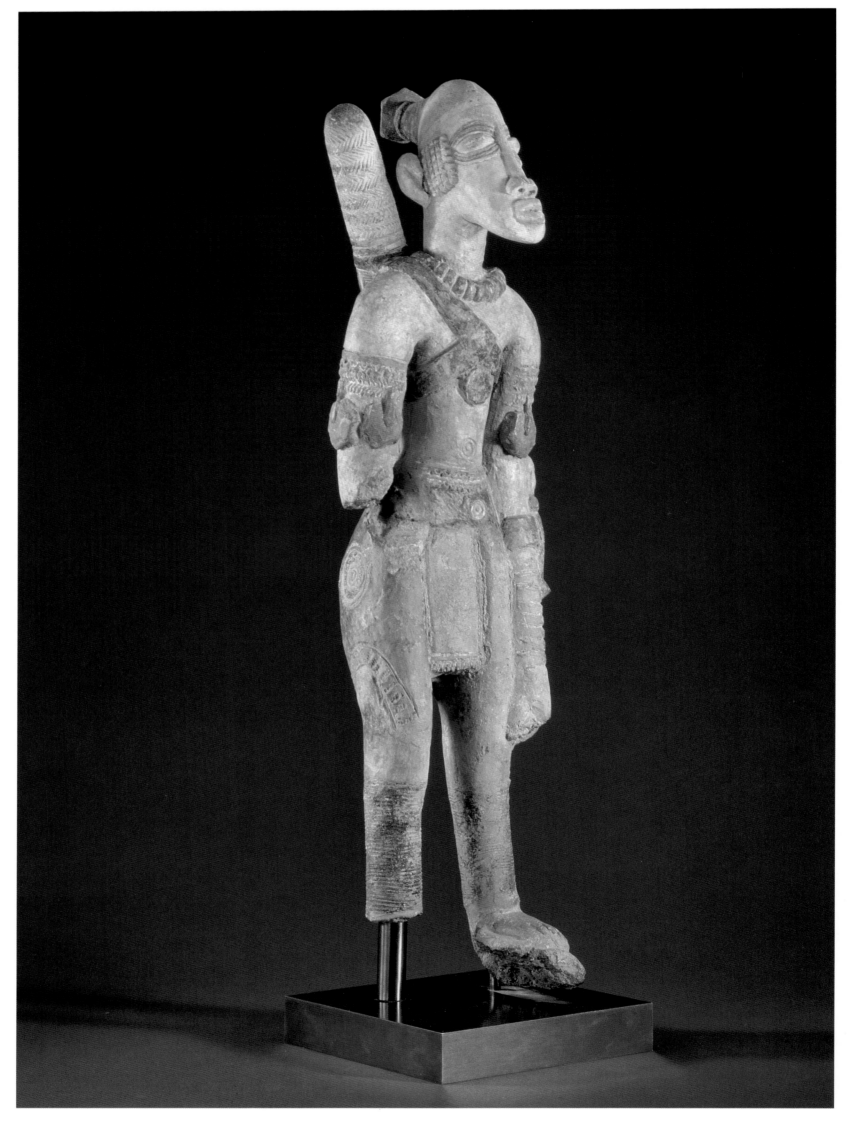

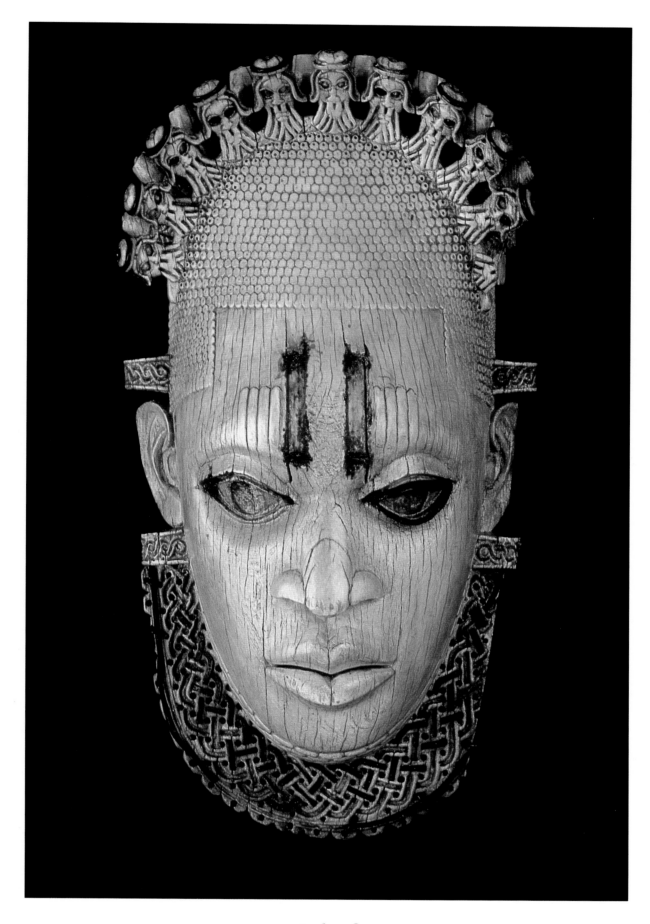

LEFT: Archer figure
Inland Delta Region, Mali
Terracotta, 24⅜ inches (61.9 cm) high
National Museum of African Art, Washington, D.C.
Museum purchase, 86-12-1

ABOVE: Hip mask
Benin, south-western Nigeria, *c.* 16th century AD
Ivory, 9⅞ inches (25 cm) high
Museum of Mankind, London

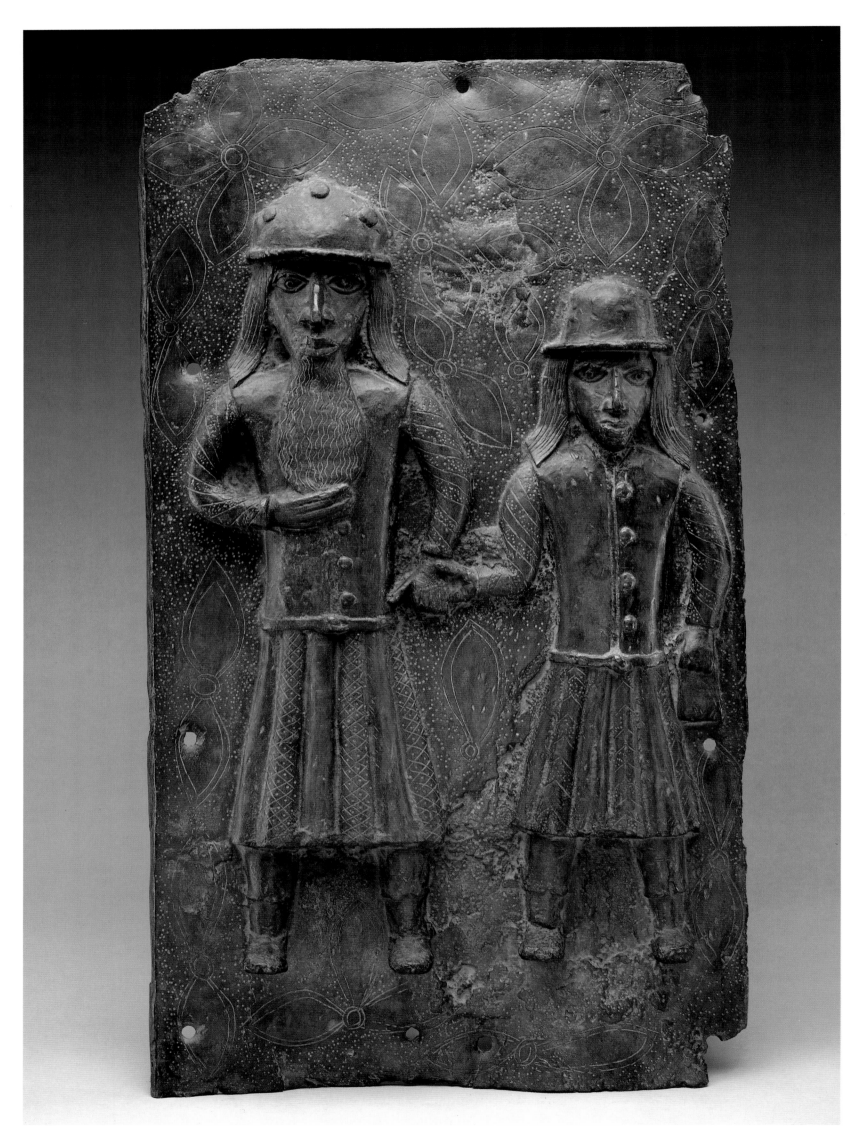

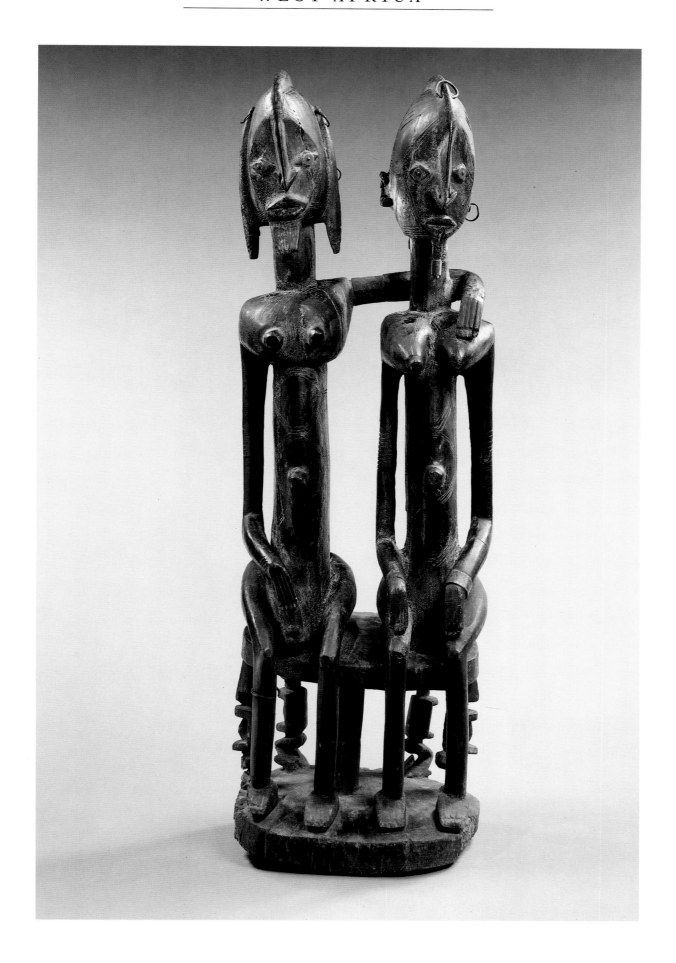

LEFT: Plaque: Two Portuguese
Benin, south-western Nigeria, 16th–17th centuries AD
Metalwork-brass, 20½ inches (52.1 cm) high
The Metropolitan Museum of Art
Gift of Mr and Mrs Klaus G. Perls, 1991 (1991. 17.18)

ABOVE: Seated Couple, Dogon, Mali
Date unknown
Wood and metal, 28¾ inches (73 cm) high
The Metropolitan Museum of Art
Gift of Lester Wunderman, 1977 (1977.394.15)

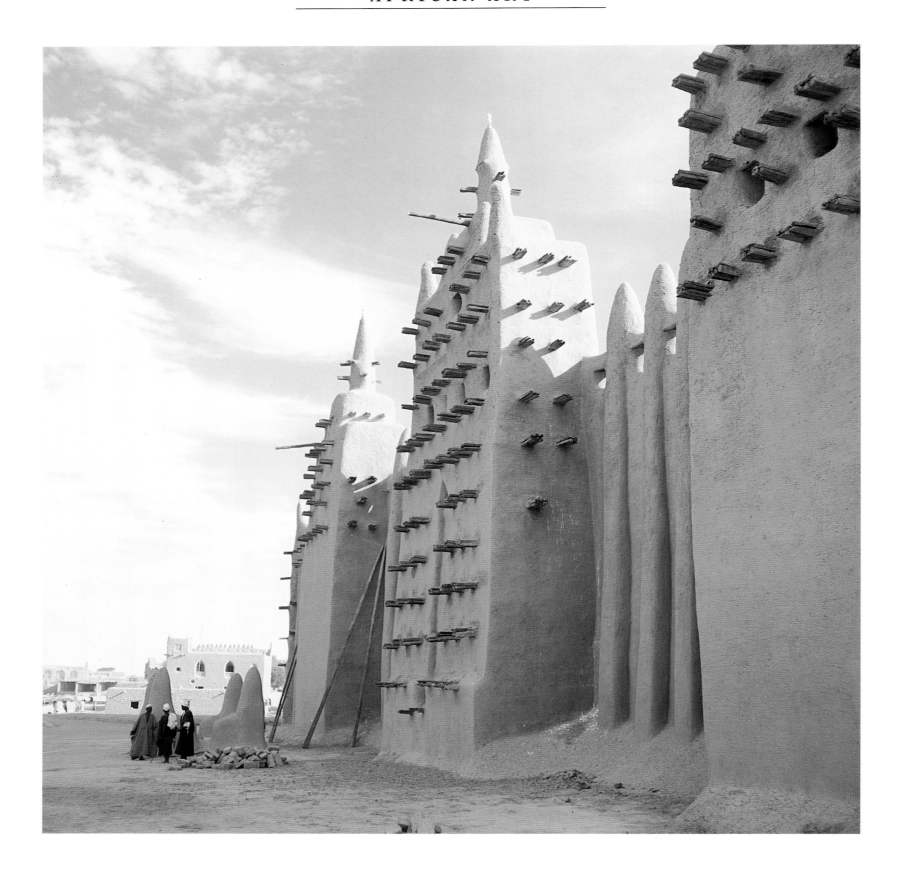

The Great Mosque, Djenne, Mali
Werner Forman Archive

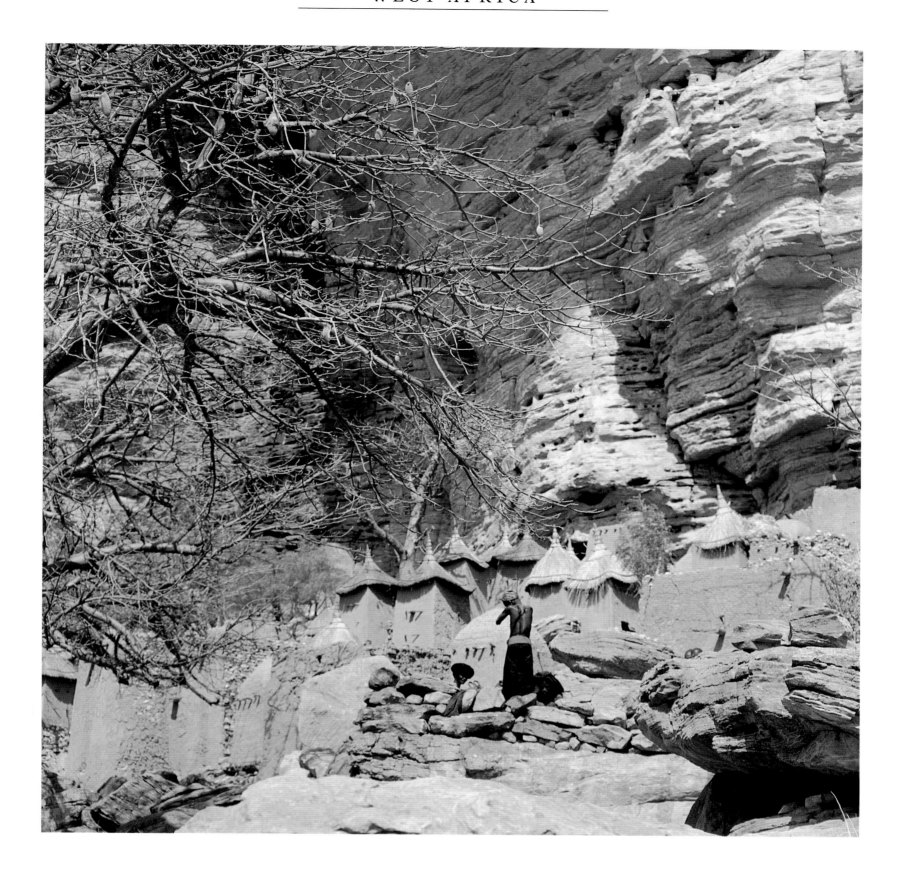

Dogon village, Bandiagara region, Mali
Werner Forman Archive

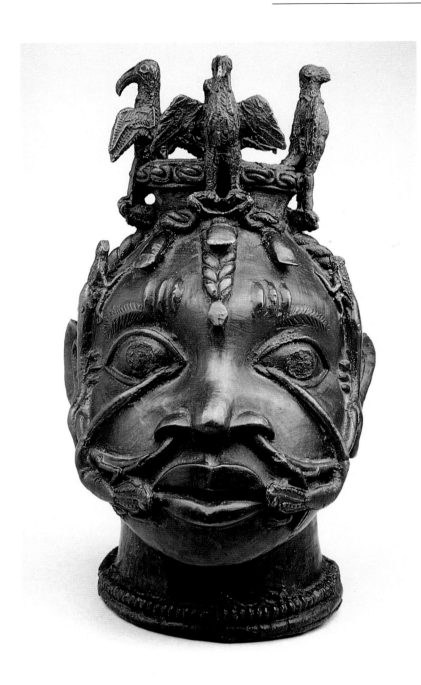

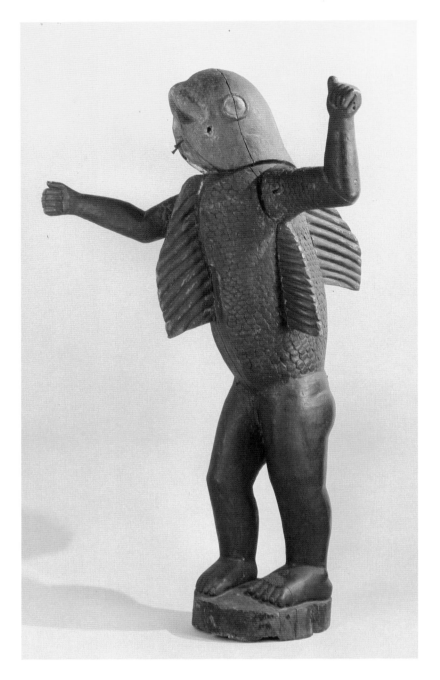

ABOVE LEFT: Osun cult head
Benin, south-western Nigeria
Late 17th/early 18th century
Brass, 10⅝ inches (27 cm) high
Museum of Mankind, London

ABOVE RIGHT: *King Behanzin as a Shark*
Fon kingdom, Benin, south-western Nigeria,
Late 19th century
Wood, 63 inches (160 cm) high
Musée de l'Homme, Paris

RIGHT: *Gou, God of Iron and War*
Fon kingdom, Benin, south-western Nigeria,
Late 19th century
Metal, 65 inches (165 cm) high
Musée de l'Homme, Paris

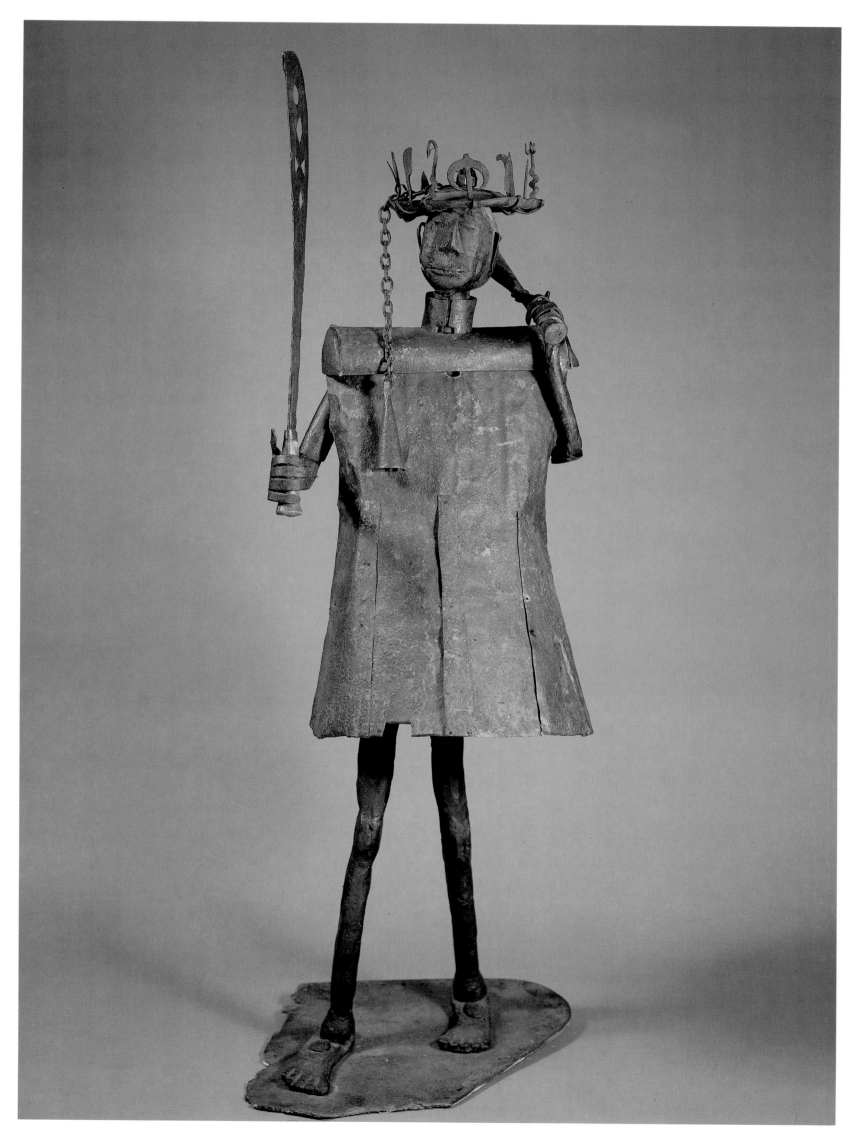

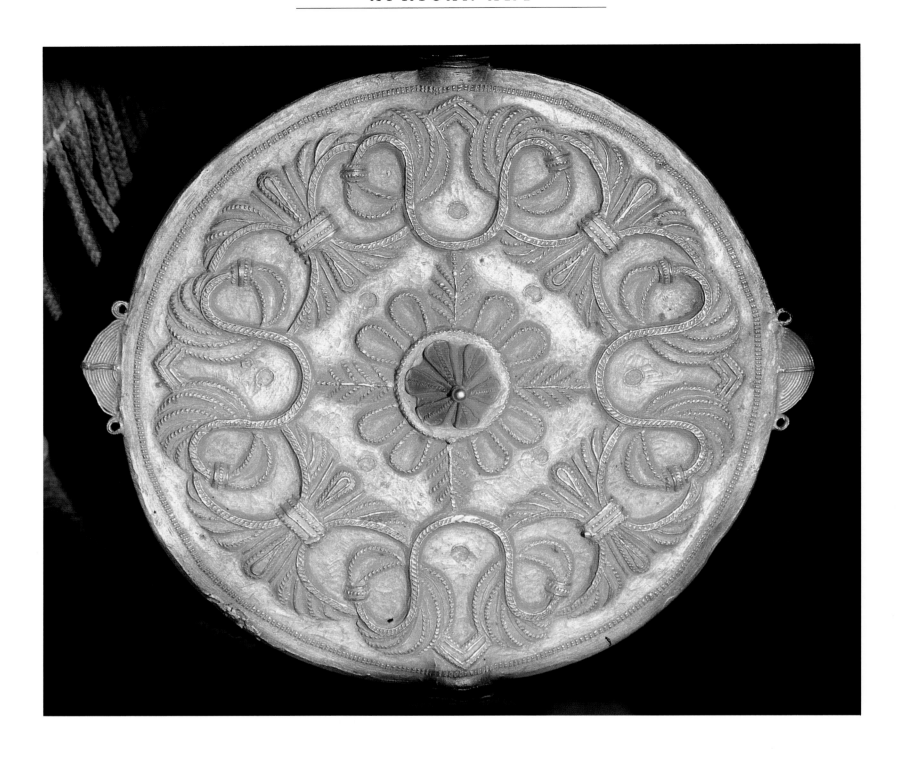

ABOVE: Ashanti gold jewelry
Ghana, 18th-19th century
British Museum, London/Werner Forman Archive

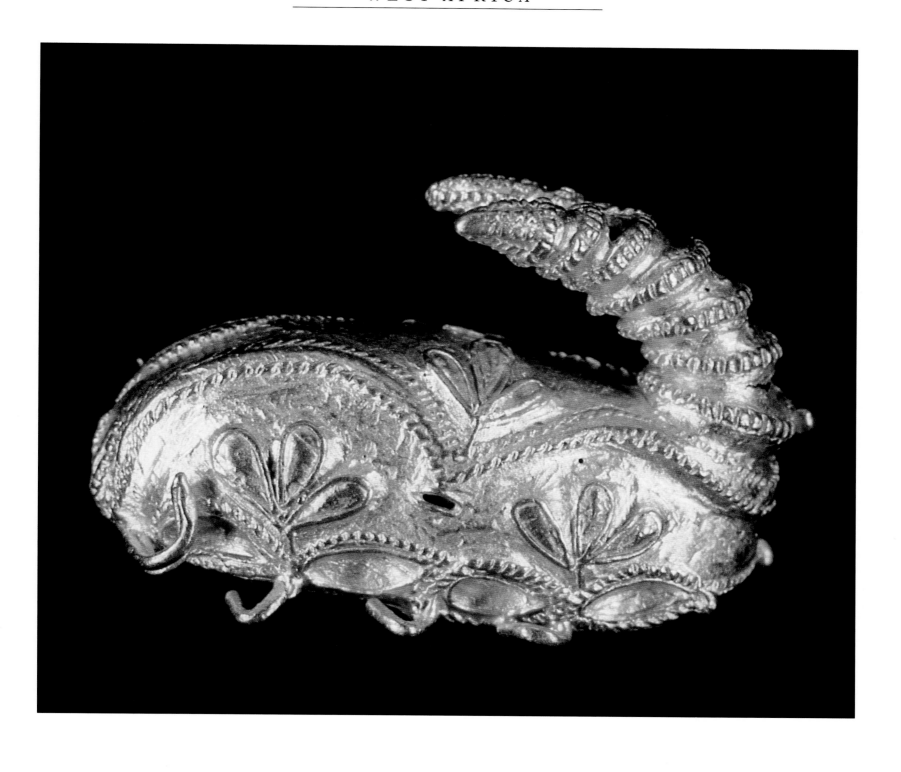

ABOVE: Ashanti gold scorpion
Ghana, 19th century
Museum of Mankind, London/Werner Forman Archive

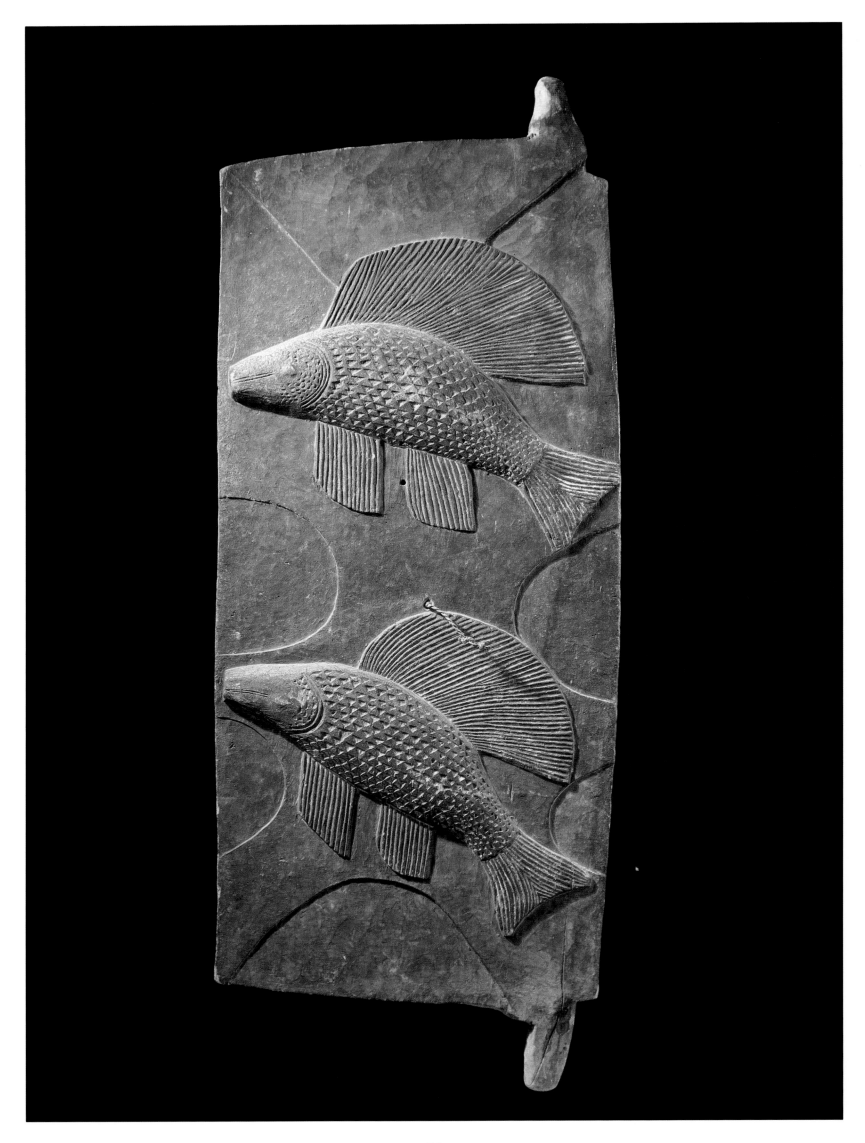

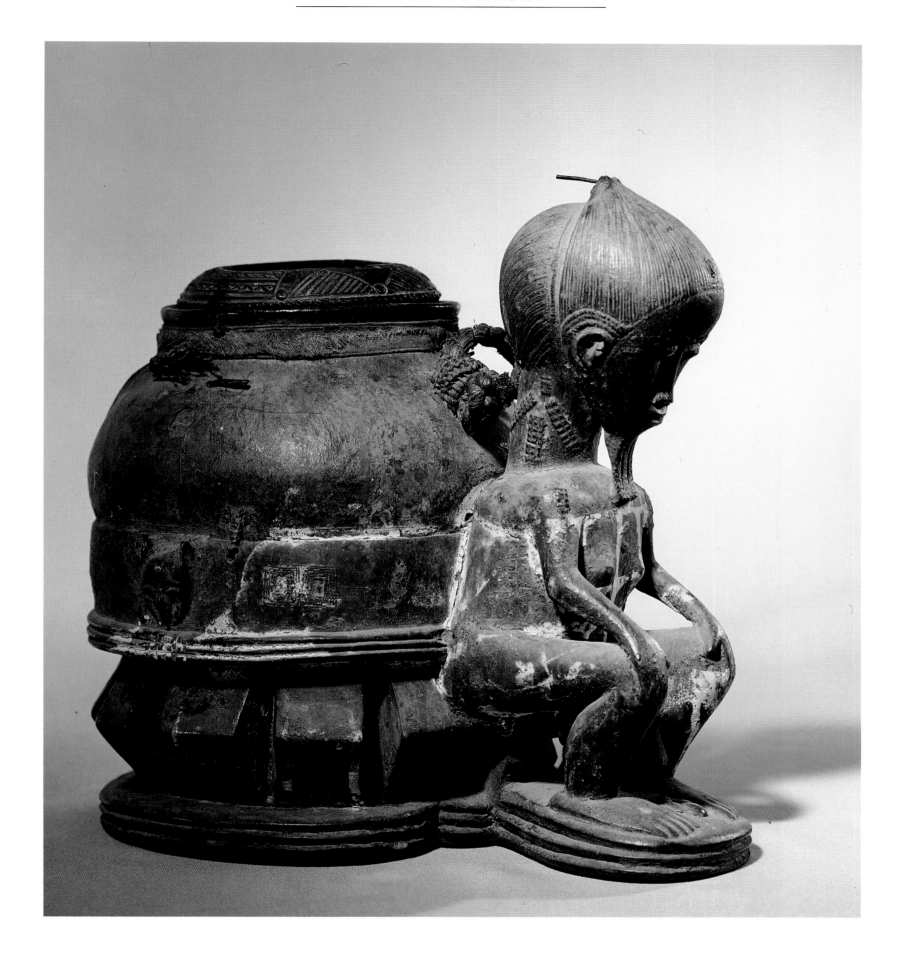

LEFT: Door
Baule people, Ivory Coast, 20th century
Wood, 57½ inches (146 cm) high
Musée Barbier-Mueller, Geneva

ABOVE: Divination vessel
Baule people, Ivory Coast, collected 1930s
Wood, fibers and skin, 9⅞ inches (25 cm) high
Musée de l'Homme, Paris

51

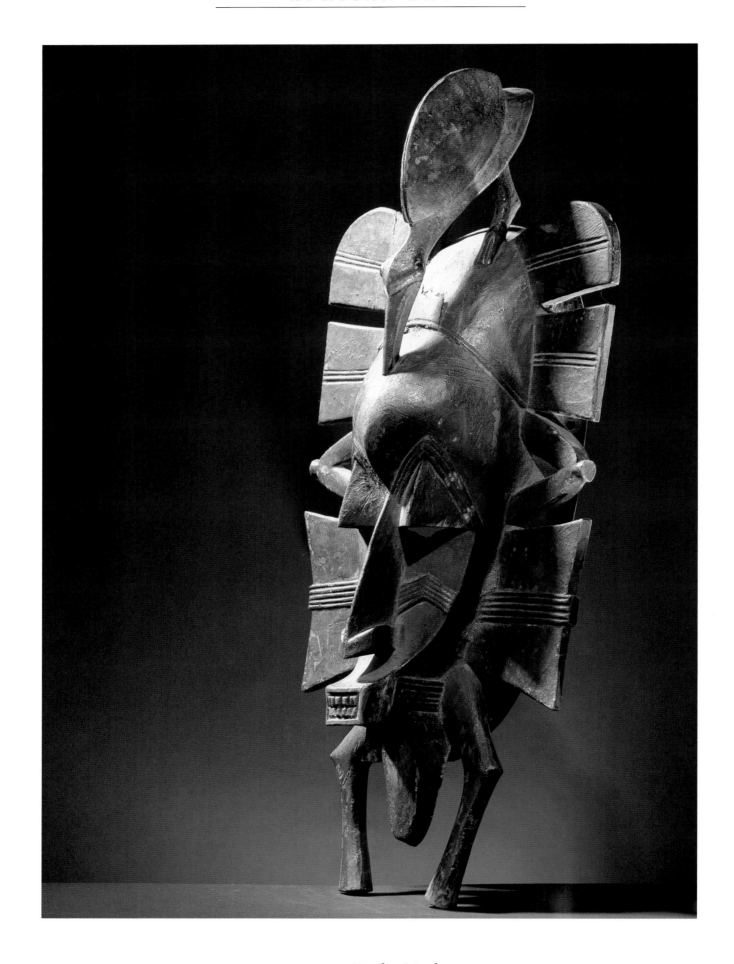

ABOVE: Kpelie Mask
Senufo, Ivory Coast
Wood
Werner Forman Archive, London

RIGHT: Female figure
Dan/Kran people, Liberia
Wood and fiber, 20⅞ inches (53 cm)
Musée Barbier-Mueller, Geneva

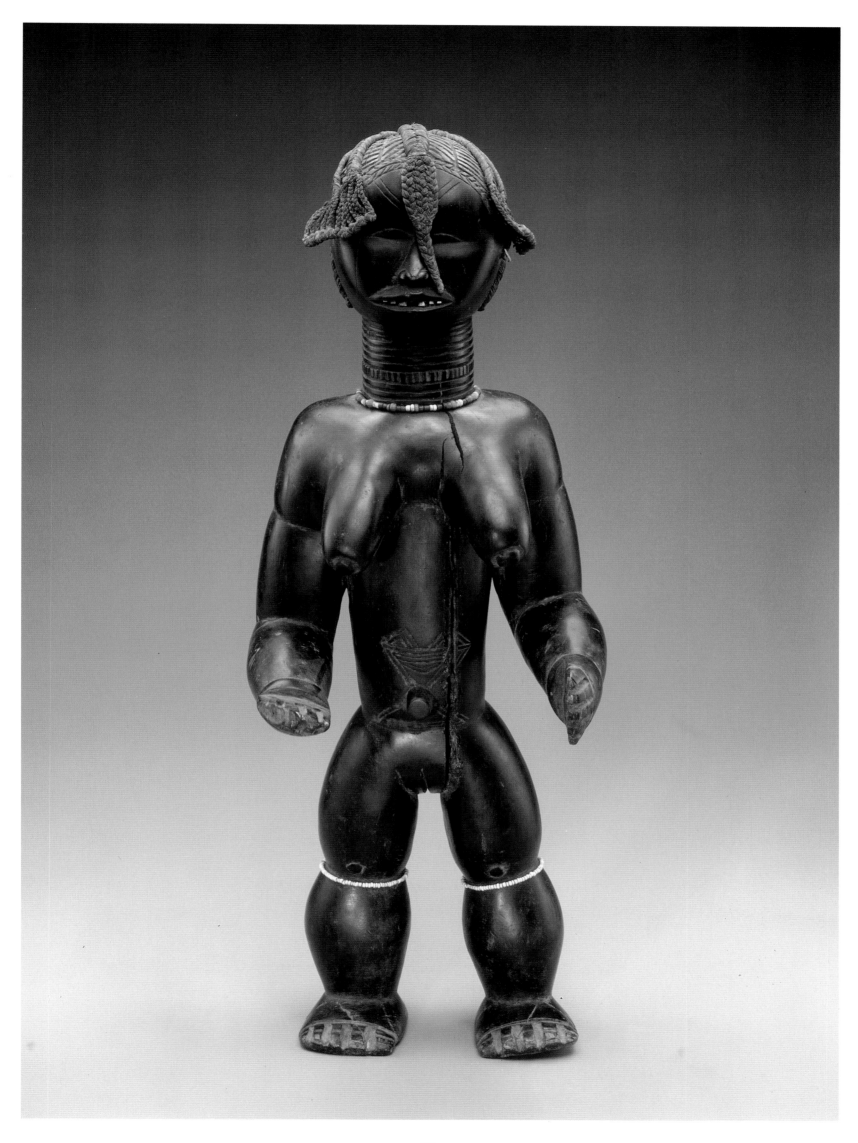

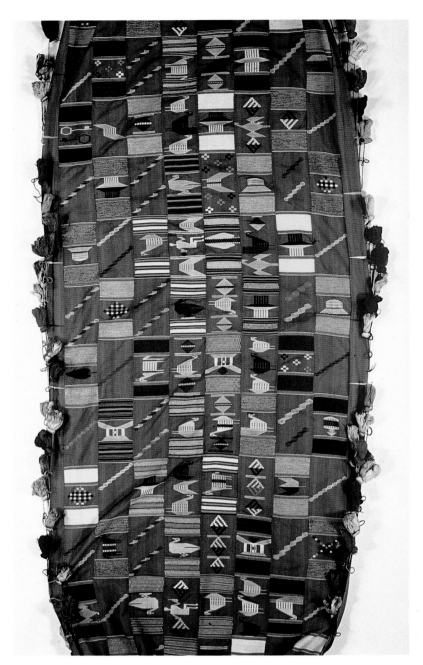
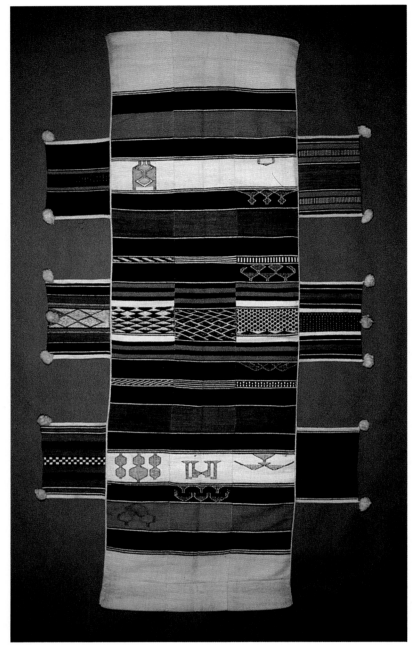

ABOVE LEFT: Hammock, Ewe people
Ghana, 20th century
Silk and cotton, 122 inches (310 cm) long
Museum of Mankind, London

ABOVE RIGHT: Hammock
Mende people, Sierra Leone, early 20th century
Cotton, 87 inches (221 cm) long
Museum of Mankind, London

RIGHT: Lamp
Nupe people, Bida, central Nigeria, 20th century
Clay, 15⅜ inches (39 cm) high
Museum of Mankind, London

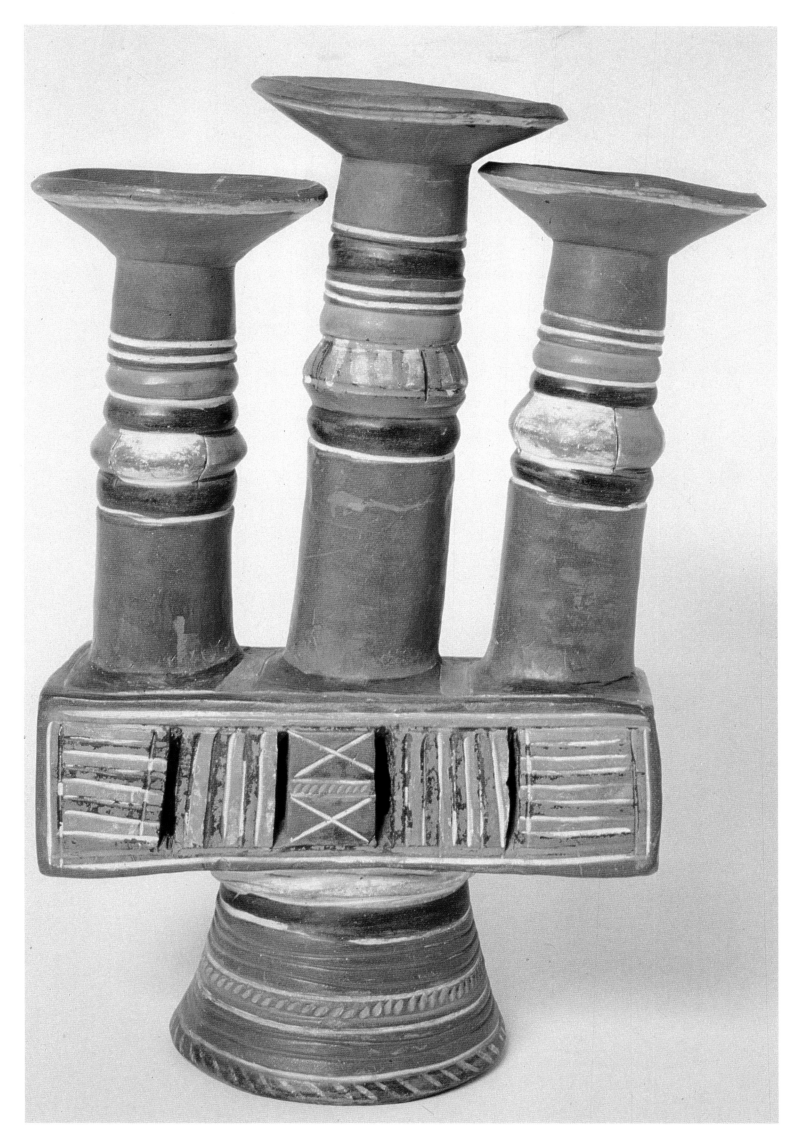

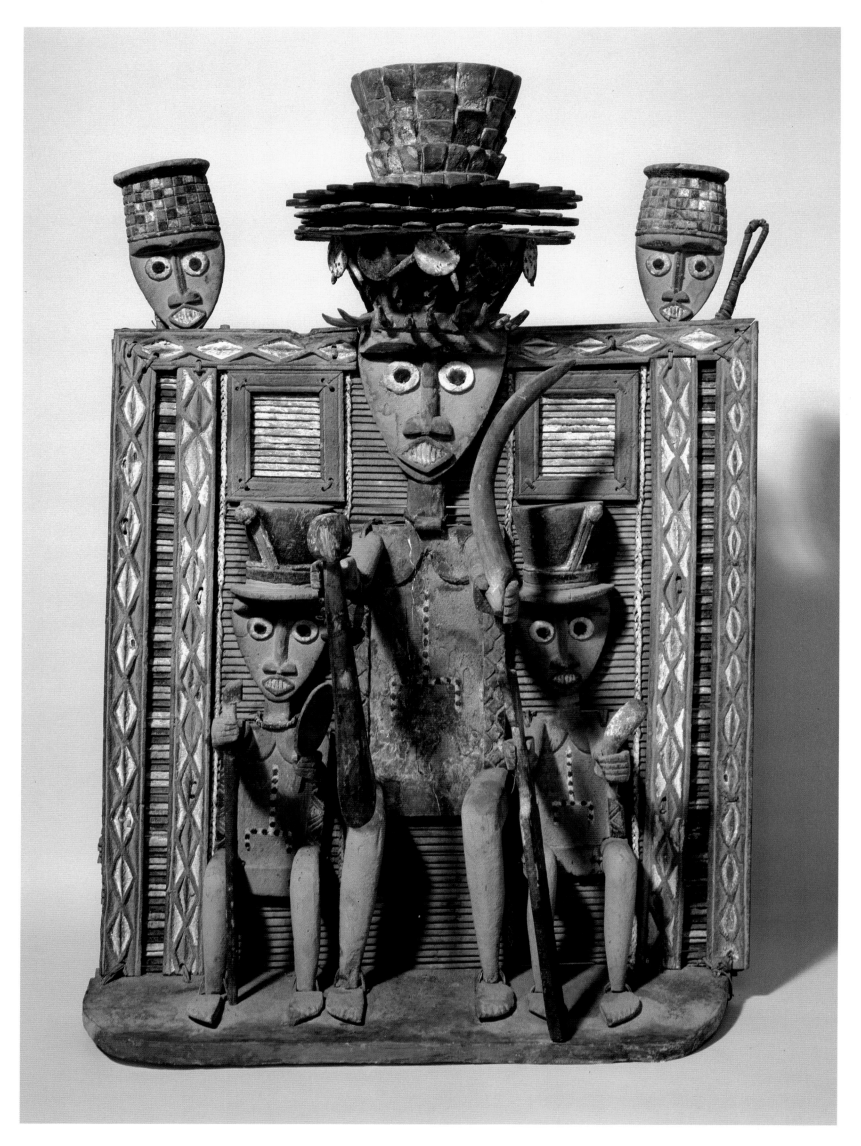

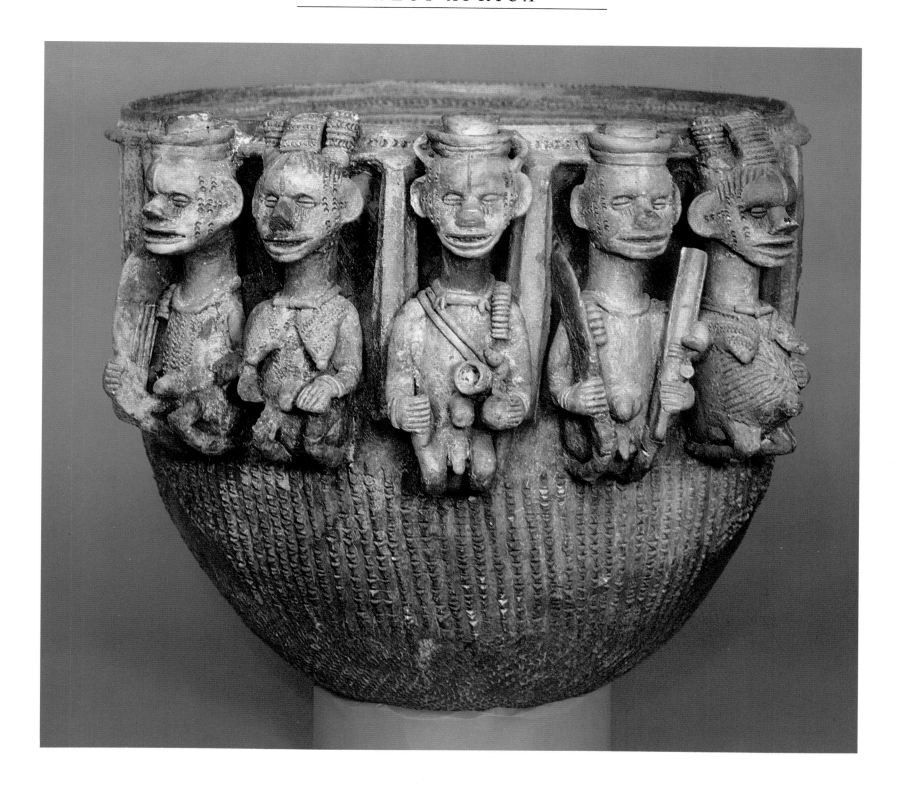

LEFT: *Duen Fobara* (ancestral screen)
Kalabari region, Niger delta, Nigeria, 19th century
Wood, split vegetable fiber, pigment,
46 × 31 × 13 inches (117 × 79 × 33 cm)
Pitt Rivers Museum, University of Oxford

ABOVE: Ceremonial pot for yam cult
Igbo people, Osisa village, Nigeria, 20th century
Clay, 18½ inches (47 cm) high
Museum of Mankind, London

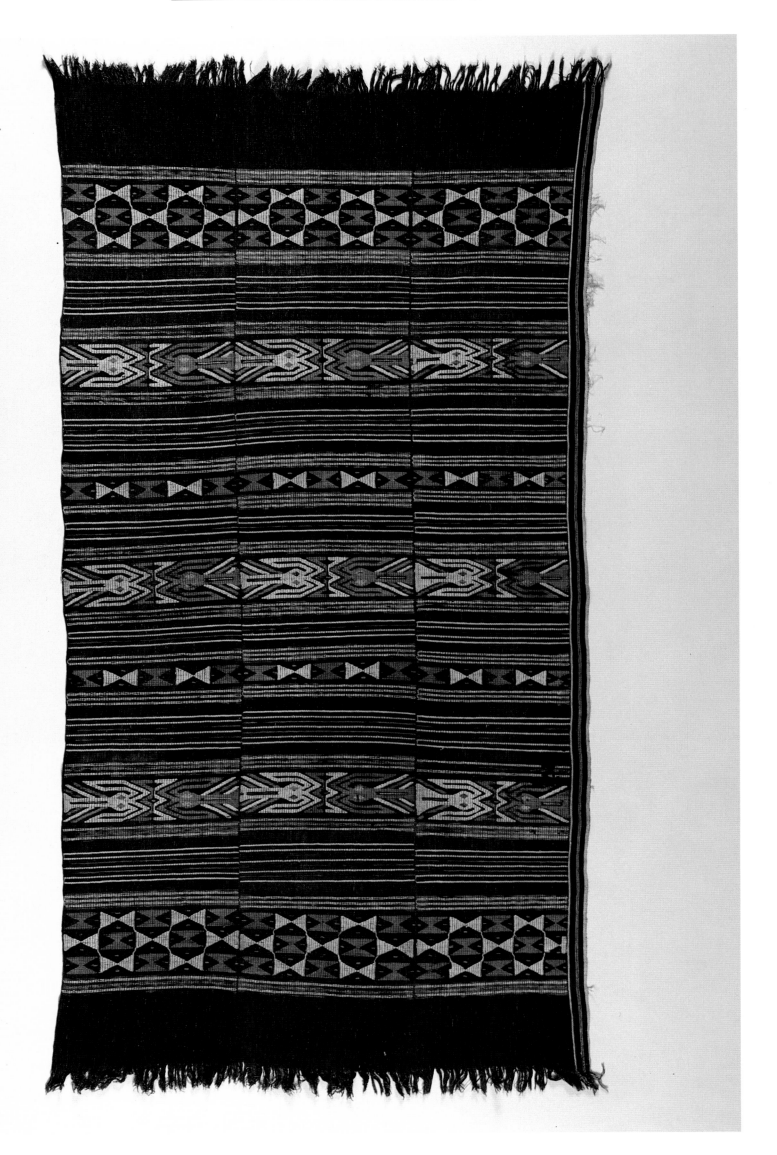

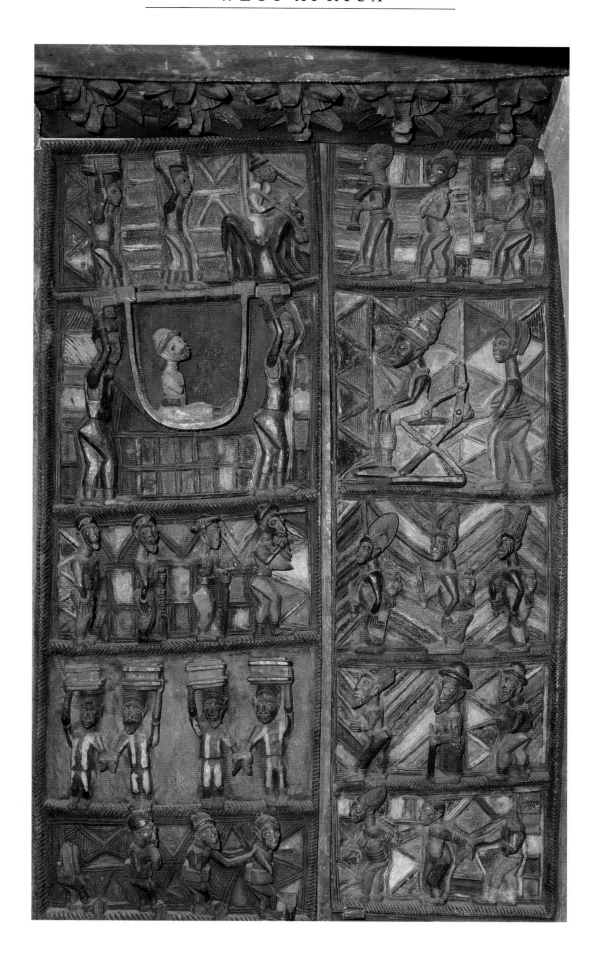

LEFT Cloth, Ijebu Ode, cotton
Southern Yoruba region, Nigeria, 18th century
Royal Scottish Museum, Edinburgh

ABOVE: Pair of carved doors, Yoruba, Nigeria
Wood, 84 inches (213 cm) high
Museum of Mankind, London

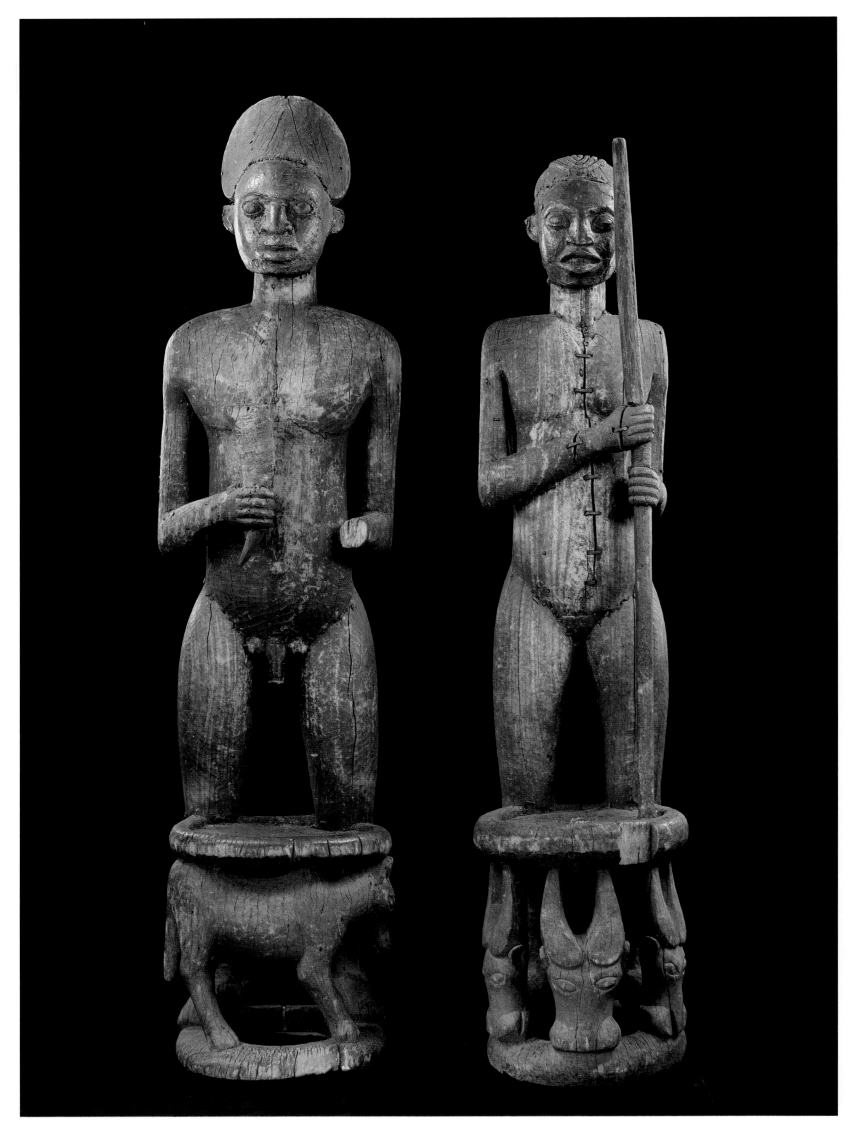

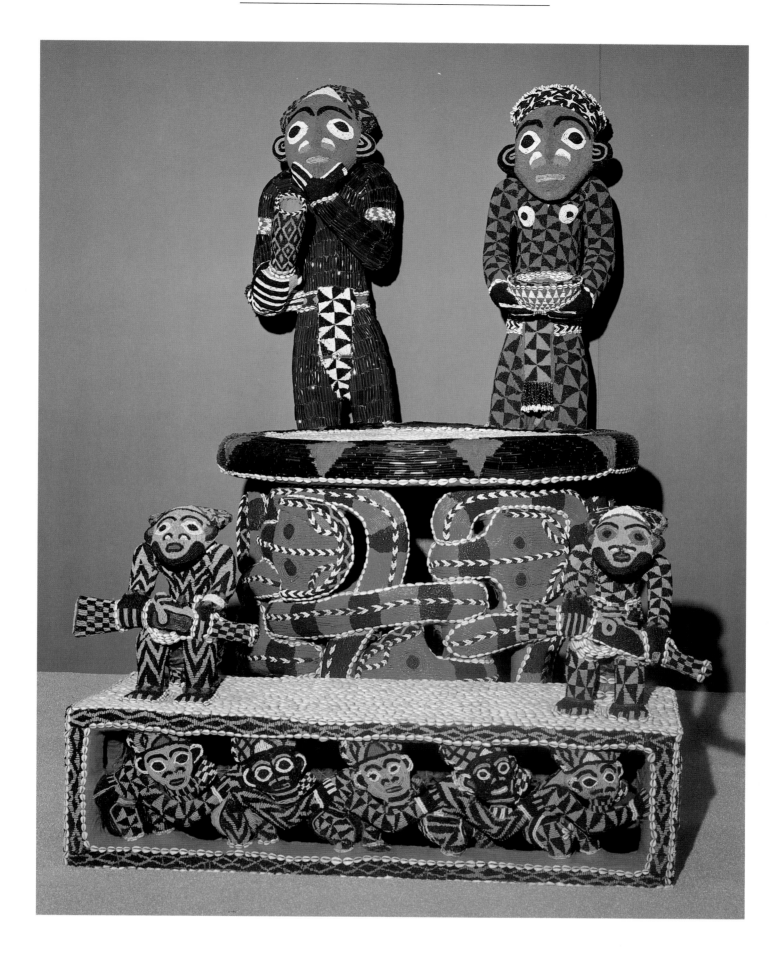

LEFT: Royal ancestors as throne figures
Bamun kingdom, Cameroon, 19th century
Wood, 19¼ inches (49 cm) high
Museum für Völkerkunde, Berlin

ABOVE: Royal throne
Bamun kingdom, Cameroon, 19th century
Wood, beads, shells, cloth, 68⅞ inches (175 cm)
Museum für Völkerkunde, Berlin

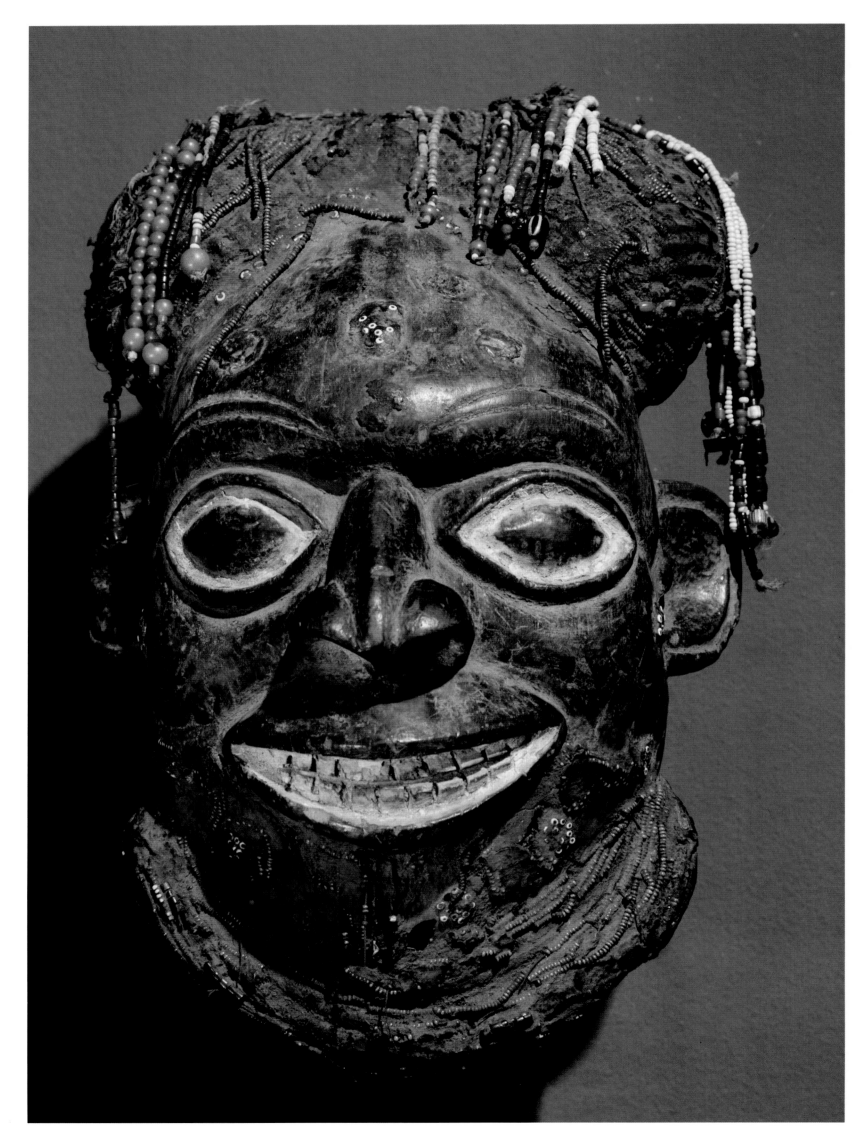

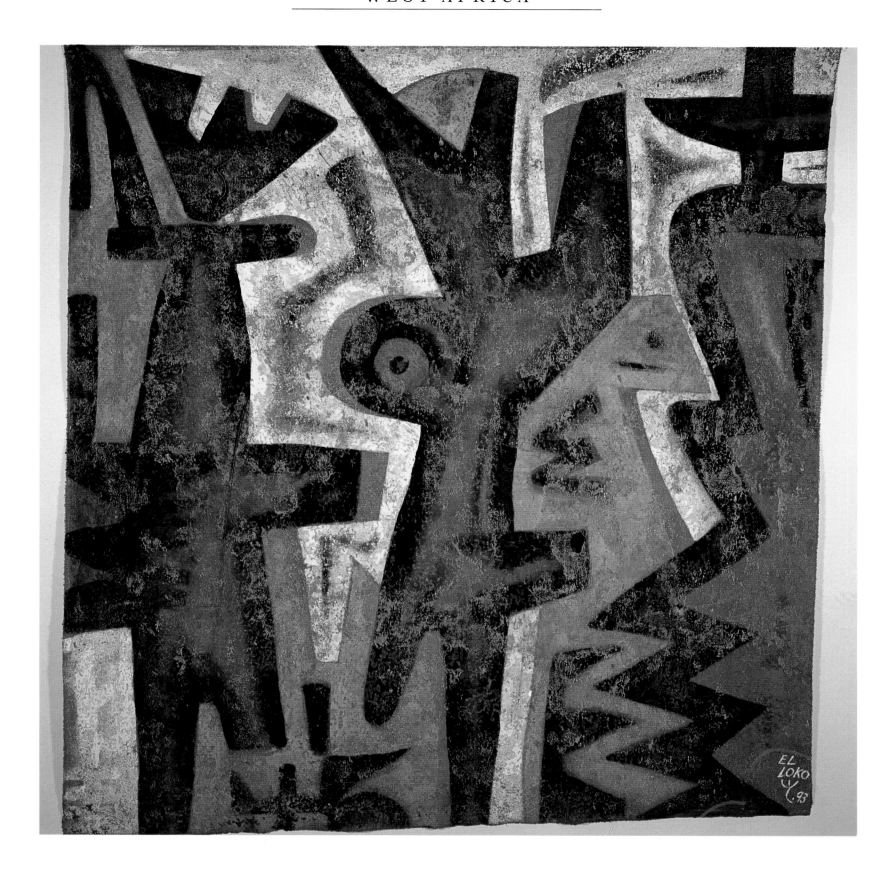

LEFT: Mask Headdress
Kom, Cameroon
Wood
Werner Forman Archive, London

ABOVE: *Comic Letters, Dancers*, 1993
El Loko (b. 1950), Togo
Mixed media, 72⅞ × 60⅞ inches (185 × 175 cm)
Courtesy of the artist

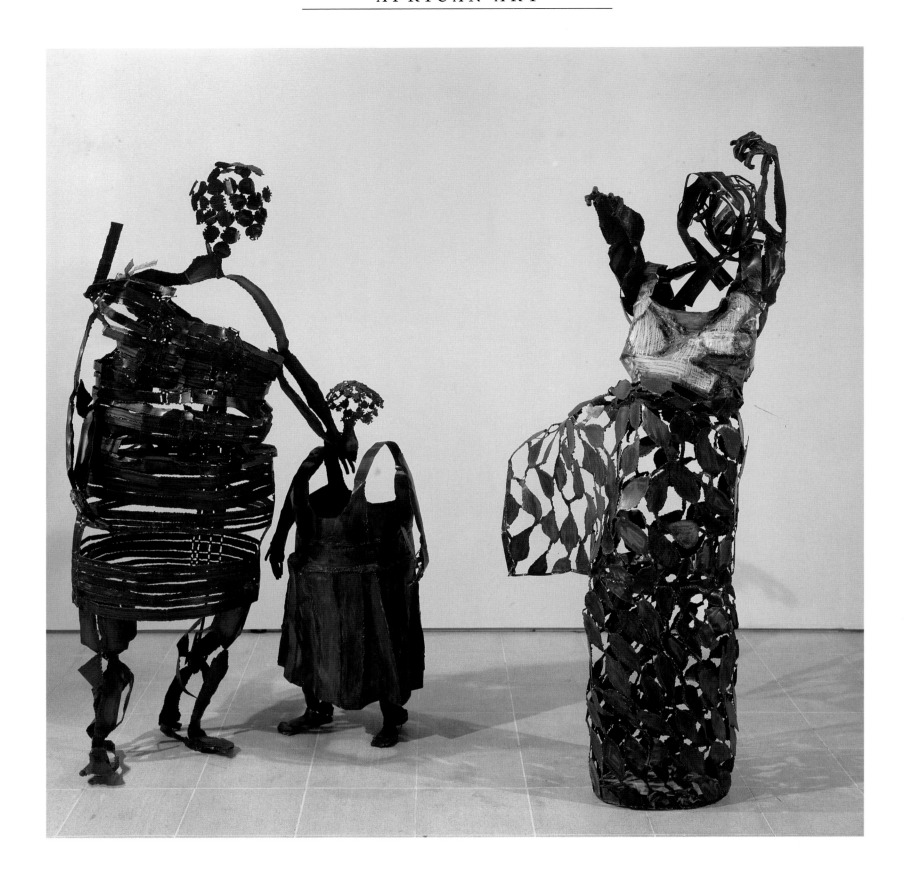

Eriabo, Iriabo and Child, 1986 (detail of *Audience*)
Sokari Douglas-Camp (b. 1958)
Welded steel, 76¾ × 137¾ × 23⅝ inches (195 × 350 × 60 cm)
Arts Council Collection, London

ABOVE LEFT: *Untitled* (detail), 1992
Bruce Onobrakpeya (b. 1932), Lagos, Nigeria
Etching, 35½ × 23⅝ inches (90 × 60 cm)
Photograph courtesy Clementine Deliss

ABOVE RIGHT: Detail of plastercast panel, 1974
Bruce Onobrakpeya (b. 1932), Lagos, Nigeria
Photograph courtesy Clementine Deliss

EAST AFRICA

Although there are many other groups producing a wide variety of artworks, including some masks and figurative sculpture, we will concentrate here on three distinctive and very different areas of art in East Africa; the arts of Ethiopia, of the coastal Swahili culture, and of the pastoral Maasai and their neighbors.

In the period before the introduction of Christianity to the Ethiopian kingdom of Aksum in the fourth century AD, trade and cultural ties of varying influence were maintained with Meroë to the north and with South Arabian polities across the Red Sea. Substantial archeological investigation of Aksumite sites has revealed much about the principles of their complex architecture, and their large carved stone stellae in the form of many-storied buildings, but inevitably we know little of the ideas and concepts underlying their use. The stone-working skills which characterized the Aksumite period reached their culmination in the amazing churches hewn from solid rock at Lalibela during the much later Zagwe dynasty (1137-1279 AD).

Following the overthrow of the Zagwe rulers, their successors, known as the Solomonic dynasty (1279-1527 AD), sought to boost their claim to legitimacy by instituting a cultural revival, building new churches, and sponsoring new translations of key religious texts. The founder of the dynasty traced his descent back through the rulers of Aksum to Menelek, a son of King Solomon and the Queen of Sheba. Although the murals, paintings, and illuminated manuscripts of the medieval period were strongly influenced by the art of the Byzantine Empire, important stylistic variations and differences in emphasis developed. Perhaps the most significant of these was the official adoption during the reign of King Zar'a Ya'cob of a cult directing prayer toward Mary as an intercessor with God. Images depicting Mary enthroned or under a canopy of angels became central to Ethiopian court art. A continued elaboration of the iconography of Mary occurred throughout the Gondarene period (seventeenth to nineteenth centuries), although the form of Ethiopian art became increasingly influenced by European religious painting.

In addition to the official religious art of the Ethiopian court, we must also note the development of painting on so-called 'magic scrolls.' These images were painted not for religious or aesthetic contemplation, but by healers, as part of rituals, in order actively to protect and cure their clients. Finally, there is an active and flourishing body of work by Ethiopian artists seeking to respond to modern developments in Western art, although often drawing on aspects of their heritage, such as the scrolls and Amharic scripts. The turbulent political situation in Ethiopia since the overthrow of the last emperor, Haile Selassie, has meant that much of this work has been produced under difficult conditions in exile in Europe and the United States.

The arts of the Swahili coast provide another example of a long history of African absorption of and interaction with overseas cultural influences. As early as the seventeenth century AD, traders from the Arabian peninsular sailed their dhows down the coast of East Africa searching for gold, ivory, and slaves. Since the pattern of prevailing winds, and the need to amass suitable cargo, required them to remain in Africa for several months each year, settlements grew on the coast where traders built homes and intermarried with the local peoples. By the twelfth century a string of coastal towns had been established from Mogadishu in Somalia down as far as Mozambique. Towns such as Lamu in Kenya, and Zanzibar, grew rich on the profits of a trading network that linked Africa, Arabia, India, and the Far East. Wealthy traders built elaborate houses which, in keeping with Islamic ideals, had plain unornamented outer walls protecting the privacy of the women secluded inside, but which expressed the power and status of their owners through elaborate carved door frames. This tradition was represented all down the Swahili coast but reached its most elaborate expression in nineteenth-century Zanzibar. Motifs on these carvings show a blending of Arab, local African, and in some cases Indian, influences. Other, similarly hybrid, forms developed in metal- and leather-working and molded plaster ornamentation of house interiors, as well as in a variety of poetical and musical styles.

The pastoral Maasai people of northern Kenya, along with less well-known neighboring groups such as the Turkana, Samburu, Pokot, and Okiek, make use of European glass beads, imported for centuries by the Arab traders on the coast, as a major component in

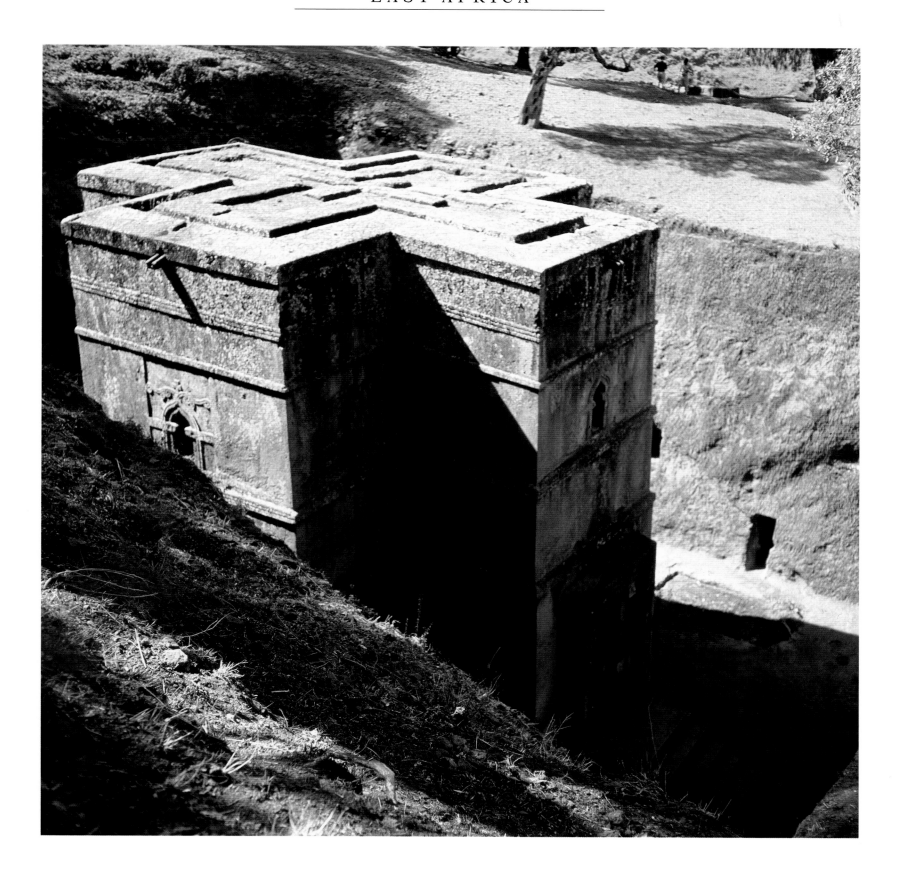

ABOVE: St George's church, Lalibela, Ethiopia, 13th century
Rock, 13 × 13 × 13 yards (12 × 12 × 12 m)
Werner Forman Archive, London

elaborate programs of personal ornamentation. In combination with aspects of dress, hair style, jewelry, and sometimes body paints, particular combinations of beadwork serve both to distinguish Turkana from Samburu, and perhaps more importantly, to define and mark gender, age, and status within each group. Male dress and hairstyles mark progress from uninitiated youth, to warrior, to elder, as well as finer distinctions such as age sets, and success in war or hunting. Women's styles indicate stages of initiation, marriage, number of children, and widowhood. Marriage is indicated among Turkana women by a brass or aluminum necklace, by a leather wristband for Pokot, and by red neckbeads among Samburu. These expressions through dress should not, however, be understood as fixed, atemporal signs expressing single meanings. Within and between each group there are fashions, sparked off by copying innovative combinations or the availability of new colors of beads, while other groups may attempt to draw on the styles of their neighbors. Okiek farming women, for example, have been shown to imitate the designs of the pastoral Maasai, while reinterpreting, or in Maasai terms misinterpreting, their schemes of color combination. Above all, however, these systems of body decoration are about local ideas of beauty, of looking good in a way that is appropriate to, and understood by, local concepts. Although the specific content of each of these systems differs, all the groups share a common understanding of the role of dress and ornament.

In looking at three very diverse art styles within East Africa we can see how different groups of African peoples are far from being the remote autonomous 'tribes' of Western cliché. Rather, each has developed, to a different degree, creative responses to both local conditions and the importation of materials, cultures, or religions in the course of long histories of interaction with both non-African and other African cultures.

RIGHT: Stela, Axum, Ethiopia
3rd–5th century AD
Werner Forman Archive, London

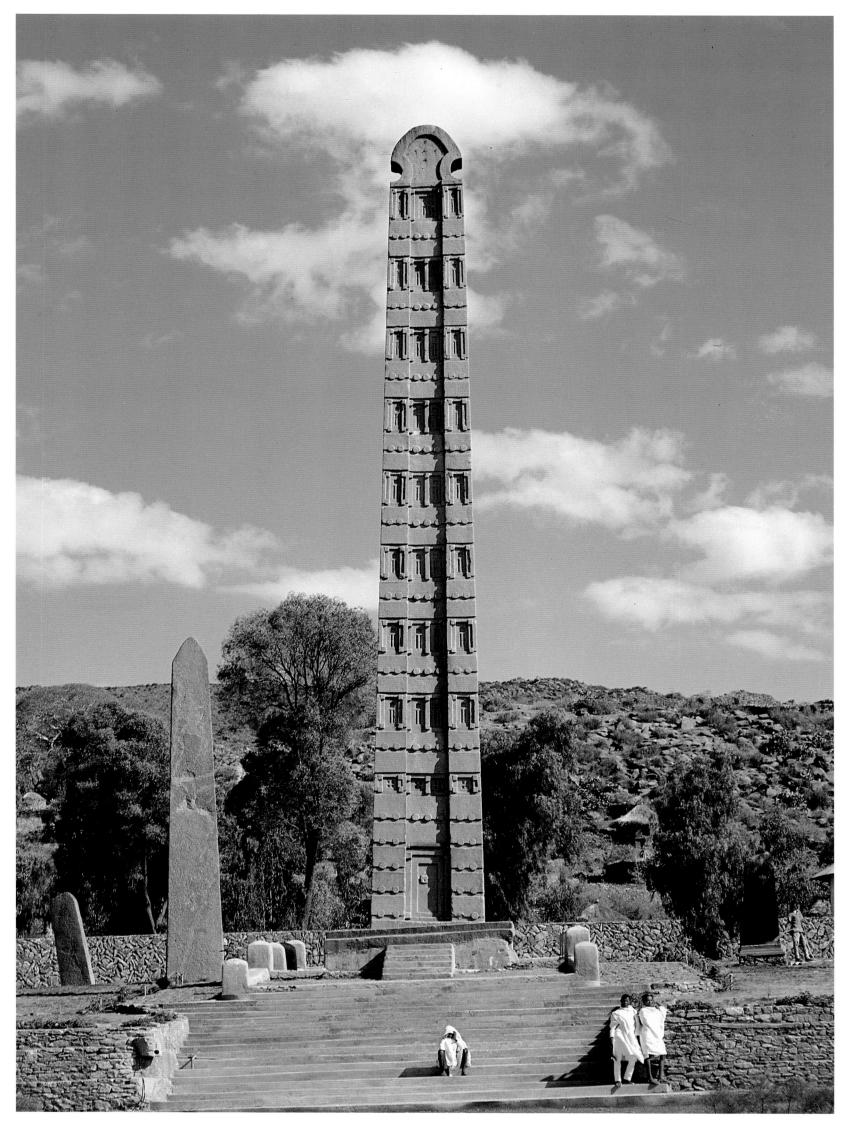

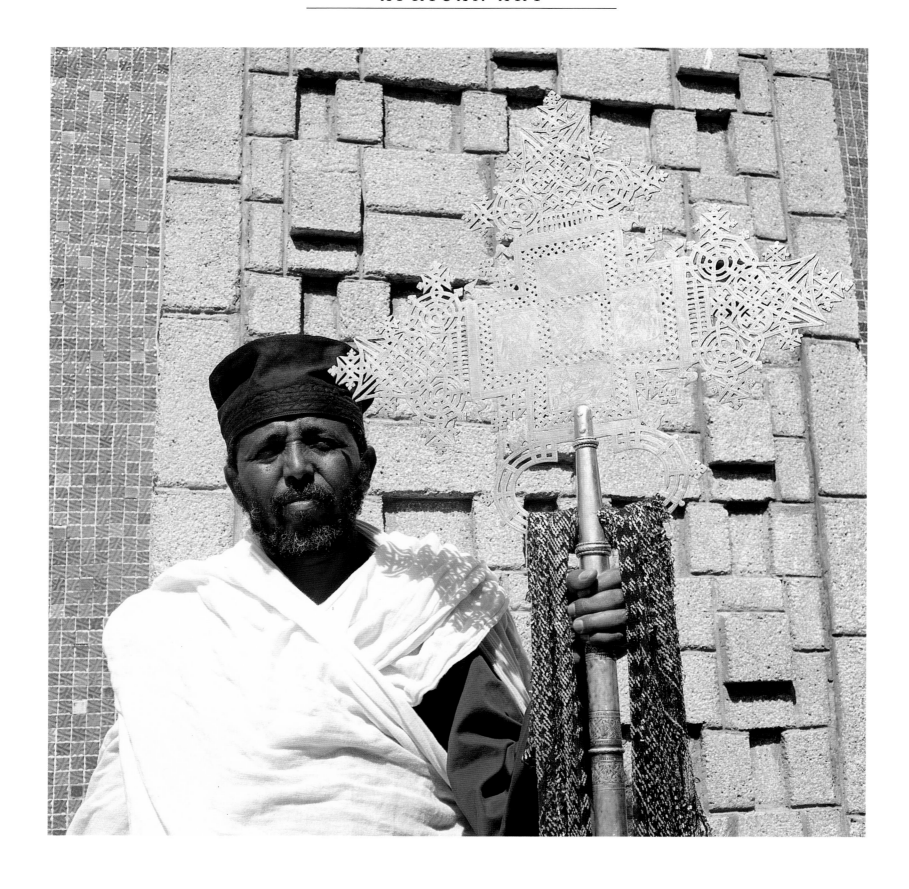

ABOVE: Processional cross
Cathedral of Our Lady of Sion at Axum, Ethiopia
Werner Forman Archive, London

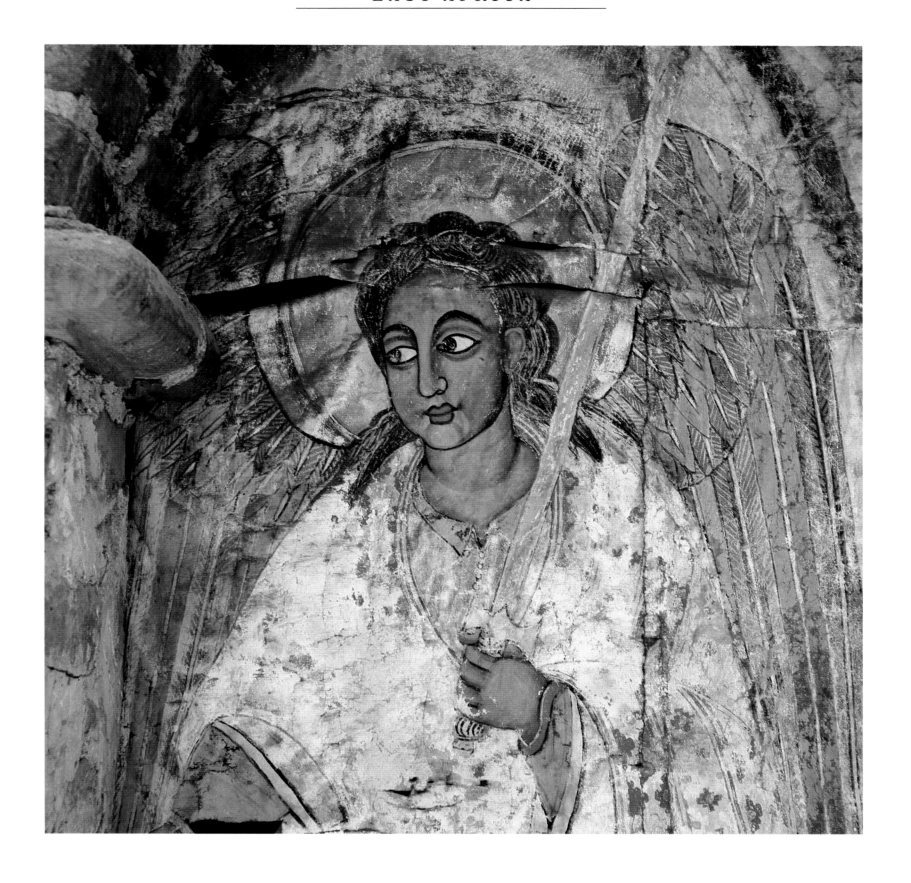

ABOVE: Icon on the door of the church of Debra Berhan
Gondar, Ethiopia, built 1682–1706
Werner Forman Archive, London

ABOVE LEFT: *Patriarche*, 1991
Mickael Bethe-Selassie (b. 1951), Ethiopia
Papier-mâché, wire and pigments, 80¾ inches
(205 cm) high
Courtesy of the artist

ABOVE RIGHT: *Ancient Gossip*, 1990
Wosene Kosrof (b. 1950), Ethiopia
Acrylic on canvas 60 × 12 inches (152.4 × 30.5 cm)
Collection of Janet Stanley, New York, photo Sasha
Markovik

FAR RIGHT ABOVE: *Bakuba Scroll* no 2, 1990
Wosene Kosrof (b. 1950), Ethiopia
Acrylic on canvas, 13 × 14 inches (33 × 35.5 cm)
Collection of Janet Stanley, New York, photo Sasha
Markovik

FAR RIGHT BELOW: *Image*, 1976
Ibrahim El-Salahi (b. 1930), Sudan
Ink on paper, 18 × 12 inches (45.7 × 30.4 cm)
Courtesy of the artist

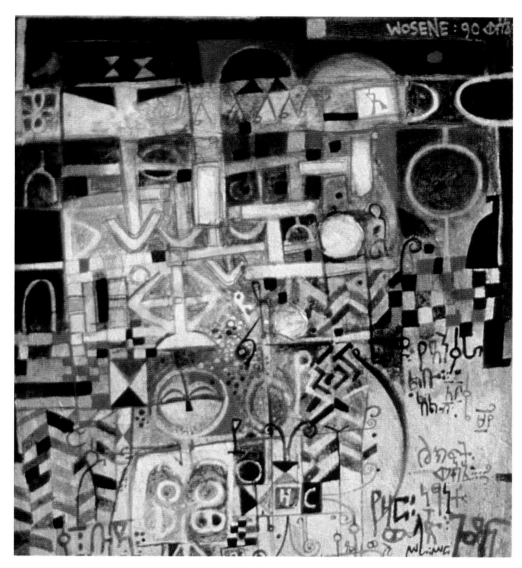

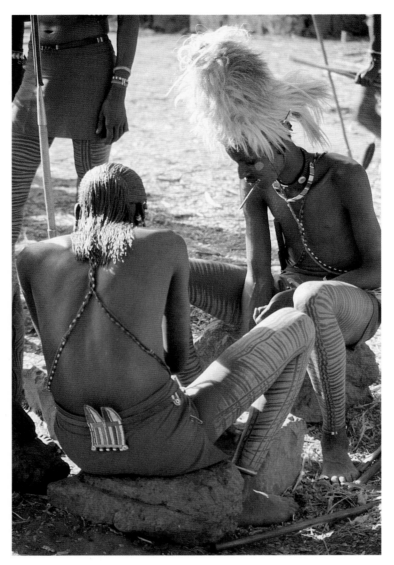

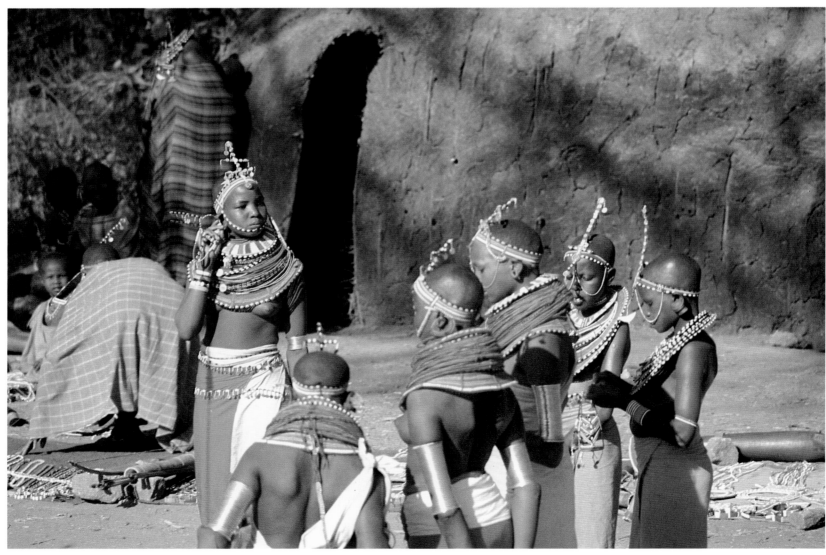

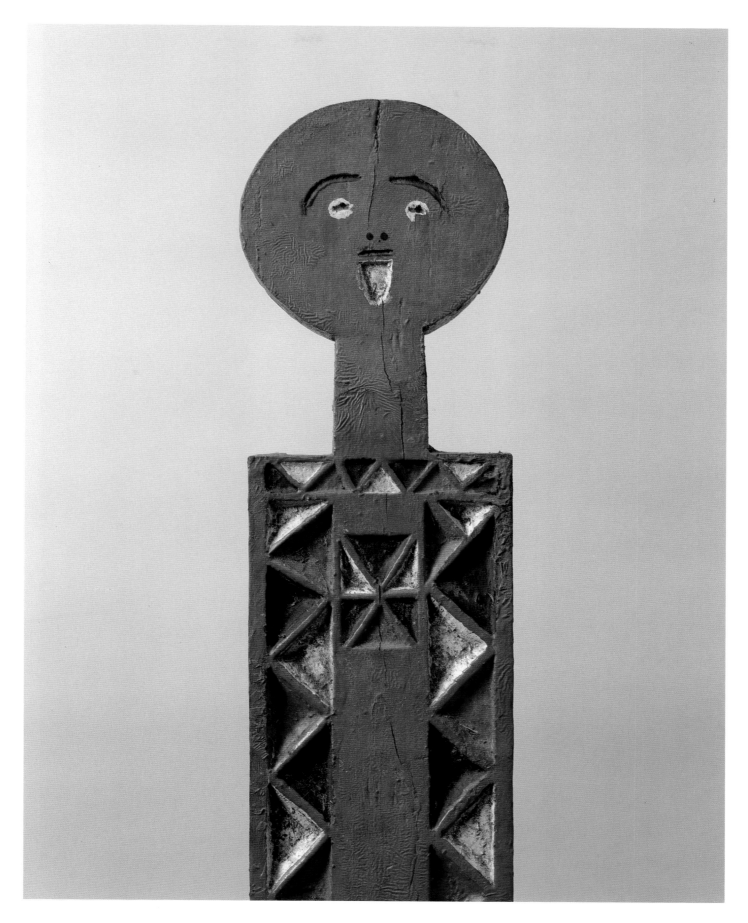

LEFT ABOVE: Maasai warriors with body paint, Kenya
Werner Forman Archive, London

LEFT BELOW: Maasai women wearing ceremonial jewelry, Kenya
Werner Forman Archive, London

ABOVE: Memorial grave effigy
Giriama people, Kenya, 20th century
Wood and pigment, 53⅝ inches (136 cm)
Hampton University Museum, Hampton, VA

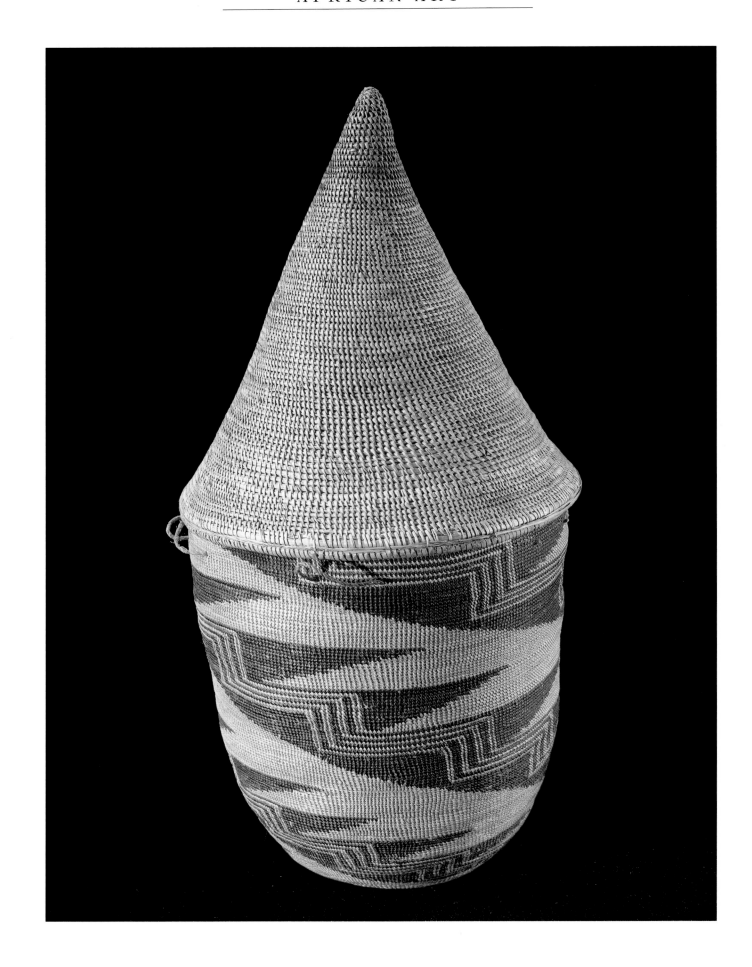

ABOVE: Basket with conical lid
Rwanda, Uganda, collected 1938/39
Fiber, 17⅜ inches (44 cm) high
Peabody Museum, Harvard University Cambridge, MA (T1696)

RIGHT: Swahili door, Zanzibar
Wood
Life File, London

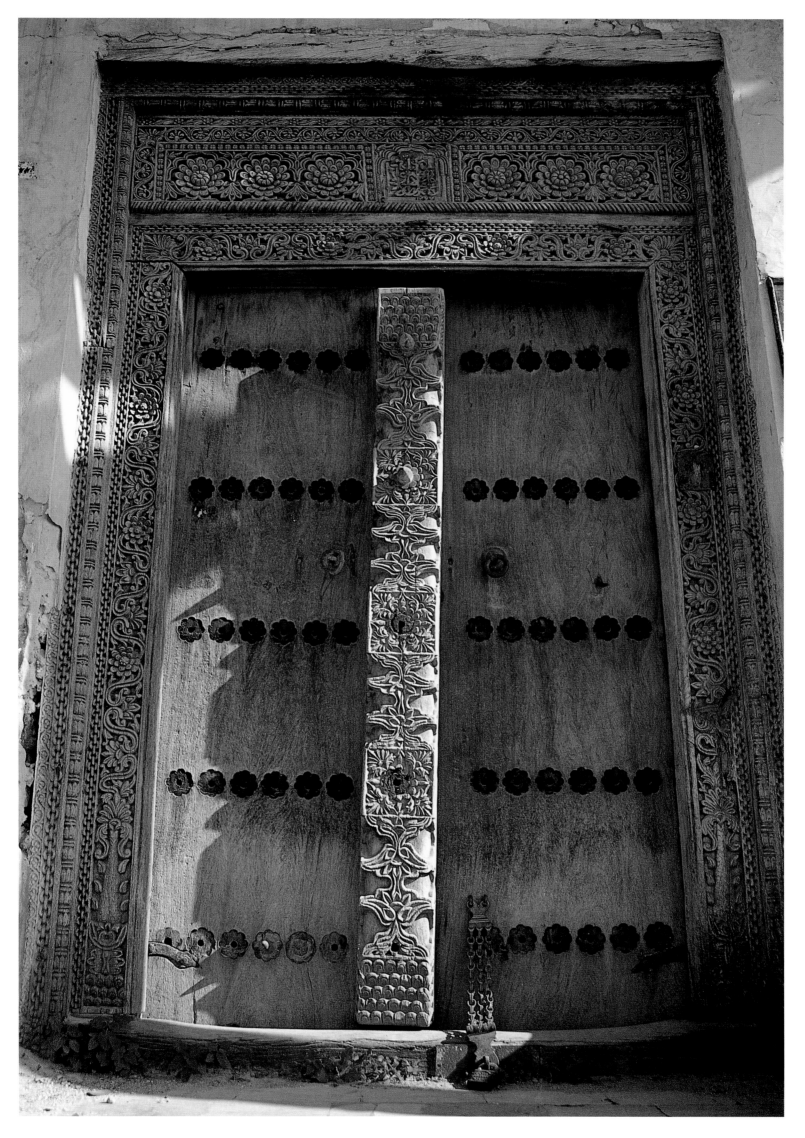

CENTRAL AFRICA

Historians of language have been able to trace the origins of the Bantu language family, and hence the majority of the population of Central Africa, back to an area around the Nigeria/Cameroon border region in *c.*3000 BC. Although the subsequent dispersal was at first seen as one huge 'Bantu migration,' it is now regarded as a gradual movement over thousands of years, in which a western and an eastern strand can be distinguished. The Bantu speakers brought with them new techniques for settled agriculture, including yam and cereal cultivation, displacing hunter-gatherer groups. They also brought new patterns of social organization and shared concepts about social and religious practice. It is thought that early Bantu societies were based around what has been called a 'House' system, groups of 30 to 50 people led by a 'big man,' with his wives, children, some relatives and clients. Shifting patterns of alliances were formed within and between Houses in unstable villages, while leaders competed for wealth, followers and prestige. Although the system remained as an organizing principle until the colonial period, centuries of innovation and counter-innovation had led to an almost infinite variety of forms and practices, from large kingdoms, to societies of elders, to autonomous villages.

Most Central African kingdoms were centers of ritual authority and prestige, to which some surrounding peoples offered allegiance and occasional tribute, but which exercised little actual power beyond the royal capital. The major exception was the Kongo kingdom, which at the peak of its power, between about 1500 and 1680 AD, maintained a standing army to enforce control over more than half a million people. The Kongo maintained close ties with the Portuguese, with the court converting to a Christianity which gradually became fused with local religious concepts. As was often the case in central Africa, artistic styles and cultural practices associated with the prestige of the Kongo kingdom spread over a far greater area, and were of much longer-lasting impact, than the power of the kingdom itself. The complex repertoire of geometric patterns that adorned ivory carvings and textiles brought back to Europe from the seventeenth-century Kongo court, were still in use in the late nineteenth and early twentieth centuries as body decorations reproduced on sculptures (page 18).

In addition to its court art, the Kongo region is known for its power sculptures, *minkisi* (sing. *nkisi*). These were owned either by villages or individual experts, and depending on the precise medicines attached to them, could be used to heal, protect, or inflict injury. Less well known are the extraordinary funerary figures of the Bwende, a Kongo subgroup. Powerful chiefs were buried, at elaborate funerals, inside these huge cloth mannequins adorned with Kongo power ideograms (page 82).

The Kuba are a group of related clans far to the east of the Kongo, in central Zaire, ruled over since the seventeenth century AD by a dynasty of the Bushoong clan. A unique series of figure sculptures, known as *ndop*, shows each of the kings with royal insignia and the emblem that identifies him (page 89). There is considerable dispute among art historians as to whether these all represent portraits carved from life, and whether those of early kings actually date to the eighteenth century. Kuba art is also characterized by the elaboration of named geometric patterns, represented here by a cut-pile raffia skirt, embroidered by women on a cloth ground woven by a male weaver.

The Chokwe formed a network of small independent chiefdoms that in the nineteenth century ruled a vast expanse of central and northern Angola. It is thought that the chiefly families were descended from invading Lunda warriors, who arrived from the east in the late fifteenth century. Although contemporary Chokwe apparently know little about the function of statues collected by early explorers, it is thought that a number of male figures (page 94) represent Chibinda Ilunga, a

RIGHT: Crucifix, Kongo kingdom, Zaire, ?16th–17th century
Copper alloy, 12¼ inches (31 cm)
Museum für Völkerkunde, Berlin

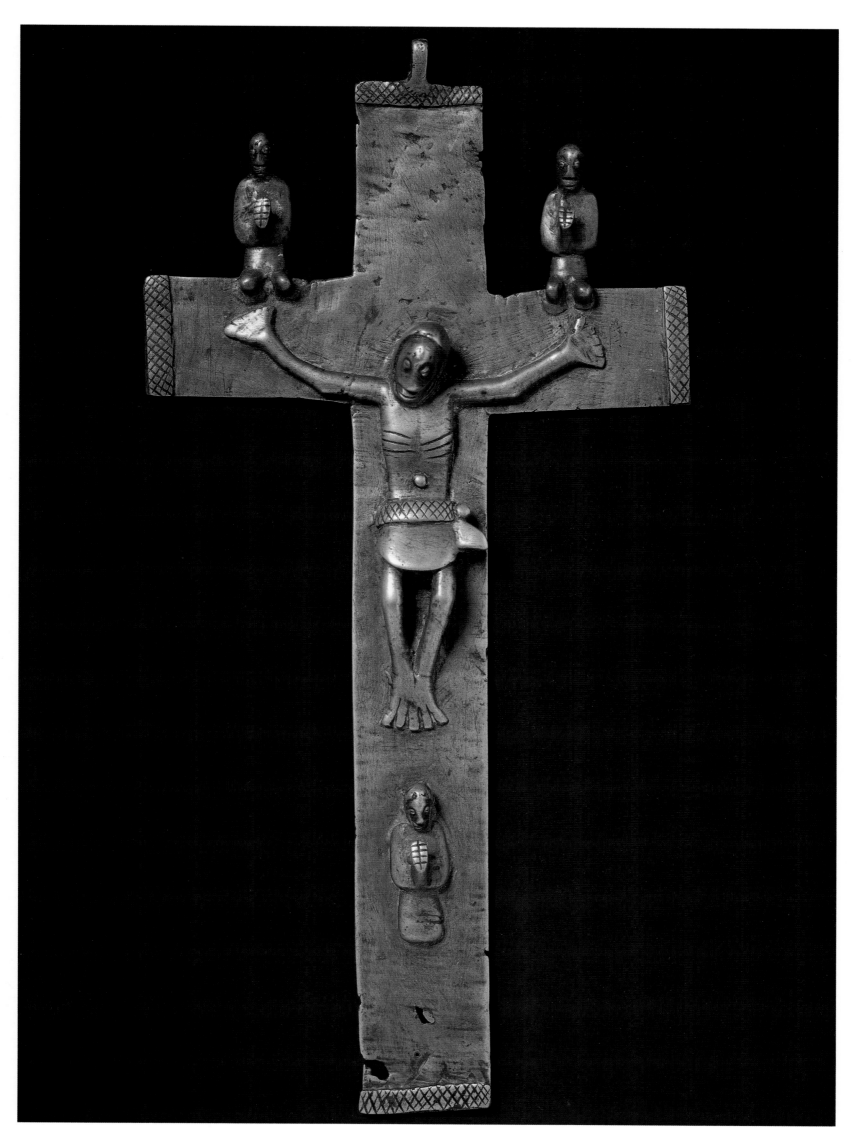

legendary Luba hero who founded the Lunda dynasty. He is depicted wearing the insignia and headgear of a Chokwe chief, as well as the equipment of a great hunter, reflecting both his role in introducing hunting skills and as the origin of new forms of chieftancy. The Luba themselves produced art in a very different style (page 90), most classic sculpture being associated with a period of expansionary kingdoms from about 1700-1860 AD. As elsewhere, the art of a powerful kingdom was copied, traded, and otherwise diffused over a wider area.

Among the Lega of eastern Zaire, most art was associated with an organization known as *Bwami*. All adults were initiated into the lowest level of the local association, but only those who could muster the necessary support could progress to the more powerful senior grades. This required wealth, and hence the support of a large number of family and clients, and also appropriate character. The role of artifacts in Bwami initiations was complex. A candidate who wished to join a higher grade had to correctly recite a vast body of law and proverbs, much of which was associated with specific initiation objects, including carved figures and masks of wood and ivory, but also baskets of natural objects such as feathers, leaves, and bones. These objects were in the care of members of the senior grade, who had to be both persuaded of the wisdom and qualifications of the candidate, and rewarded with gifts, before they would bring essential items to the ceremony. Both men and women could attain the highest grades, although men appear to have exercised greater authority. Unfortunately the Belgian colonial authorities in the 1960s supressed and largely dismantled what appears to have been a unique and fascinating system of government.

During the 1950s and 1960s a genre of popular paintings developed in the mining areas of southern Zaire, depicting themes such as colonial repression, scenes from the civil war, and the mermaid-like goddess of wealth Mammy Water. More recently a number of artists working in this style have attracted the attention of collectors and dealers in Europe. Cheri Samba (page 21), in particular, has successfully fused a comic-book-influenced technique with radical political slogans, although ironically this very success makes his paintings no longer accessible to a local popular audience.

RIGHT: Mwana Pwo Dance Mask
Chokwe, Angola/Zaire, 19th/20th century
Wood, brass studs, vegetable fiber
Werner Forman Archive, London, courtesy Entwistle Gallery

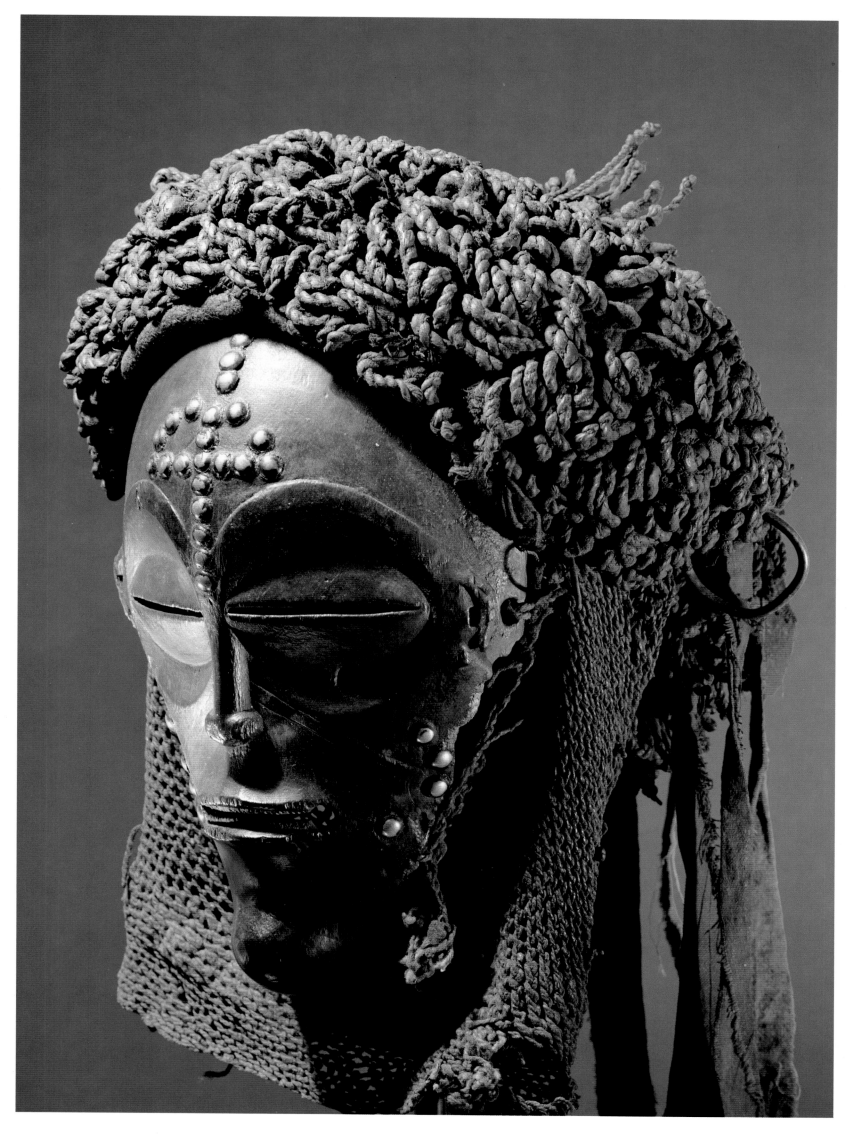

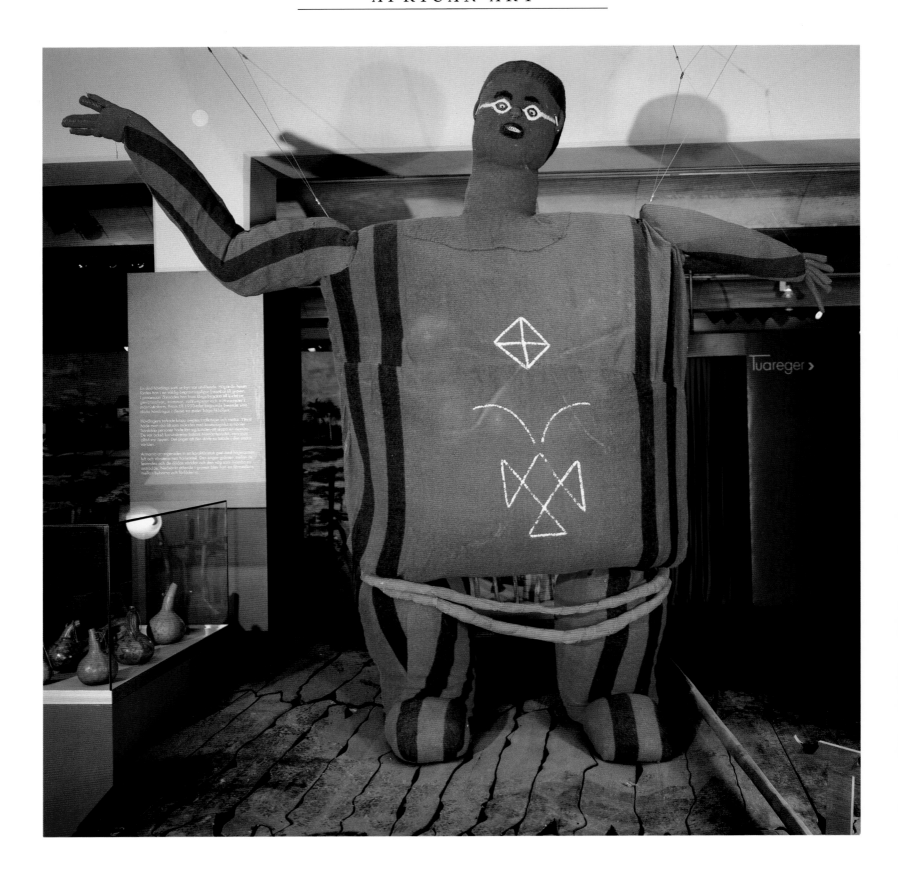

ABOVE: Niombo funerary mannequin, 1930s
Makoza of Kingoyi, Bwende peoples, Kongo region, Zaire
Cloth, 70⅞ inches (180 cm)
Folkens Museu, Stockholm

RIGHT: Nkondi figure
Kongo peoples, Zaire, 19th/early 20th century
Wood, nails, fiber, shells, clay, 44½ inches (113 cm) high
© The Field Museum, Neg# A109979c, Chicago IL (A109979c)
Photo by Diane Alexander White

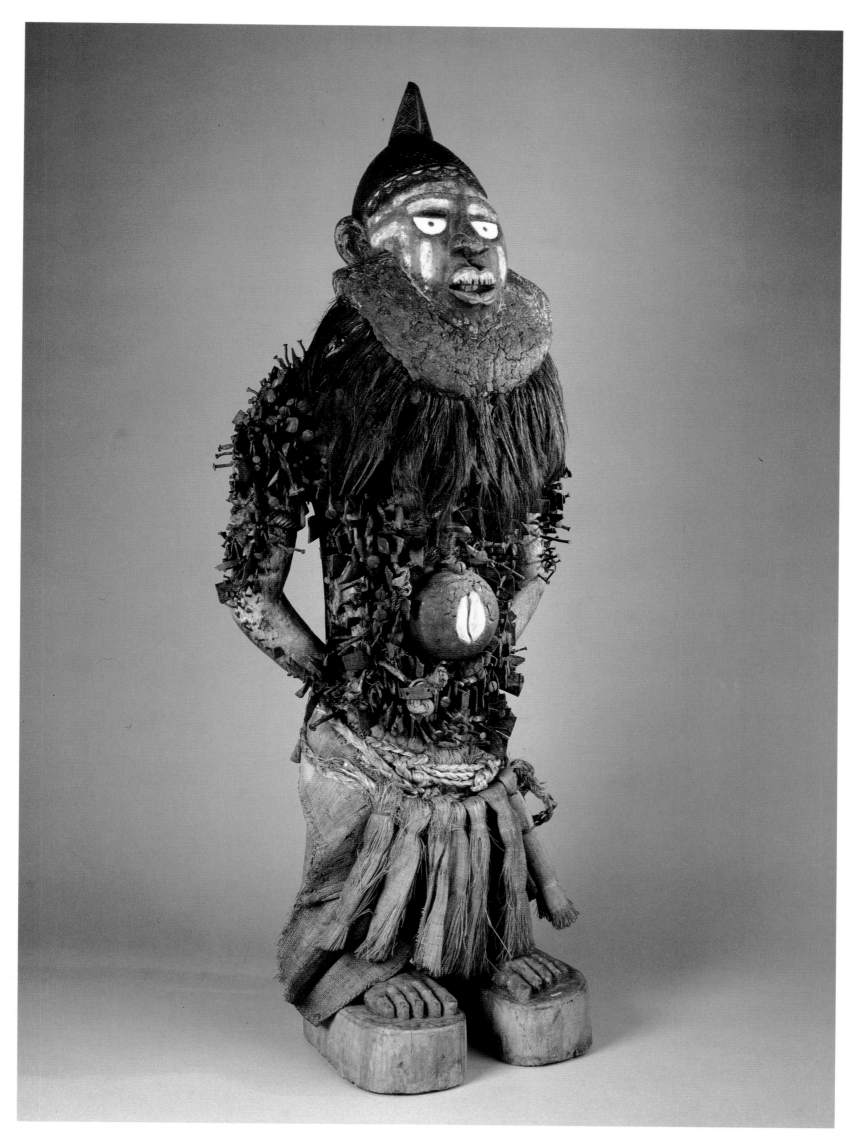

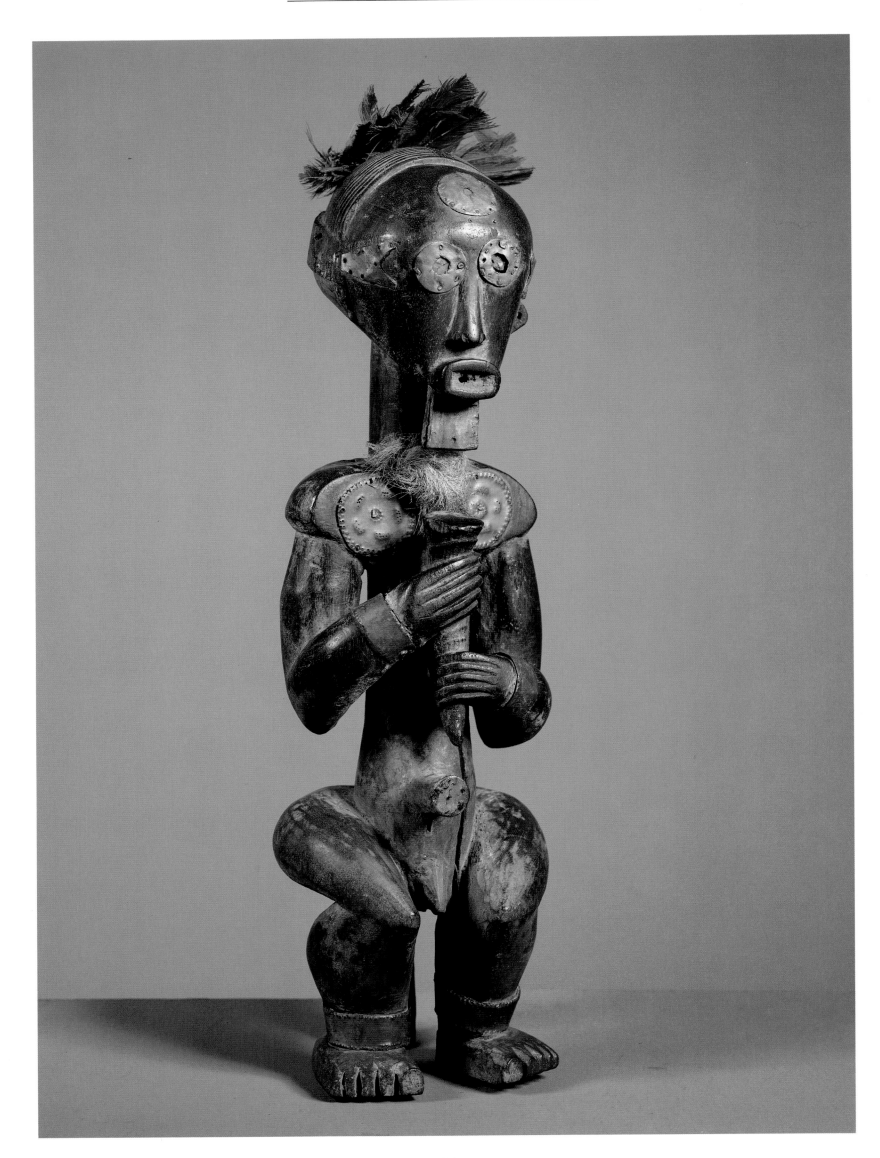

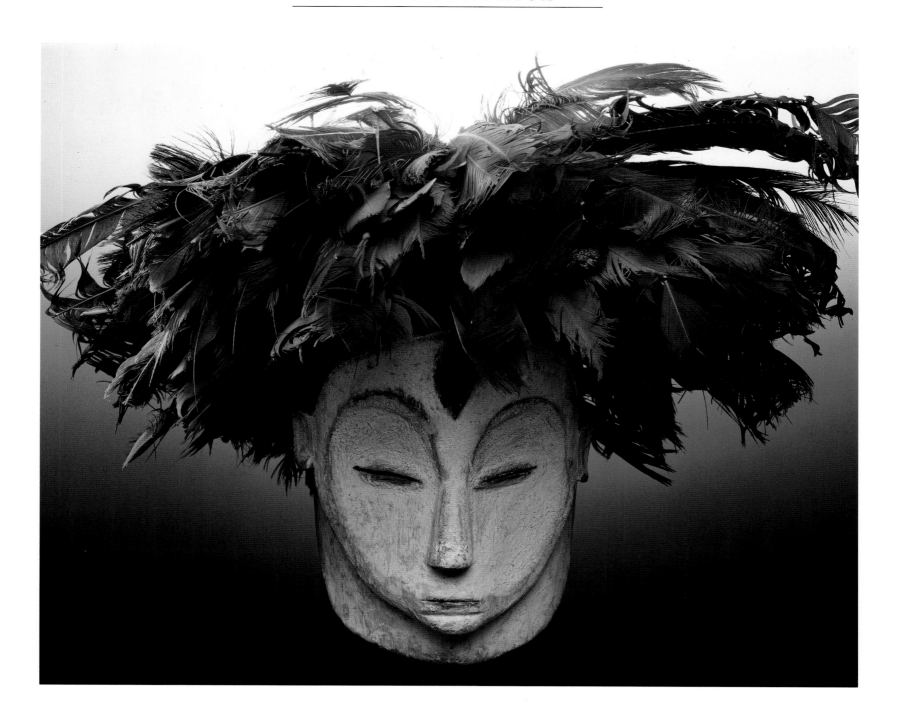

LEFT: Reliquary guardian figure
Ngumba people, Cameroon
Wood, brass, copper, fiber and feathers, 28 inches (71 cm)
Museum für Völkerkunde, Berlin

ABOVE: Mask, Fang people
Gabon, 20th century
Wood, feathers and kaolin, 11 inches (28 cm) wide
Musée des Arts Africains et Océaniens, Paris

85

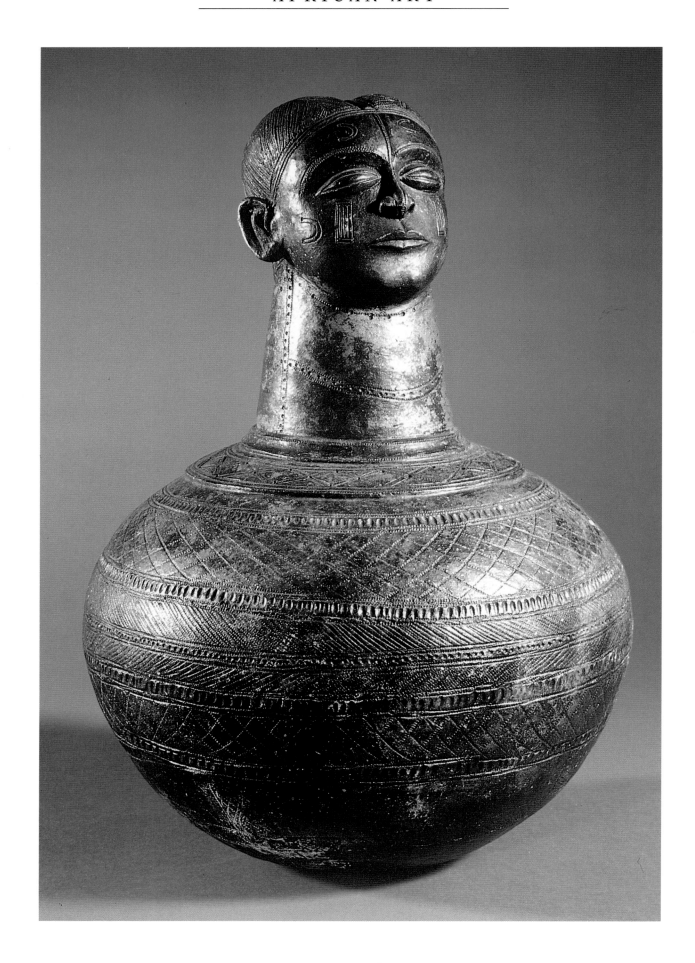

ABOVE: Azande pot
North-east Zaire, early 20th century
Clay, 18 inches (46 cm) high
Museum of Mankind, London

RIGHT: Azande male figure
North-east Zaire, late 19th/early 20th century
Wood, 31½ inches (80 cm)
Museum of Mankind, London

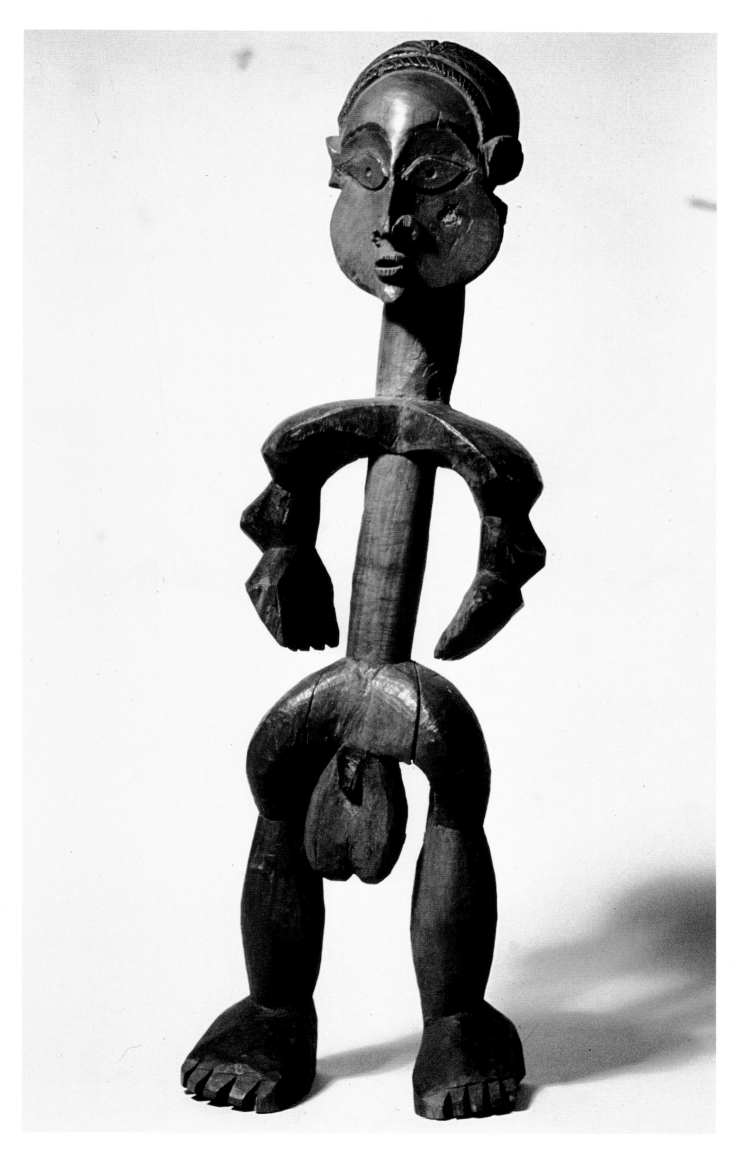

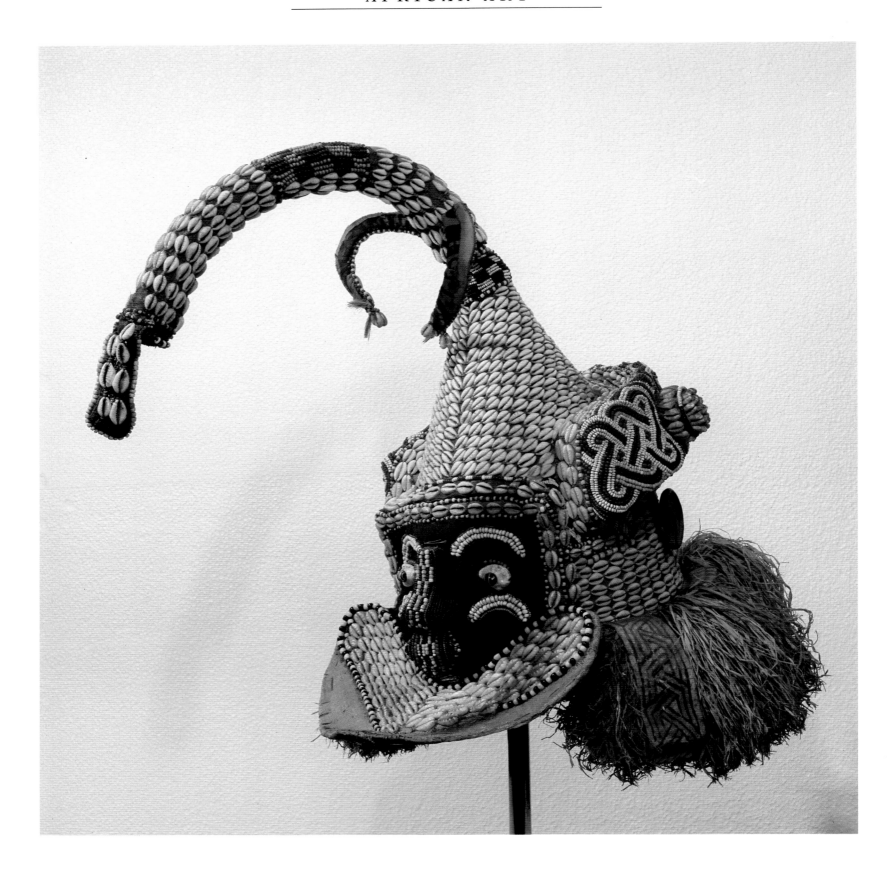

ABOVE: Mwaash a Mboy Mask
Kuba, Bushoong, Zaire, 19th/20th century
Wood, brass beads, shell, cloth, 15¾ inches (40 cm) high
Werner Forman Archive, London

RIGHT: Ndop king figure, representing King Shyaam aMbul aNgoong
Kuba-Bushoong people, Zaire, ?18th century
Wood, 21½ inches (54.5 cm) high
Museum of Mankind, London

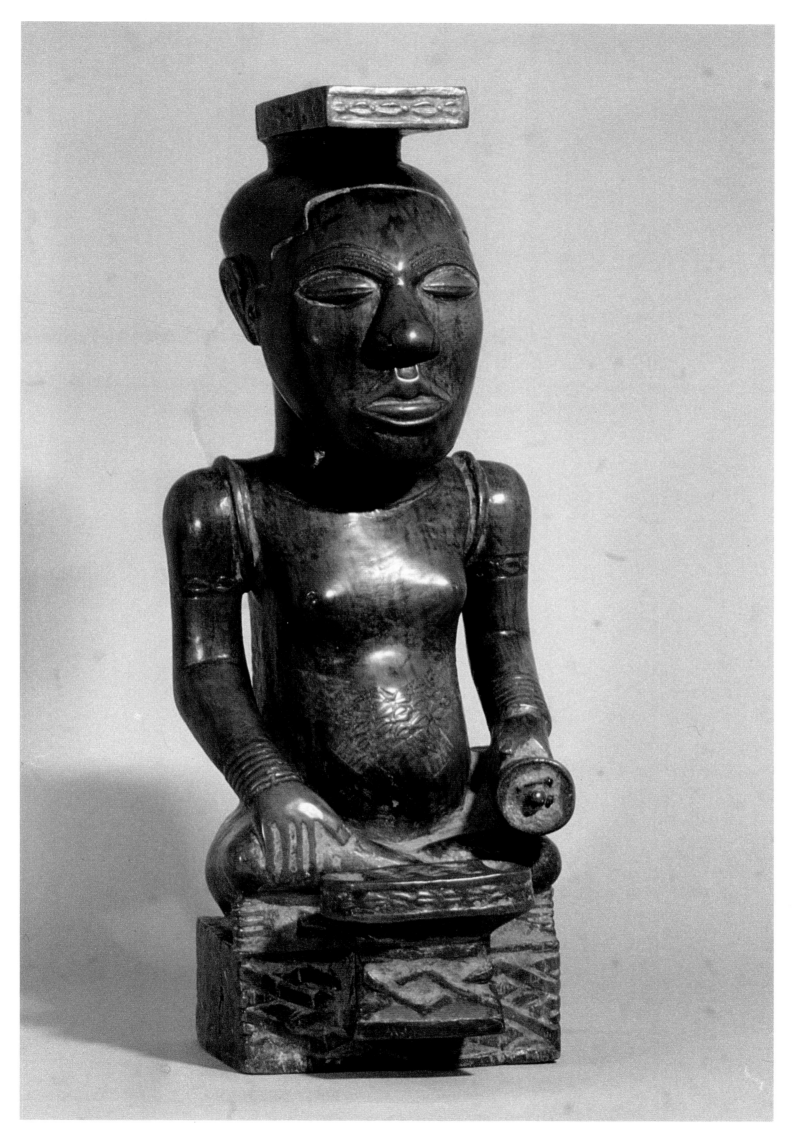

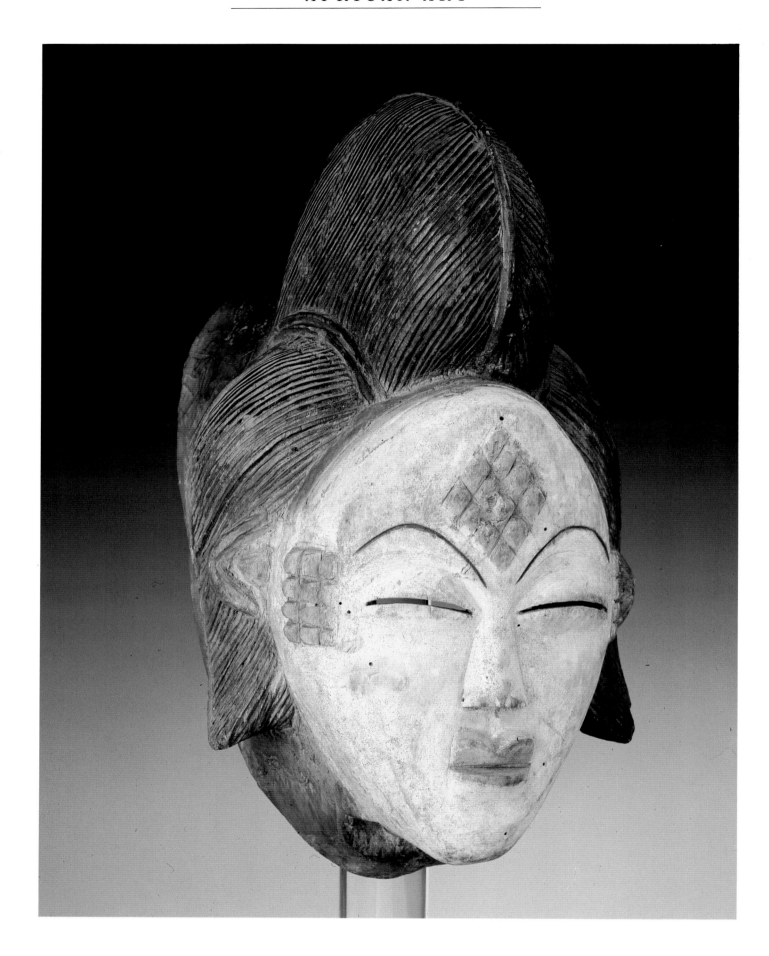

ABOVE: Mask
Ngunie river, Gabon
Wood, coloring, 14½ inches (36.8 cm)
Musée de L'Homme, Paris

RIGHT: Reliquary Guardian
Kota, Gabon
Wood, copper, brass, 18 inches (40 cm) high
Musée de L'Homme, Paris

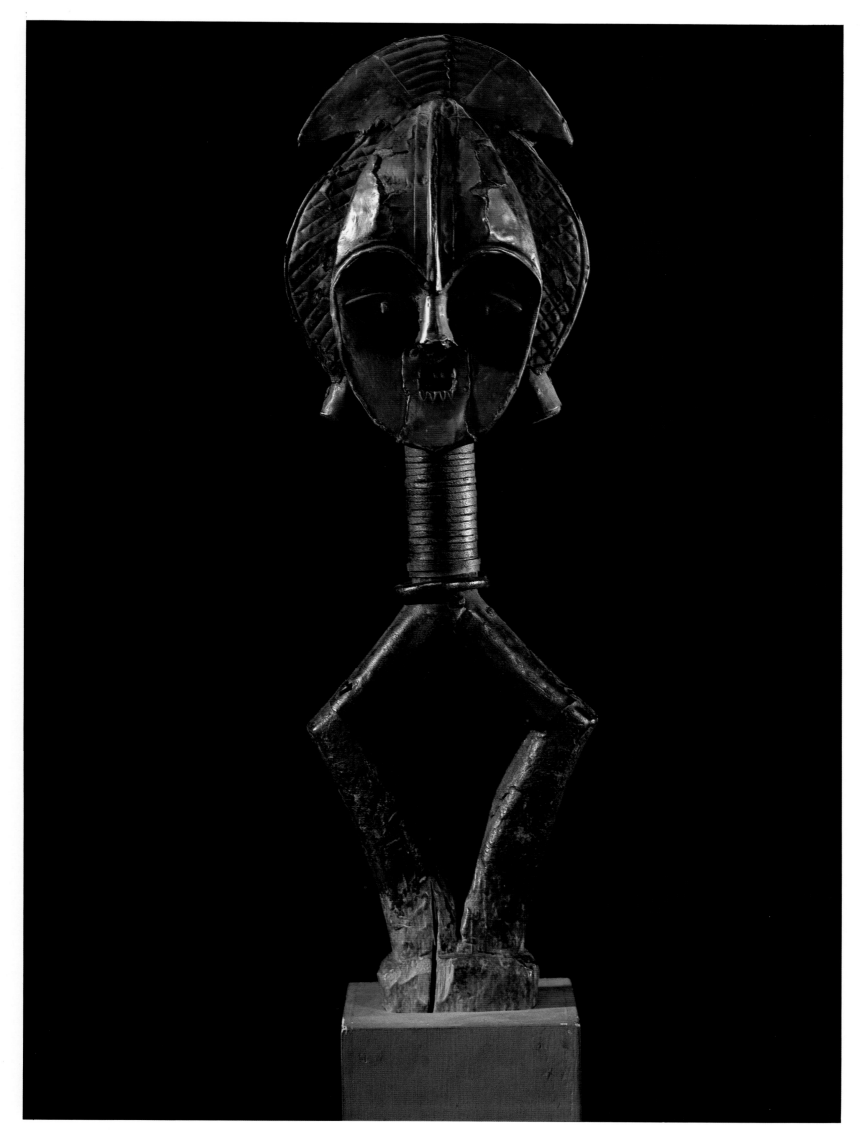

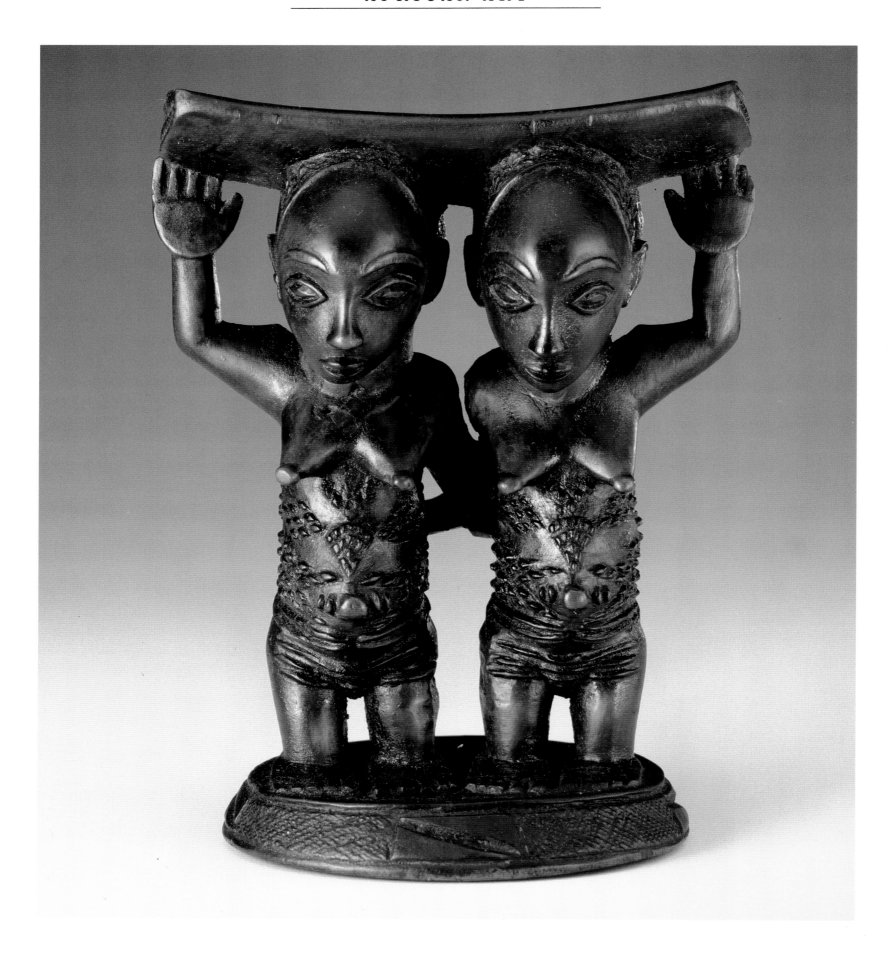

RIGHT: Kasungalala Figure, Lega, eastern Zaire
19th century
Wood and kaolin, 12 × 3¼ inches (30.5 × 8.3 cm)
© The Fine Arts Museum of San Francisco CA
Museum purchase
Gift of Mrs Paul L. Wattis Fund and the
Fine Arts Museum Acquisition Fund (1986.16.5)

ABOVE: Headrest, Luba people, Zaire
19th-20th century
Wood, 6¾ × 4⅞ inches (17.1 × 12.4 cm)
National Museum of African Art, Washington, D.C.
Museum purchase (86.12.14)

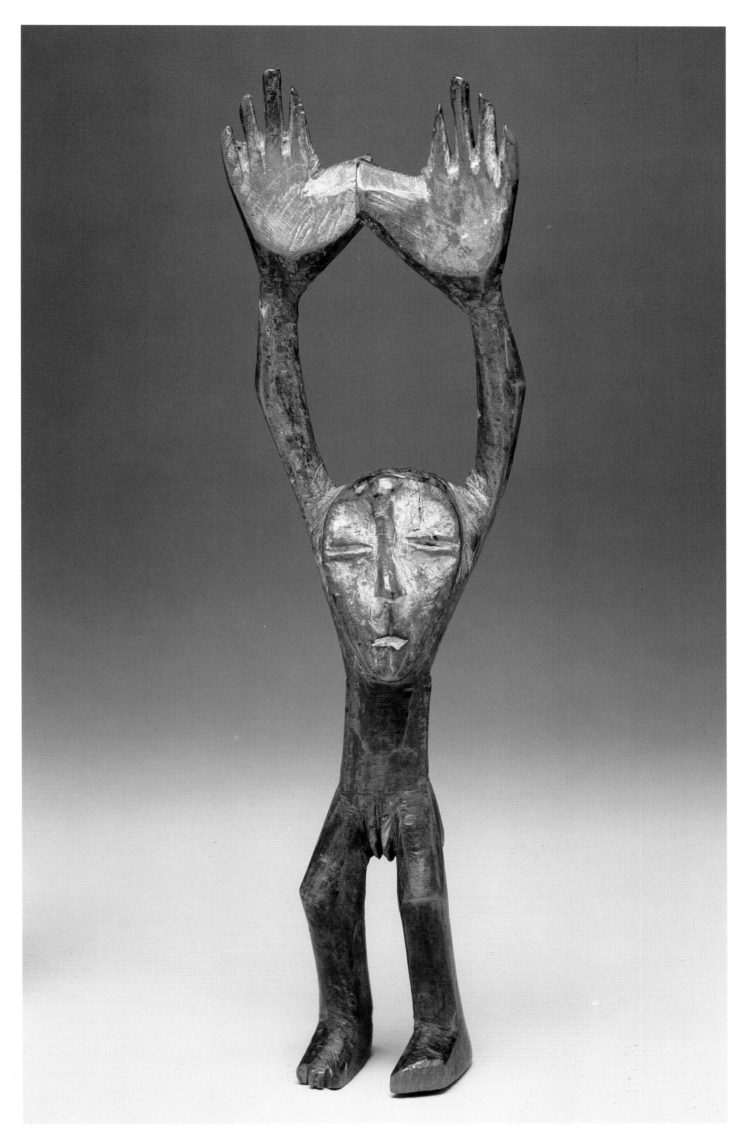

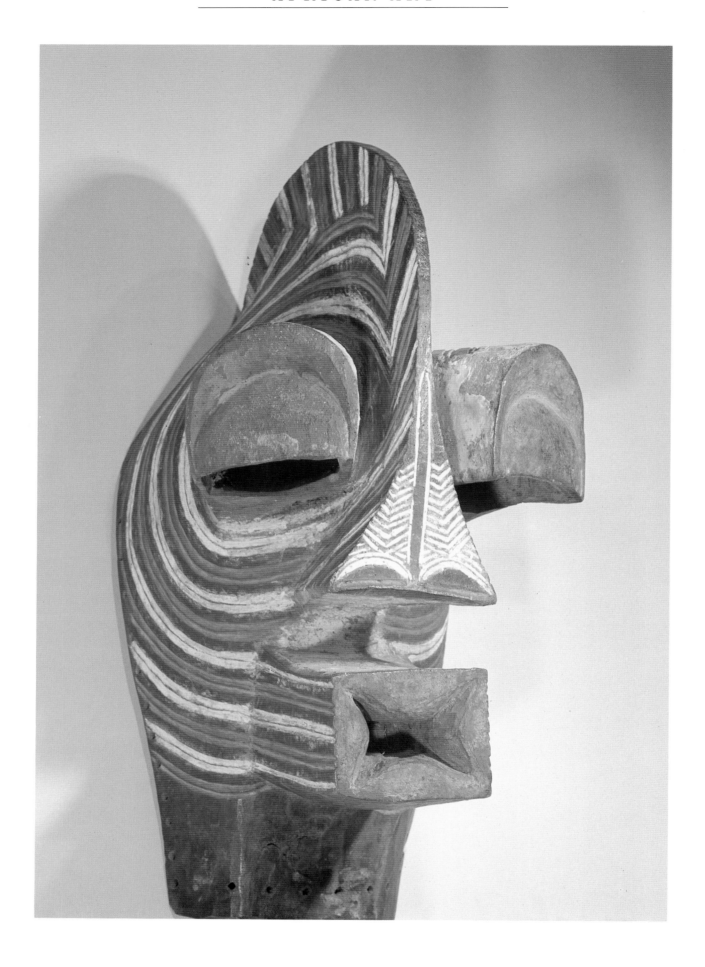

ABOVE: Kifwebe Mask
Songye, Zaire
Wood, 24¾ inches (62.9 cm) high
Werner Forman Archive, London/Simpson
Collection, New York

RIGHT: Stool with standing caryatid
Late 19th century
The 'Buli Master', Luba Hemba people, Zaire
Wood, 24 inches (61 cm) high
The Metropolitan Museum of Art, New York, NY
Purchase, Buckeye Trust and Charles B. Beneson Gifts,
Rogers Fund and funds from various donors,
1979 (1979.290)

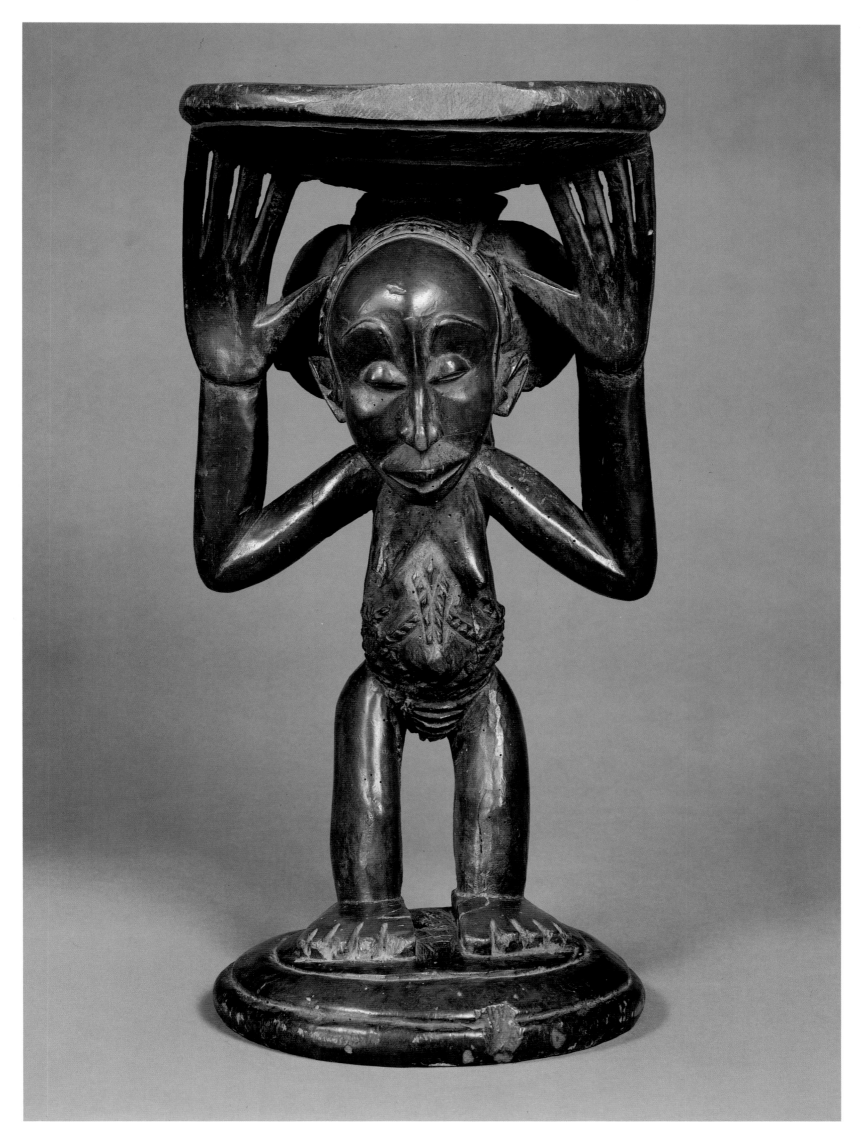

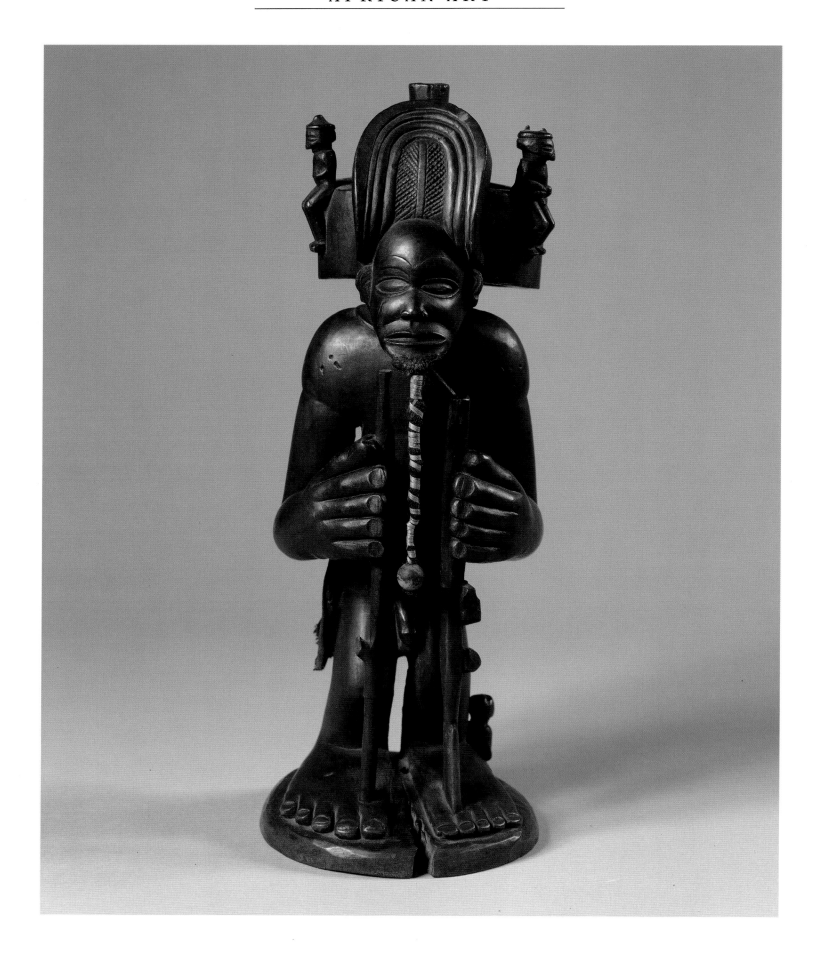

ABOVE: Figure representing the legendary hunter Chibinda Ilunga
Chokwe people, Angola, 19th century
Wood, fiber and glass, 15⅜ inches (39 cm) high
Museum für Völkerkunde, Berlin

RIGHT: Figure representing a royal woman
Chokwe people, Angola, 19th century
Wood, iron, beads, human hair, 23¼ inches (59 cm) high
Museum für Völkerkunde, Berlin

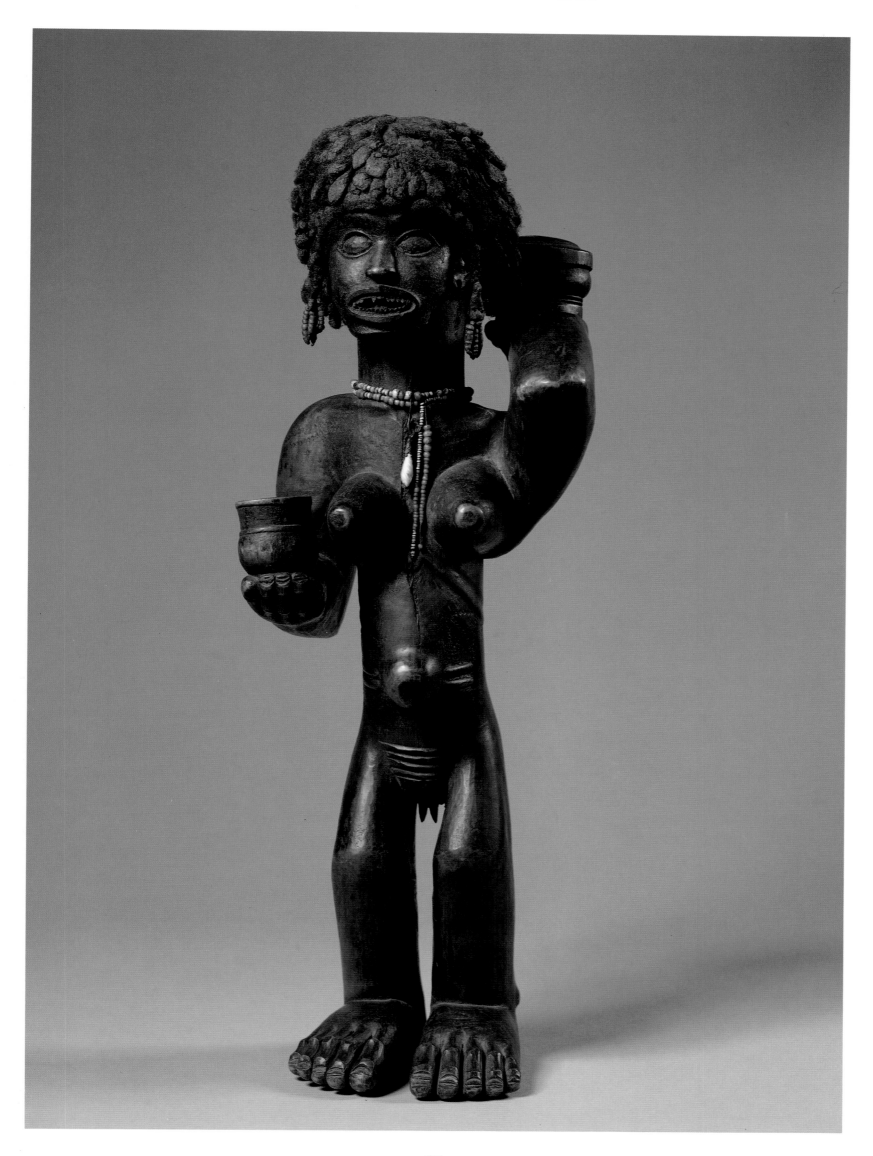

SOUTHERN AFRICA

Although the arts of South Africa itself are the main focus of this section, we must also note two other important areas, Zimbabwe and Madagascar. The apparently mysterious stone ruins at Great Zimbabwe were believed by many European colonists to be the legendary lost city of King Solomon. Despite the damage caused by numerous early searches for the hidden treasure they were convinced must be buried there, later archeological work, and a more sympathetic approach to the oral history of the local peoples, has established that the site was actually the center of a complex Shona civilization extending across a vast area of southern Africa from the early twelfth century AD to about 1450. The fragmented pattern of stone walling has been explained as linking together less durable dwelling huts. Numerous other far smaller stone buildings have been found, while a number of carved soapstone birds recovered at Zimbabwe itself have been linked to Shona conceptions of the eagle as a messenger between man and the gods.

In contrast to the indigenous culture of the Shona, Malagasy arts are a melding of influences from local sources, the African mainland, the Arab Indian ocean trade, and migrant peoples from the Indonesian archipelago. The illustrations highlight aspects related to the most unexpected of these components, the influence of south-east Asian artistic techniques and cultural practices. By the late nineteenth century, weaving in Madagascar had reached levels of technical virtuosity arguably without parallel elsewhere in Africa, using local versions of looms, including the back-strap loom, largely derived from Indonesian prototypes. Many of the more elaborate textiles such as the Merina silk cloth shown (page 100) were used as burial shrouds by the wealthy, particularly in second-burial ceremonies, part of a whole cluster of beliefs regarding the ancestral dead that have been seen to relate to south-east Asian origins. A variety of forms of grave marker were also

developed, with elaborate sculpted poles (page 101) used by royal clans of the Mahafaly people.

Little is known about the use of a remarkable group of ceramic heads found at Lydenburgh in the Transvaal, South Africa, although they have been linked to early Iron Age cultures in the region dating to c. 500 AD. Recent research has made considerable progress, however, in interpreting the many rock paintings left by the Khoisan hunter-gatherer peoples displaced from most of South Africa by incoming Bantu-speakers, and later virtually wiped out by Boer colonists. Early general readings of all rock paintings as a form of sympathetic hunting magic have been undermined by study of the culture of surviving San and Khoikhoi groups in the Kalahari region. It is now thought that most of the images are related to, and were probably painted during, shamanistic healing rituals.

Much of the course of the twentieth-century history of black artistic expression in South Africa has inevitably been shaped by, and often in explicit opposition to, the policies of the apartheid regime. Even an art form as abstract and apparently traditional as the murals painted by Ndzundza Ndebele women of the Transvaal is in fact closely related to wider political developments. On one level this art, the best known of a number of mural-painting traditions in South Africa, may be seen as concerned with female control over domestic space, utilizing motifs also found on beadwork and embroidery and marking life-cycle stages and ethnic identity. Nevertheless the contemporary look owes much to the promotion, during the 1950s and 1960s, of one particular Ndebele community as a 'typical African village' by government authorities, who regularly supplied building materials and commercial paints and bussed in tourists to photograph the results. Other women copied these designs and invented their own in home-made paints, decorating their houses on scattered farmsteads. The forced relocation of many

RIGHT: Great Zimbabwe, Shona people, Zimbabwe
14th–15th century
Werner Forman Archive

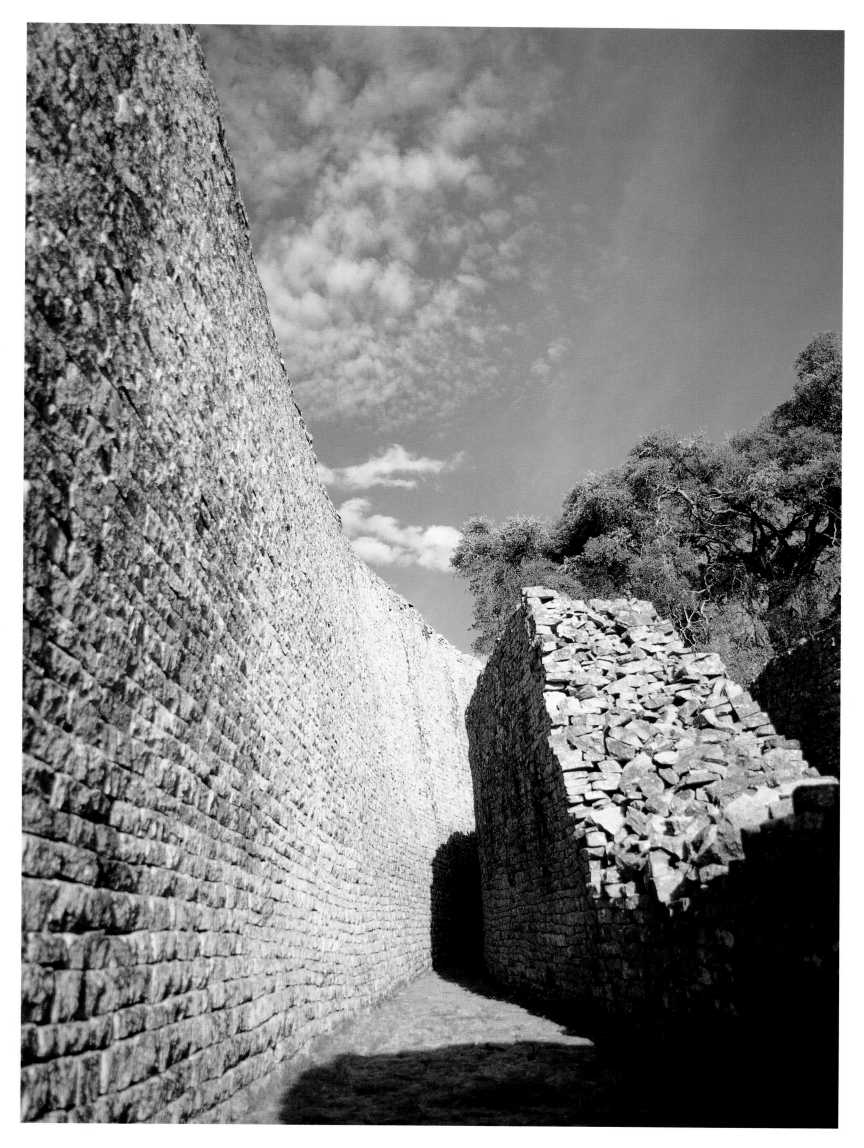

Ndebele in a so-called independent homeland in the late 1970s brought much of this activity to an end, although some buildings such as churches and chiefs' houses were still painted. Despite its somewhat artificial origins, however, the mural style, and especially the beadwork, have become part of the construction of a Ndebele identity in a wider South African context.

It has been extremely difficult for black would-be artists to obtain adequate fine-arts training in South Africa. The few pioneers, such as Gerard Sekoto (1913-1993) and John Mohl (1903-1985), had to rely on assistance from white benefactors. Small and underfunded arts centers were established in some townships in the late 1960s, on the model of a workshop known as the Polly Street Art Center from which many talented artists emerged. The Rorke's Drift Art and Craft Center, funded by missionaries, trained many future art educators and produced artists such as John Muafangejo. The struggle to learn from a wide range of sources is demonstrated in the career of Helen Sebidi. Initially encouraged to paint while working as a servant for a

white artist, she learnt from her grandmother, who painted murals in the Ndebele region, from classes given by John Mohl in Soweto, from attending and then teaching at the Kettlehong Art Center, and finally from one of a number of recent workshops where foreign artists worked with both black and white artists from southern Africa. In 1989 her mature style was recognized when she was awarded the most prestigious prize for South African artists.

It has been argued that few contemporary artists in South Africa display in their work the interest in, and ambiguous attitude toward, the art traditions of precolonial origin we have noted elsewhere. In part this may be due to the isolation of South African artists, but more fundamentally it reflects a rejection of government attempts to co-opt symbols of 'tribalism' in a divide-and-rule strategy. Many visual artists have participated in, and their work has responded to, the frequent debates about the responsibilites of artists in opposing an oppressive system, and more recently in trying to build a new future. While some have stressed

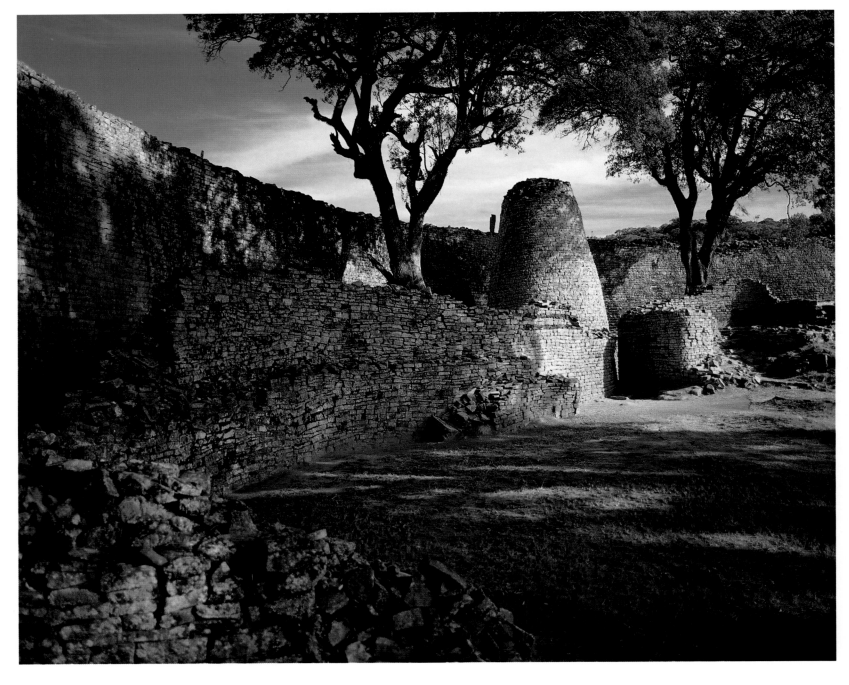

the necessity of art combining a clear political and social message with aesthetic value, others have argued against pre-conceived limits on the form and content of art. David Koloane, for example, has claimed that it is precisely this need for artistic freedom of expression that gives a political subtext even to entirely abstract art. Andries Botha has worked with people in the countryside, incorporating their techniques of thatch-ing and basketry in his sculptures, while Penny Siopis seeks to challenge both racial and gender stereotypes in the representation of South African women. It is far too early to tell how the change to majority rule will influence South African art, but we can only be confident that greater resources and openness will stimulate an art scene that has already produced such diverse work under such difficult conditions.

BELOW LEFT: Great Zimbabwe, Shona people, Zimbabwe
14th–15th century
Werner Forman Archive

BELOW: *Woman's Head* (unfinished), 1993
Tapfuma Gutsa (b. 1956), Zimbabwe
Stone
Photography courtesy Clementine Deliss

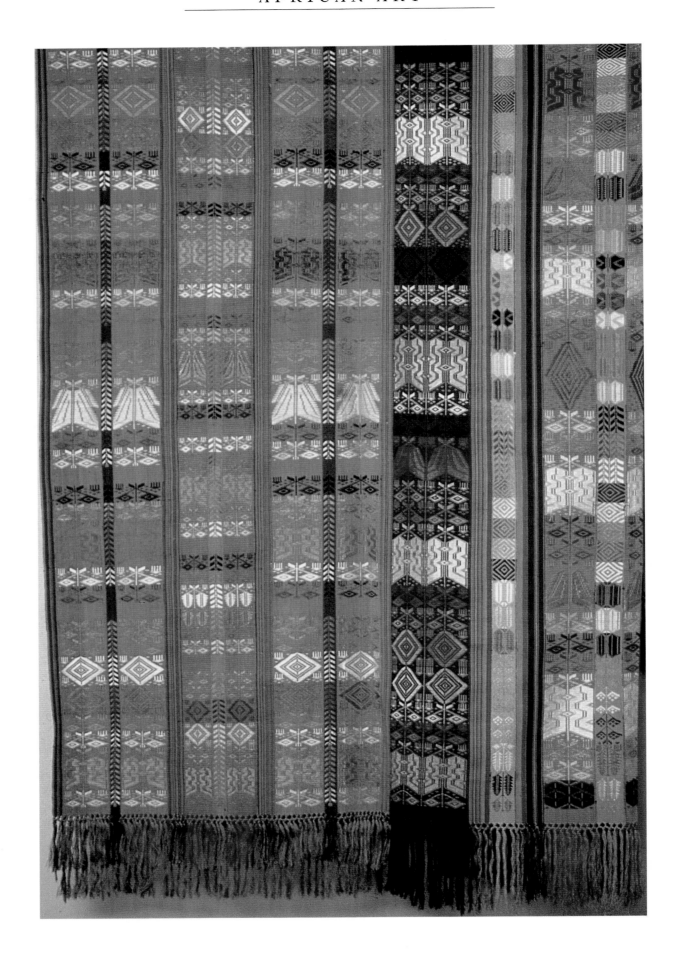

ABOVE: Cloth, Merina people, Madagascar
Early 20th century
Silk, 69⅝ inches (177 cm)
Museum of Mankind, London

RIGHT: Grave marker, Sakalava people, Madagascar
19th century
Wood, 82⅝ inches (210 cm)
Musée de l'Homme, Paris

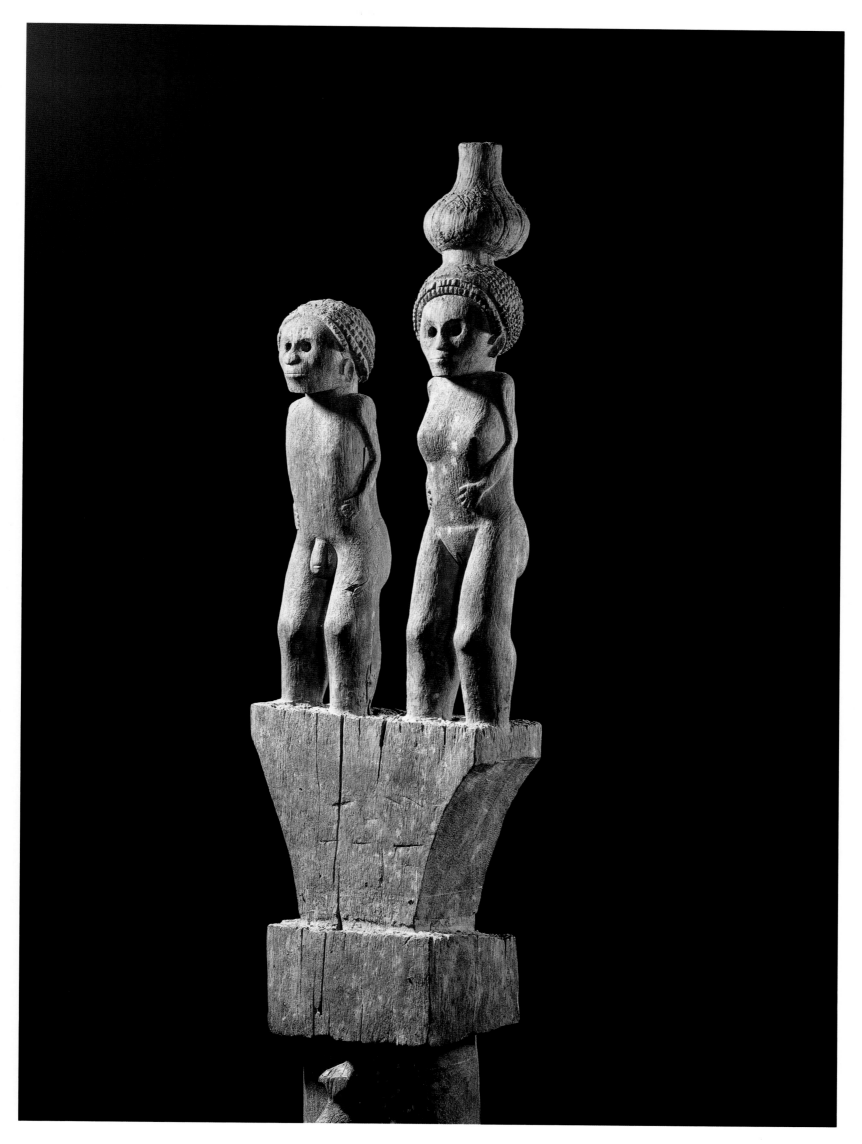

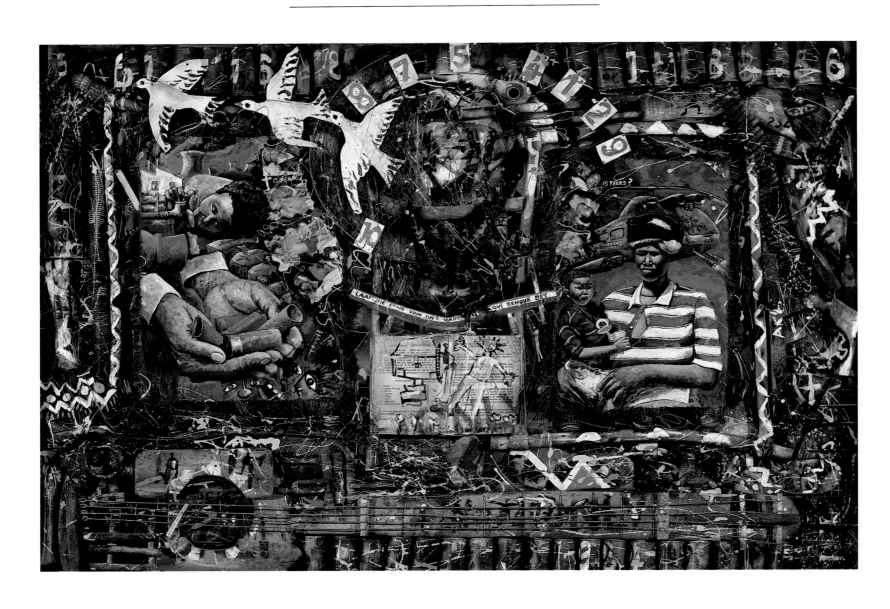

Transition, 1994
Willie Bester (b. 1956), South Africa
Mixed media collage, 50 × 72½ × 93¾ inches (127 × 184 × 9.5 cm)
Private collection

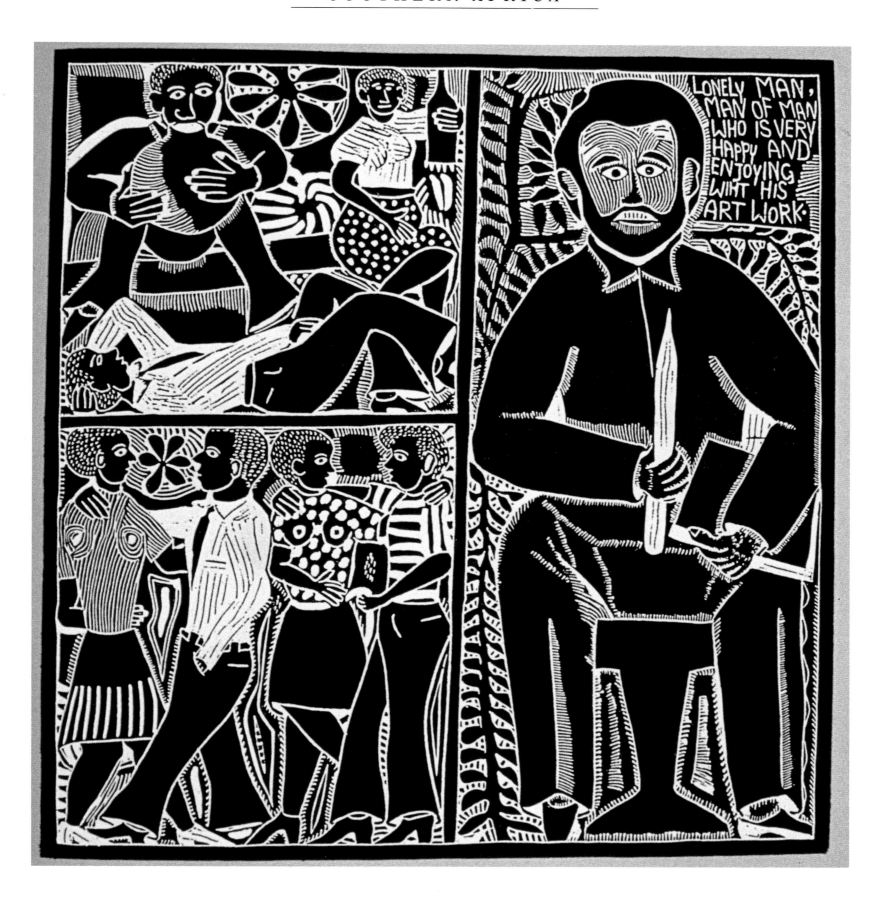

Lonely Man, 1974
John Muafangejo (1943–87), South Africa/Namibia
Linocut, 33⅞ × 24 inches (80 × 60.8 cm)
Johannesburg Art Gallery, John Muafangejo Trust

ABOVE: Venda pots, Transvaal, early 20th century
Burnished red pottery with graphite panels
Museum of Mankind, London

ABOVE RIGHT: Figure sculpture
Tsonga people, South Africa, late 19th/early 20th century
Wood, 24½ inches (62 cm) high
Museum of Mankind, London

BELOW RIGHT: Mural, Nzundza Ndebele people, South Africa
Acrylic
Audience Planners, photograph South African Tourist Board

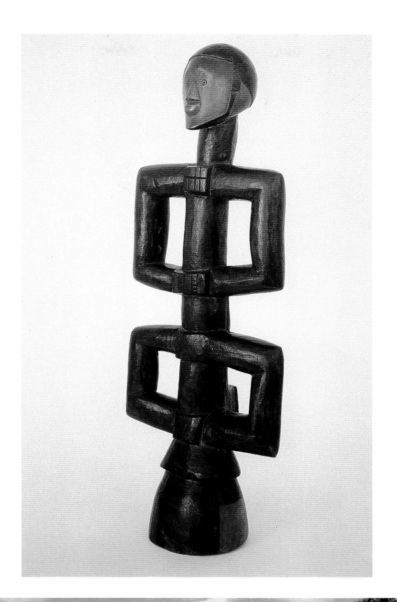

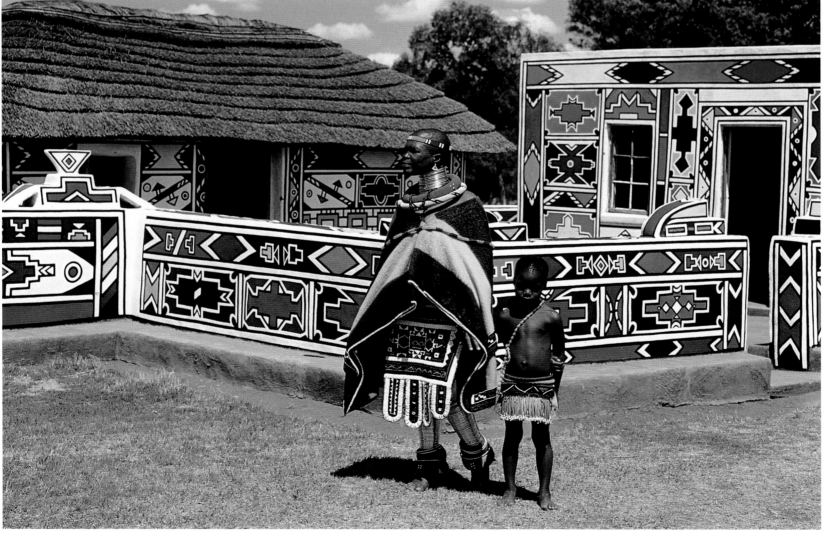

ABOVE: *Four Men and a Guitar*, 1980s
Gerard Sekoto, (1913–93), South Africa
Oil on canvas, 19⅞ × 22⅝ inches (50.5 × 57.5 cm)
South African National Gallery, Cape Town

RIGHT: *Mother Africa*, 1988
Helen Mmakgoba Sebidi (b. 1943), South Africa
Pastel and collage on paper, 63⅞ × 50⅜ inches (162.2 × 128 cm)
Goodman Gallery, Johannesburg

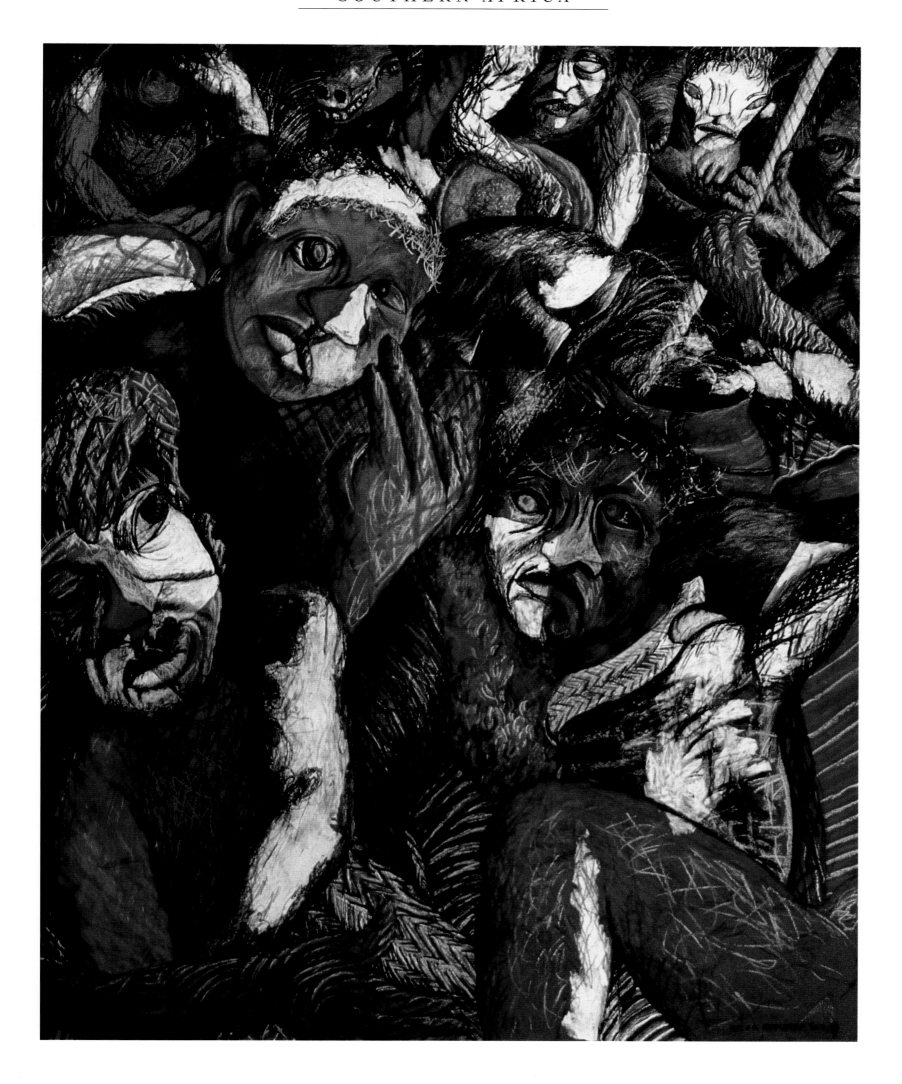

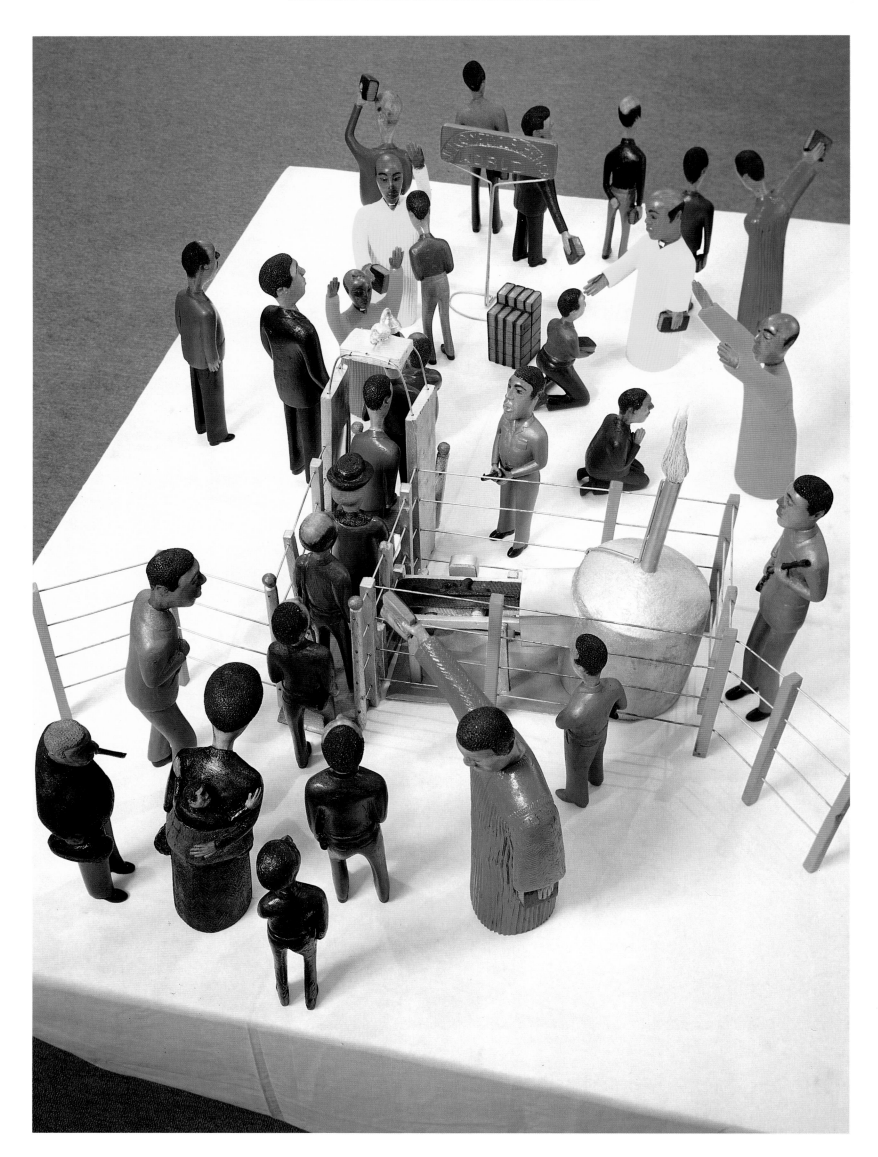

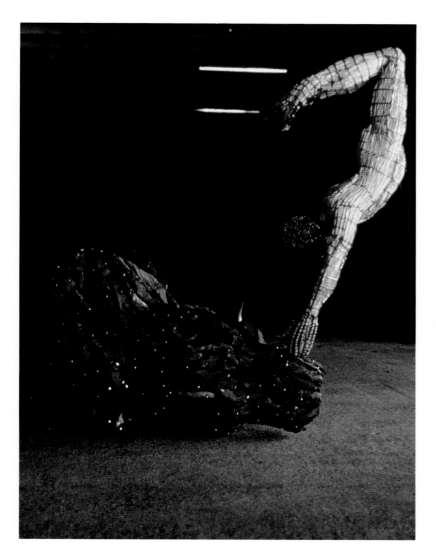

LEFT: *Welcome in Our Peace World*,
Johannes Segogela (b. 1936), South Africa
Painted wood
Goodman Gallery, Sandton, South Africa

ABOVE LEFT: *Genesis, Genesis, Jesus*, 1990
Andries Botha (b. 1950), South Africa
Leadwood, thatching grass and metal,
50 × 48½ × 78¾ inches (127 × 123 × 200 cm)
Courtesy of the artist

ACKNOWLEDGMENTS

The publisher would like to thank Martin Bristow for designing this book, Jessica Hodge for editing it, Suzanne O'Farrell and Sara E Dunphy for picture research and Simon Shelmerdine for production. The following individuals, agencies and institutions provided photographic material.

Africa-Museum, Tervuren, Belgium: 18, 19
American Museum of Natural History, New York: 9
Arts Council Collection, London: 64
Ashmolean Museum, Oxford: 26/27
Association Internationale des Amis et Defenseurs de l'Oeuvre de Man Ray: 10
Bethe-Selassie, Michael, Paris: 72 left
Bildarchiv Preussischer Kulturbesitz, Berlin: 14
Botha, Andries: 111 (left)
British Museum, London: 28 both, 29, 41, 46 left, 49, 52 both, 55, 57, 59, 86, 87, 89, 102, 106, 107 above
Centre de Recherche Esthetique et Cités Oullins, Lyon: 23 below
Deliss, Clementine: 65 both, 100
El Loko: 63
El-Salahi, Ibrahim: 73 below
Field Museum of Natural History, Chicago, IL: 83
Fine Arts Museum of San Francisco, CA: 93
Folkens Museu, Stockholm: 82 (photo Boris Kaplja)
Glasgow Museum: Art Gallery and Museum, Kelvingrove: 16
Goodman Gallery, Sandton, South Africa: 4/5, 102, 109, 110, 111 right, 111
Institut du Monde Arabe, Paris: 34, 35
Janet Stanley Collection, New York: 72 right, 73 above
John Muafangejo Trust, Johannesburg Art Gallery: 105
Life File Ltd: 77 (photo Flora Torrance)
Malangatana, Valente, Mozambique: 22
The Metropolitan Museum of Art, New York: 40, 43, 95
The Minneapolis Institute of Arts, MN: 1 (John R Van Derlip Fund)
Musée Barbier-Mueller, Geneva: 17 (photo R Asselberghs), 50 (photo P A Ferrozzini), 53 (photo R Asselberghs)
Musée de l'Homme, Paris: 12 above, 38, 39, 46 right, 47, 51, 90, 91, 103
Musée des Arts Africains et Océaniens, Paris: 85
Museo Prehistorico e Etnografico, Rome: 6
Museum voor Volkenkunde, Rotterdam: 20
National Museum of Athens: 25
National Museum of African Art, Smithsonian Institution, Washington, D.C.: 23 above (photo Franko Khoury), 42 (photo Jeffrey Ploskonka), 92 (photo Frank Khoury)
National Museum of African Art and National Museum of Natural History: 11
National Museum of Scotland, Edinburgh: 58
Nour Foundation, London: 30 (photo Studio 27)
Patras Galerie, Paris: 21
Peabody Museum, Cambridge, MA: 76
Phoebe A Hearst Museum of Anthropology, University of California at Berkeley: 13
Picton, John: 7, 37 above, below left and below right
Pitt Rivers Museum, University of Oxford: 56
Roxford Books, Hertingfordbury, Herts: 12 below (photo Alastair Lamb)
Roy, Christopher D (1985): 15
Saarland Museum, Saarbrucken: 8
South African National Gallery, Cape Town: 108
South African Tourist Board: 107 below
Staatliche Museen Preussischer Kulturbesitz, Museum für Völkerkunde, Berlin: 2 (photo Waltraut Schneider-Schutz), 60 (photo Waltraut Schneider-Schutz), 61 (photo Dietrich Graf), 79, 84, 96 (photo Dietrich Graf), 97 (photo Dietrich Graf)
University of Iowa, IA: 15
University of Witwatersrand, Johannesburg: 109
Werner Forman Archive, London: 31, 35, 44, 45, 48, 52, 62, 67, 69, 70, 71, 74 both, 80 (courtesy Entwistle Gallery, London), 88, 94 99